The Fire King and Beyond:

Anchor Hocking™
Decorated Pitchers and Glasses

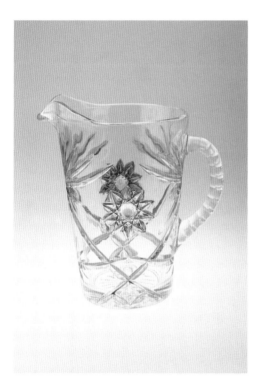

Philip L. Hopper

Schiffer Publishing Ltd

4880 Lower Valley Road, Atglen, PA 19310 USA

Disclaimer

All trademarks mentioned in this book belong to the Anchor Hocking Corporation or other companies holding those trademarks. The Anchor Hocking Corporation did not authorize this book nor furnish or approve any of the information contained therein. This book is derived from the author's independent research. This book does not infringe upon any copyright and is intended only to inform, educate, and entertain its readership.

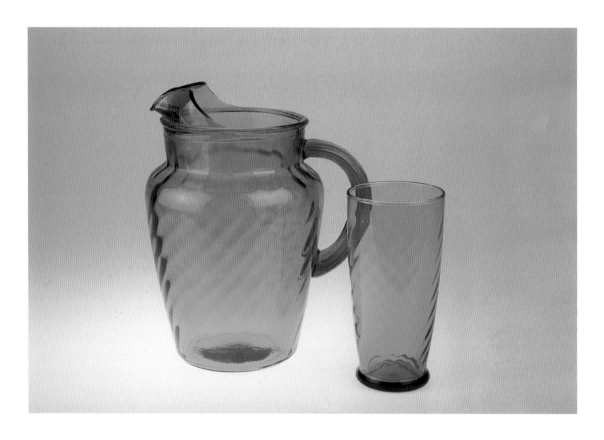

Published by Schiffer Publishing Ltd.
4880 Lower Valley Road
Atglen, PA 19310
Phone: (610) 593-1777; Fax: (610) 593-2002
E-mail: Schifferbk@aol.com
Please visit our web site catalog at **www.schifferbooks.com**
We are always looking for people to write books on new and related subjects. If you have an idea for a book please contact us at the above address.

This book may be purchased from the publisher.
Include $3.95 for shipping.
Please try your bookstore first.
You may write for a free catalog.

In Europe, Schiffer books are distributed by
Bushwood Books
6 Marksbury Ave.
Kew Gardens
Surrey TW9 4JF England
Phone: 44 (0)20-8392-8585
Fax: 44 (0)20-8392-9876
E-mail: Bushwd@aol.com
Free postage in the UK. Europe: air mail at cost

Designed by Mark David Bowyer
Type set in Americana XBd BT/Lydian BT

ISBN: 0-7643-1761-X
Printed in China
1 2 3 4

Dedication

Now that I have reached the second fifty years of my life, I have come to realize how important "family" is. Everyone needs to have a sense of belonging and I certainly have that. I was lucky to have several families in my life. I was part of the Air Force family, the glass collectors' family, and the railroaders' family. Most important, however, has been my true family, and especially my daughter Shelley. When I think back at all the dumb, crazy, and downright stupid things I did as a child, I know how blessed I was with Shelley. She was good in school, didn't get into trouble (at least I never knew about it!), and she was a very special person.

As a parent, it is often difficult to talk to our children. I was no different than any other parent. Shelley and I did have those infamous "father – daughter" talks, but in a rather strange time and place. They usually occurred on the way to some junkyard when I was searching for old car parts. It was strange to say, "Look for old Pontiacs" in one instance and then say, "You want the details about doing what?" a minute later. Still, we could talk and that is all that matters. Eventually, we set Sunday aside as "our" day. We would start off with breakfast at the Shoney's or Denny's and then go somewhere . . . anywhere . . . it didn't matter. There was no schedule or itinerary to keep, just the day to be together.

I look back at all the things I did wrong as a parent. I think we all do this, eventually. Still, I see Shelley as a grown woman with the maturity, drive, honesty, foresight, compassion, dedication, and fortitude to be successful in anything she attempts. She may never know how much I miss those "special" times together. I can only say that I love her with all my heart and soul!

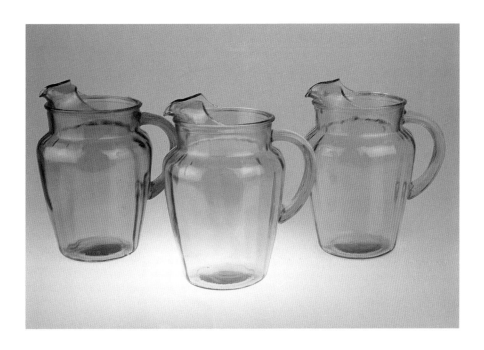

Foreword

Initially, I had a difficult time trying to decide how to organize this book to make it "user friendly." I finally decided to divide the book into three volumes: (1) one volume to cover the earlier years (approximately 1920 through 1950), (2) a second volume to cover the Fire King™ years (approximately 1950 to 1970), and (3) a final volume to cover everything made until the present day. I also tried to group the pitchers into decorative categories, such as pitcher with stripes, juice pitchers, frosted pitchers, etc., since many of the decorations are not listed in catalogs and have no company decoration designation. In the later years, Anchor Hocking used three general styles of pitchers: (1) the 86 oz. upright pitcher, (2) the Finlandia™ style pitcher, and (3) the Chateau™ style pitcher. Some of the styles have been used for over twenty years and may still be in use. These three pitcher styles were originally made of colored glass without any decoration. In later years, the company added etching or enameled decorations. Then, the pitcher was given a name indicative of the added decoration and not the basic shape or style of the pitcher.

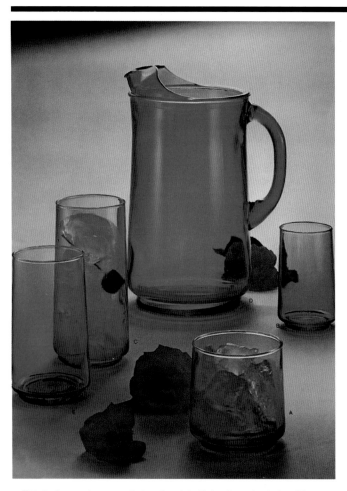

This is the catalog page listing the plain Finlandia style pitcher. The catalogs list Finlandia in Laser Blue, Crystal, Honey Gold, Aquamarine, and Avocado Green.

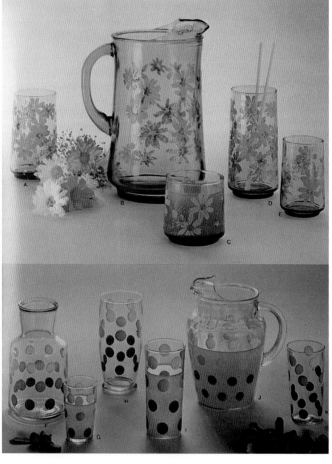

The same catalog also lists the decorated Finlandia style pitcher, with floral decorations, as Misty Daisy. The Misty Daisy decoration was applied to all the colors of the plain Finlandia design pitcher.

Contents

Introduction

Pricing

The prices in this book are only a guide. They are retail prices for mint condition glassware. Several factors will have on effect of glassware prices: regional availability, depth and consistency in coloring, the presence or absence of Anchor Hocking™ markings in the glass or as paper labels, and relative rarity of the piece. Certain items will command higher prices if they are sets in the original packaging. I would also consider labeled pieces (paper or marks embedded in the glass) to command a ten to twenty percent increase in price over unmarked pieces. Prices will drop considerably for glassware that is chipped, scratched, cracked, or deformed. No matter what any reference book states, the bottom line is . . .glassware is only worth what someone is willing to pay for it!

Measurements

I have tried to make this reference book as "user friendly" as possible. Too many times I have been in an antique shop and spotted a tumbler I wanted and the reference book I was using said this was a 12 oz. tumbler. Without a container of liquid and measuring cup, I would have no way to actually determine if the tumbler held 12 ounces. I would rather know the tumbler is 5 inches high with a top diameter of 3 inches. This I can measure with a ruler. Unless otherwise noted, the measurements listed in the book are the height of the item. You need to realize that, throughout the production of certain glassware items, the mold dimensions did vary. The measurements in the book are the actual measurements made on each piece of glassware pictured.

Resources Available to Collectors

Collectors today have a great variety of resources available. With the advent of the "electronic age," collecting capabilities have been greatly expanded. I can honestly state this book would not have been possible without using the vast resources available, especially on the internet. Below I have listed the resources collectors can use for locating antiques and glassware; however, realize this list is not all-inclusive.

Internet Resources: Without leaving the comfort of your home or office, you can search worldwide for items to add to your collection. Presently, there are both antique dealers and auctions services on the internet.

eBay™ Auction Service: The eBay Auction Service provides a continually changing source of items. This internet service contains over 3,000,000 items in 371 categories. Internet users can register as both buyers and/or sellers. The majority of the items remain on the "auction block" for seven days. You can search the auction database for specific items. A list of items will be presented following the search. For example, you might want to find a Fire King Jadeite vase made by Anchor Hocking. Because the seller enters the item's description in the database, you often have to anticipate how the item is described. Don't limit the searches. In this case, you might have to search under Jadeite, hocking, fireking (no space), fire king (with the space), or vase to find the item you want.

Internet Antique Malls: There are several internet antique malls I have found to be extremely useful in locating glassware. Each mall contains numerous individual dealers with items for sale. The malls I used are listed below:
1. TIAS Mall – (http://www.tias.com/)
2. Collector Online Mall – (http://www.collector online.com/)
3. Facets Mall – (http://www.facets.net/facets/shopindx.htm)
4. Depression Era Glass and China Megashow – (http://www.glassshow.com/)
5. Cyberattic Antiques and Collectibles – (http://cyberattic.com/)

Glass shows, antique shops, and flea markets: All collectors still enjoy searching the deep, dark crevices of the local antique shops and flea markets. Many of the best "finds" in my personal collection were located in flea markets and "junk" shops. Most of the dealers in glass shows have a good working knowledge of glassware, so "real finds" are not too plentiful.

Periodicals: Both Depression Glass Magazine and The Daze, Inc. are periodicals which will greatly enhance your collecting abilities. Along with the numerous advertisements for glassware, there are informative articles on all facets of collecting glassware.

Word of Mouth: This is one resource so often overlooked. Let others know what you are looking for. Consider expanding you search by including friends, relatives, and other collectors. This book could not have been written without the help of many fellow collectors.

Do not limit your collecting to only one resource. Remember, the items you seek are out there . . . somewhere!

Request for Additional Information

I am always seeking information concerning Anchor Hocking's glassware production. Much of the information about the company is not available in a printed format. This book will undoubtedly be updated and it is imperative that new information be made available to collectors. If you have any information you would like to share with the "collector world," please contact me at the following address:

Philip L. Hopper
6126 Bear Branch Drive
San Antonio, Texas 78222
E-mail: rrglass@satx.rr.com

Please be patient if you need a response. I am not in the glassware business. I am a Certified Industrial Hygienist (CIH) first and a collector the rest of the time. I will make every effort to provide prompt feedback on you inquiries. Include a self-addressed, stamped envelope if you desire a written response.

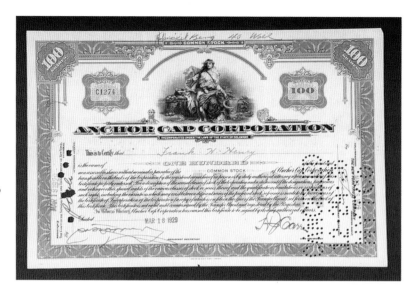

Common stock certificate for the Anchor Cap Corporation.

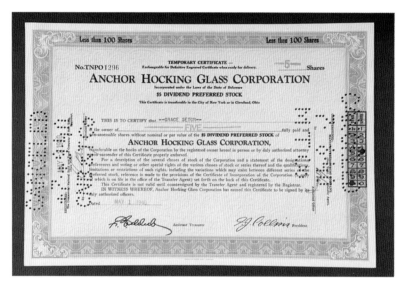

Anchor Hocking Glass Corporation stock certificate.

Common stock certificate for the Anchor Cap Corporation.

Anchor Hocking first came into existence when Isaac J. Collins and six friends raised $8,000 to buy the Lancaster Carbon Company, Lancaster, Ohio, when it went into receivership in 1905. The company's facility was known as the Black Cat from all the carbon dust. Mr. Collins, a native of Salisbury, Maryland, had been working in the decorating department of the Ohio Flint Glass Company when this opportunity arose. Unfortunately, the $8,000 that was raised was not sufficient to purchase and operate the new company; so, Mr. Collins enlisted the help of Mr. E. B. Good. With a check for $17,000 provided by Mr. Good, one building, two day-tanks, and fifty employees, Mr. Collins was able to begin operations at the Hocking Glass Company.

The company, named for the Hocking River running near the plant, made and sold approximately $20,000 worth of glassware in the first year. Production was expanded with the purchase of another day-tank. This project was funded by selling $5,000 in stock to Thomas Fulton, who was to become the Secretary-Treasurer.

Just when everything seemed to be going well, tragedy struck the company in 1924. The Black Cat was reduced to ashes by a tremendous fire. Mr. Collins and his associates were not discouraged. They managed to raise the funding to build what is known as Plant 1 on top of the ashes of the Black Cat. This facility was specifically designed for the production of glassware. Later that year, the company also purchased controlling interest in the Lancaster Glass Company (later called Plant 2) and the Standard Glass Manufacturing Company, with plants in Bremen and Canal Winchester, Ohio.

The development of a revolutionary machine that pressed glass automatically would save the company when the Great Depression hit. The new machine raised production rates from one item per minute to over thirty items per minute. When the 1929 stock market crash hit, the company responded by developing a fifteen-mold machine that could produce ninety pieces of blown glass per minute. This allowed the company to sell tumblers "two for a nickel" and survive the depression when so many other companies vanished.

Hocking Glass Company entered the glass container business in 1931 with the purchase of fifty percent of the General Glass Company, which in turn acquired Turner Glass Company of Winchester, Indiana. In 1934, Anchor Hocking and its subsidiary developed the first one-way beer bottle.

Anchor Hocking Glass Corporation came into existence on December 31, 1937, when the Anchor Cap and Closure Corporation and its subsidiaries merged with the Hocking Glass Company. The Anchor Cap and Closure Corporation had closure plants in Long Island City, New York, and Toronto, Canada, and glass container plants in Salem, New Jersey, and Connellsville, Pennsylvania.

Anchor Hocking Glass Corporation continued to expand into other areas of production, such as tableware, closure and sealing machinery, and toiletries and cosmetic containers, through the expansion of existing facilities and the purchase of Balti-more, Maryland, based Carr-Lowry Glass Company and the West Coast's Maywood Glass. In the 1950s, the corporation established the Research and Development Center in Lancaster, Ohio, purchased the Tropical Glass and Container Company in Jacksonville, Florida, and built a new facility in San Leandro, California, in 1959.

In 1962, the company built a new glass container plant in Houston, Texas, while also adding a second unit to the Research and Development Center, known as the General Development Laboratory. In 1963, Zanesville Mold Company in Ohio became an Anchor Hocking Corporation subsidiary. The company designed and manufactured mold equipment for Anchor Hocking.

The word "Glass" was dropped from the company's name in 1969 because the company had evolved into an international firm with an infinite product list. They had entered the plastic market in 1968 with the acquisition of Plastics Incorporated in St. Paul, Minnesota. They continued to expand their presence in the plastic container market with the construction of a plant in Springdale, Ohio. This plant was designed to produce blown mold plastic containers. Anchor Hocking Corporation entered the lighting field in September 1970 with the purchase of Phoenix Glass Company in Monaca, Pennsylvania. They also bought the Taylor, Smith & Taylor Company, located in Chester, West Virginia, to make earthenware, fine stoneware, institutional china dinnerware, and commemorative collector plates.

Over the years, several changes occurred in the company. Phoenix Glass Company was destroyed by fire on 15 July 1978, Shenango China (New Castle, Pennsylvania) was purchased in 28 March 1979, Taylor, Smith & Taylor was sold on 30 September 1981, and on 1 April 1983, the company's decided to divest its interest in the Glass Container Division to an affiliate of the Wesray Corporation. The Glass Container Division was to be known as the Anchor Glass Container Corporation, with seven manufacturing plants and its office in Lancaster, Ohio.

The Newell Corporation acquired the Anchor Hocking Corporation on 2 July 1987. With this renewed influx of capital, several facilities were upgraded and some less profitable facilities were either closed or sold. The Clarksburg, West Virginia, facility was closed in November 1987, Shenango China was sold on 22 January 1988, and Carr-Lowry Glass was sold on 12 October 1989. Today, Anchor Hocking enjoys the financial backing and resources as one of the eighteen decentralized Newell companies that manufacture and market products in four basic markets: house wares, hardware, home furnishings, and office products. You may recognize such familiar Newell companies such as Intercraft, Levolor Home Fashions, Anchor Hocking Glass, Goody Products, Anchor Hocking Specialty Glass, Sanford, Stuart Hall, Newell Home Furnishings, Amerock, BerzOmatic, or Lee/Rowan.

Early in 2001, Newell Corporation entered into negotiations with Libbey Glass for the purchase and transfer of the Anchor Hocking Glass Corporation. After months of negotiations, Libbey Glass withdrew their offer in the midst of serious objections by the federal government.

Identification Marks

Over the years, Anchor Hocking has used several identification marks on their glassware. In 1980, the company issued a limited edition 75th anniversary ashtray, pictured below, which portrays the corporate identification marks. During the photographing, the marks on the ashtray were blackened with a magic marker so they would show up in the image. Originally, when the Hocking Glass Company was established in 1905, the company used the mark seen on the left side of the ashtray. This mark was used from 1905 until 1937, when it was replaced by the more familiar anchor over H mark (center of ashtray) to illustrate the merger of the Hocking Glass Company and the Anchor Cap Company. Finally, in October 1977, the company adopted a new symbol (right side of the ashtray), an anchor with a modern, contemporary appearance to further the new corporate identity.

The 75th anniversary ashtray in the original box, $50-55.

The mark of the Hazel Atlas Glass Company is often misidentified as being a mark for Anchor Hocking Glass Company. If this were a mark for Anchor Hocking, the letters would be reversed with the capital "A" over the lower case "h".

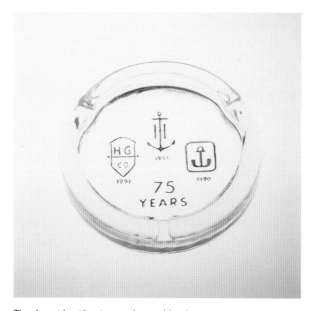

The three identification marks used by the company.

Catalog Identification

Anchor Hocking used a series of numbers and letters to denote glassware identification in the catalogs. Starting with a basic design number, the company placed a letter (prefix) in front of the number to denote the color and cut or glass type selection. The following is a listing of the letter designations generally used throughout the catalogs:

No prefix – Crystal
E – Forest Green
F – Laser Blue
H – Crystal Fire King
J – Cut Glass
L – Luster Shell
N – Honey Gold
R – Royal Ruby
T – Avocado
Y – Spicy Brown
W – White

For pitchers and glasses, each item of a particular pattern was given its own designation to indicate the capacity. Below are the common capacity designations:

63 – 6 oz. fruit juice
65 – 11 oz. tumbler
69 – 15 oz. iced tea
92 – 19 oz. large iced tea
93 – 22 oz. giant iced tea
3375 – 32 oz. giant sized ice tea
86 – 86 oz. capacity of pitcher

The patterns were also given specific designations. Below is a listing of some common Forest Green pattern designations:

325 – Colonial Lady
351 – Leaf Design
352 – Polka Dots
5612 – Spinning Wheel and Churn
5613 – Wild Geese
5614 – Floral and Diamond
5615 – Gazelle
5705 – Gold and White Vintage
5807 – White Lace

Putting this all together, the #E92/5612 would indicate a Forest Green tumbler (E), 19 oz. large iced tea (92), in the Spinning Wheel and Churn pattern (5612).

What is Glass?

Most people were taught that there are three states of matter in the universe: solids, liquids, and gasses. So, how would you classify glass? People, who have hit a car window during an automobile accident or leaned on a glass counter in a department store, would say that glass is a solid. Well, that is not the case. A solid, by definition, is any material that retains its shape without being contained. Glass is constantly flowing and does not retain it shape. Now, the process is extremely slow. Glass is termed a super-cooled liquid because it is solid and molecular motion only ceases when glass is at -459.69 degrees Fahrenheit (absolute zero). At this temperature, which has never been achieved, glass would become a solid. If a substance was a solid, it should have a melting point. There are no melting points listed for glass since it is always a liquid except at absolute zero. When companies process glass, they are not melting the glass; they are only making it more fluid. The hotter the glass gets, the more fluid it becomes.

Have you ever noticed that old glass windows tend to rattle as they get older? They also are wavy in appearance. How does this happen and why are the lines in a window always horizontal? First, since glass is a super-cooled liquid that is always in motion, it is being constantly pulled downward by gravity. The process is very, very slow. Over a number of years, the glass begins to form irregular wavy lines on the surface. The top of a pane of glass is becoming thinner and the bottom becoming thicker. Eventually, the glass at the top of the windowpane becomes so thin that it is loose in the frame. Any loud noise, gust of wind or strong movement within the building will cause the top of the windowpane to move and rattle.

Now consider what happens when someone hits a baseball through that old window. After the ball has shattered the windowpane, the top pieces fall out easily. But the bottom pieces remain firmly affixed in the window frame. Over the years, as gravity pulled the glass downward, the thickness of the windowpane was increasing at the bottom edge. This wedged the glass between the putty and window frame. Even with the ball rocketing through the window, the lower portion of the window remained firmly in place while the top pieces fell out of the frame. Even in the horror movies you see people injured by the glass falling out of the top of the frame while the bottom pieces remain firmly in place. They are not using old windows, they just happen to be recreating what would really happen when an old window is broken.

Fire King Glass Versus
Regular Glass

Confusion exists over the differences between Fire King and regular soda lime glass. Fire King is not a brand name for glass; it is a type of glass. Fire King is borosilicate glass made by melting a combination of sand with sodium borate. This glass melts at a temperature about 200 degrees Fahrenheit higher than regular soda lime glass. Borosilicate glass is noted for its very low expansion coefficient. It can be used in ovens for cooking, but not on the stove. During the making of Fire King glass, the furnace emits boron compounds that are environmentally "unfriendly" and corrosive to the brick lining in the glass furnaces. For these reasons, Fire King glass is reasonably expensive to produce.

What we know as "regular" glass is a melted mixture of sand, soda ash (anhydrous sodium carbonate), and limestone (calcium carbonate). It has an expansion rate three times that of borosilicate glass. When heated unevenly (i.e., on a stove), the heated portions near the hot stove elements will expand at three times the rate of the unheated portions. This will cause internal stress points to form in the glass. If the stress becomes sufficient, cracking will occur.

Anchor Hocking Glass
Museum

Since I started collecting Anchor Hocking glass, I have always heard and read about the infamous "morgue." The "morgue" is located at Anchor Hocking's Lancaster, Ohio, plant. The "morgue" contains examples of glass production spanning many years. I have toured the area on more than one occasion and found it to be very interesting.

Access to the "morgue" is severely limited because the area is located in the middle of the production facility. Most of the glassware items in the "morgue" are later production pieces and generally only cover production at the Lancaster, Ohio, plant. The glass is displayed on large roller shelves. The glass is crowded, unlabelled, not well organized, and very difficult to observe because the roller shelves can only be separated by about three to four feet. I did not see examples of Anchor Hocking's bottle production, but there are limited examples of glass produced in other divisions of the company. Overall, it was an interesting piece of Anchor Hocking history to see and an exciting experience.

I think it is important for everyone to actually see the glass that Anchor Hocking produced, so I built a facility to display my collection of over 8,000 pieces of Anchor Hocking glass. All the glass pictured in my books will be on display in the museum. There will also be some extremely rare pieces of Anchor Hocking glass on display that will be featured in upcoming books. The museum will not have regular hours of operation. The collection can be viewed by calling the museum's phone number, which will be published on the museum website once the museum is officially open. I designed and built the facility over the last twenty-four months and have included a long porch that will have rocking chairs for visitors to sit in and relax. We are already planning a second facility to display an extensive collection of boxed sets, more glass, and company catalogs. Eventually, we will also add a photo studio to the facility.

Chapter One.
Simple Methods to Identify Anchor Hocking Pitchers

There are some very simple ways to distinguish Anchor Hocking pitchers from those of other glass companies. Most of the pitchers in this book were identified from the extensive library of company catalogs that I have. When the particular pitcher cannot be located in the catalogs, I use another method. While the companies did tend to copy decoration applied to the glass, there are some very pronounced differences in the shape or design of the pitcher itself.

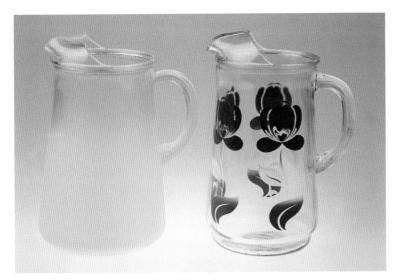

Left to right: Bartlett-Collins Satin finish 80 oz. ice lip jug pitcher; Anchor Hocking Finlandia design pitcher. While both of the pitchers are similar in height, there are two distinct differences. First, the Bartlett-Collins pitcher is flat on the bottom while the Anchor Hocking Finlandia design pitcher has a 3/8" pedestal. Second, the Bartlett-Collins pitcher's sides spread out more near the base, while the Anchor Hocking Finlandia pitcher's sides are more vertical.

Left to right: Anchor Hocking 86 oz. upright pitcher; Bartlett-Collins 80 oz. ice lip jug, Decoration #103, made in 1955. You will notice that the sides of the Anchor Hocking pitcher are more curved than the Bartlett-Collins pitcher. Also, the shoulder of the Anchor Hocking pitcher has a distinct series of flat spots while the Bartlett-Collins pitcher shoulder is smooth.

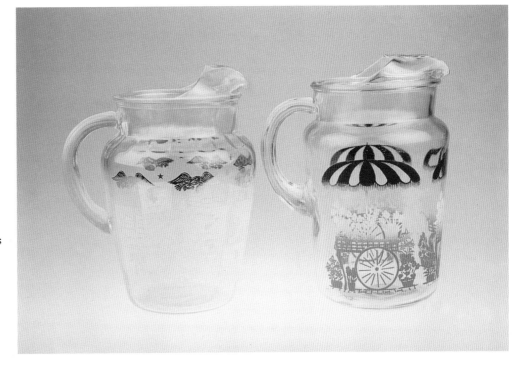

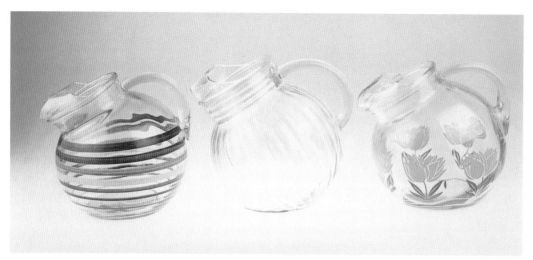

Left to right: Bartlett-Collins #100 ball jug, Decoration #18, made in 1942; Anchor Hocking tilt ball pitcher; Bartlett-Collins #100 ball jug, Decoration #377, made from 1938 to 1940. There are three distinct differences between the pitchers from the two companies. First, the Anchor Hocking tilt ball pitcher has circular rings around the neck. These rings are not found on Bartlett-Collins ball jugs. Second, the handle of Anchor Hocking pitchers curves farther away from the pitcher. Finally, the neck of the Anchor Hocking pitcher is about fifty percent taller than Bartlett-Collins pitchers.

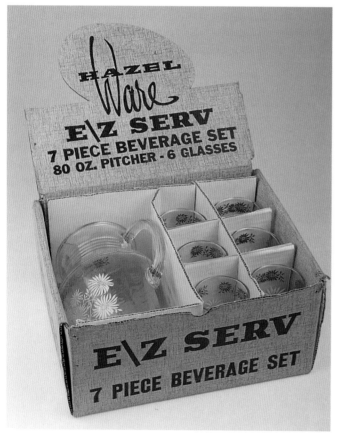

Hazel Atlas beverage sets were even packed in boxes similar to Anchor Hocking's boxes.

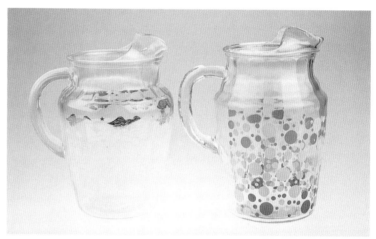

Left to right: Anchor Hocking 86 oz. upright pitcher; Hazel Atlas 80 oz. jug, number 52X-1816 decoration #1033, made from 1938 to 1939. You will notice that the Hazel Atlas pitcher is about 3/4" taller than the Anchor Hocking pitcher, it is thinner in diameter, and the shoulder has a totally different shape.

Many collectors confuse Anchor Hocking and Hazel Atlas pitchers, especially these two. The most noticeable difference is the multiple lines that circle around the neck, shoulder area, and base of the Hazel Atlas pitcher. Anchor Hocking pitchers were not made with this multiple line design.

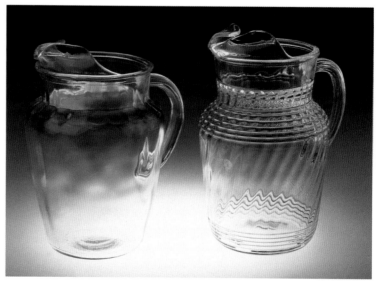

Close-up of the multiple lines that circle the neck and shoulder area of many Hazel Atlas pitchers.

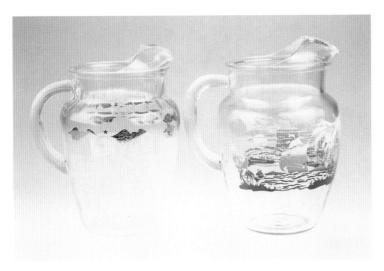

Left to right: Anchor Hocking 86 oz. upright pitcher; Federal #175 85 oz., decoration #8580 South Seas, pitcher made in 1953. There are two basic differences to look for here. First, the handle of the Federal pitcher is horizontal at the top, while the Anchor Hocking pitcher's handle is completely curved from top to bottom. Second, the sides of the Federal pitcher are more curved, so the base is smaller in diameter than the Anchor Hocking pitcher.

Left to right: Anchor Hocking 86 oz. upright pitcher; Federal #177 85 oz., decoration #7890 Windows, pitcher made in 1963. There are four distinct differences to observe. First, the handle of the Federal pitcher is horizontal at the top. Second, there is a distinct line around the shoulder of the Federal pitcher. Third, the base of the Federal pitcher has a 1/2" pedestal. Finally, the sides of the Federal pitcher are basically straight while the Anchor Hocking pitcher's sides are gently curved.

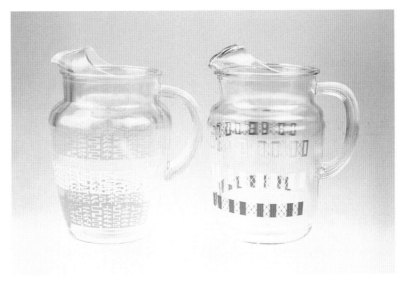

Left to right: Libbey 32 oz. juice pitcher; Anchor Hocking 36 oz. juice pitcher. Notice that the horizontal area of the handle is on the bottom of the Libbey pitcher but on the top of the Anchor Hocking pitcher. The Libbey pitcher also has a smaller diameter.

The Federal Windows design beverage set in the original box.

Left to right: Anchor Hocking 86 oz. upright pitcher; Libbey 86 oz. upright pitcher. Notice the pitchers are virtually identical with the exception of the applied yellow decoration.

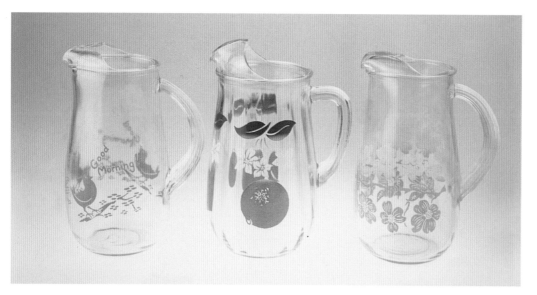

Left to right: Federal 32 oz. juice pitcher; Anchor Hocking 36 oz. juice pitcher; Federal 32 oz. juice pitcher. While both the Federal and Anchor Hocking juice pitchers have the same general shape and height, there are two distinct differences. First, the upper portion of the Anchor Hocking pitcher's handle is horizontal while the Federal pitcher's handle is completely curved from top to bottom. Second, the Federal pitcher has a smaller diameter than the Anchor Hocking pitcher.

Close-up of label on the Line Lites box.

Since most Anchor Hocking and Libbey pitchers are almost impossible to tell apart, boxed sets become increasingly important in identification. The yellow frosted pitcher looks identical to the Anchor Hocking 86 oz. upright pitcher. Unless you found the frosted pitcher in the original box you might not know who made it. Since Libbey and Anchor Hocking pitchers and glasses are so similar, be sure to look at the glasses for clues. Most Libbey glasses have an upper case, cursive "L" in the glass. Most of the Libbey gold designed glasses are all marked with this symbol. The same holds true with most Hazel Atlas sets. While the pitchers are not generally marked, the glasses usually have the upper case "H" over the lower case "a" mark.

Another set of glasses sold by Anchor Glass Container.

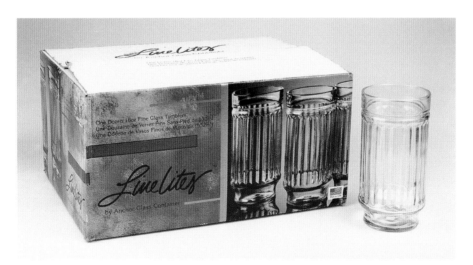

Boxed set of Line Lites. These sets are being sold on the internet as Anchor Hocking products when, in fact, they are not. Anchor Glass Container made these glasses. This is not an Anchor Hocking company. Anchor Glass Container also uses a mark that looks like two "Js" placed back to back. This symbol is mistaken for the Anchor Hocking "anchor over H" symbol, used from 1937 to 1977.

Chapter Two.
Mix and Match

Through the years, I have been amazed at the combinations of pitchers and glasses that I have discovered. With the advent of companies such as Gay Fad Studios of Lancaster, Ohio, pitchers and glasses from different companies were "married" together to produce some unusual combinations. The Gay Fad Studios hand painted glassware from several companies and either they, or some other company, sold glass from different companies as sets. Below are some unusual examples.

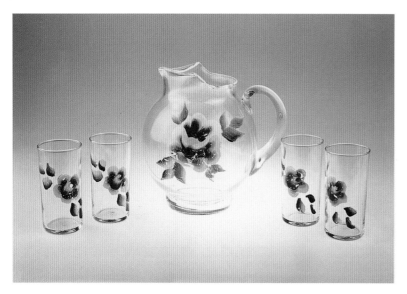

Macbeth-Evans Corning 80 oz. handmade ice lip chiller with marked 11 oz., 4 3/4" Anchor Hocking straight shell glasses, $75-85 for the entire set.

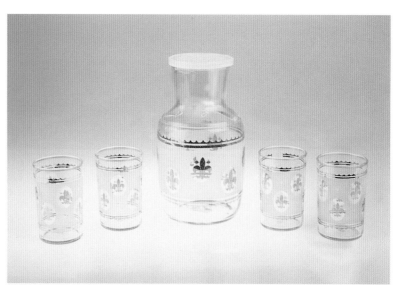

Marked Anchor Hocking 40 oz. chiller with marked Federal Glass Company 3 1/2" glasses, $40-50 for the entire set.

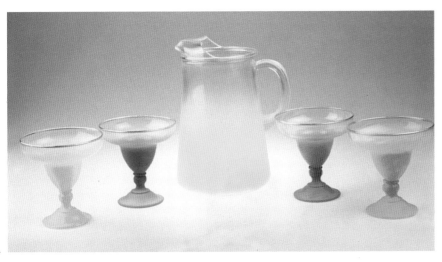

Bartlett-Collins yellow frosted 80 oz. ice lip jug with Anchor Hocking 9 oz., 4 7/8" coupette glasses, $30-40 for the entire set.

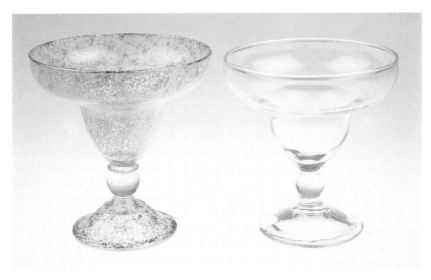

Two very similar designs for the 9 oz. coupette glasses. Left to right: Anchor Hocking coupette, $2-5; Bartlett-Collins coupette, $2-5.

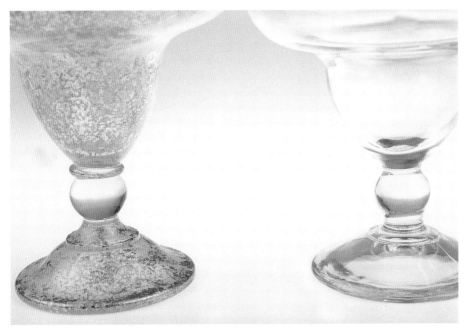

Notice the small "wafer" of glass just under the bowl of the coupette on the left. This is common on Anchor Hocking stemmed glasses. The Bartlett-Collins coupette on the right does not have the wafer.

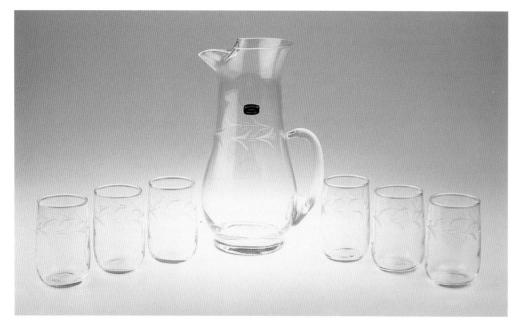

Mountaineer Glass etched pitcher with Anchor Hocking 5 oz., 3 3/8" Roly Poly juice glasses, $40-50 for the entire set.

Bartlett-Collins ice lip pitcher with marked Anchor Hocking 5 oz., 3 3/8" Roly Poly juice glasses, $50-60 for the entire set. The glasses are marked with the "anchor over H" emblem.

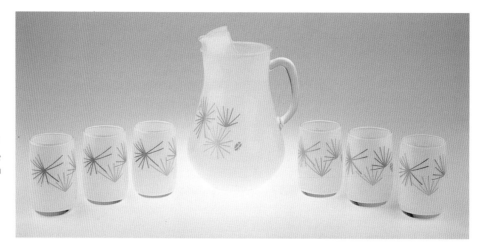

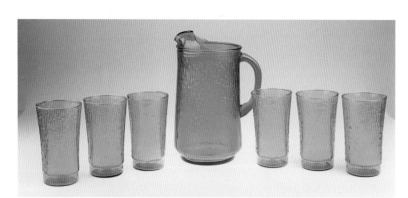

This was not the only "mix and match" process going on during these years. Even Anchor Hocking mixed patterns to produce some unusual sets. Shown here is a Finlandia style pitcher that is covered with the Pagoda surface design. The set was not sold with Finlandia style glasses, but with Pagoda water glasses.

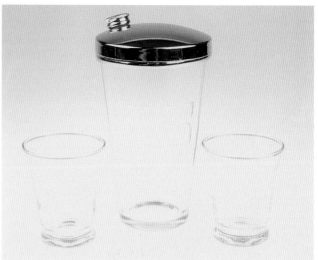

Marked Federal 6 1/2" (to the top of the spout) cocktail shaker with Anchor Hocking 3 1/2 oz., 3" cocktail glasses.

Chapter Three.
Not All Hand Painted Glass
Was Made by the Gay Fad Studio

Over the years, collectors have come to treasure hand painted glassware. Probably the most notable company to hand paint glass was the Gay Fad Studio™ of Lancaster, Ohio. When most collectors see hand painted items, they naturally conclude the glass was painted at the Gay Fad Studio. Unfortunately, this is not always true. There were many art studios besides the Gay Fad Studio that hand painted glassware. I have found pieces of glass with labels from Hansetta-Artware Company™ of New York, New York, Washington Company™ of Washington, Pennsylvania, United Glass Industries™ (location unknown), and Imperial™ (location unknown). Information about these art studios and companies is very limited due to their small size, brief history, and limited production. Undoubtedly, there are others that will surface in time.

While most people associate the Gay Fad Studio with hand painted glassware, the studio was also responsible for producing many machine-decorated items. Many of the decorations are so intricate that they could only have been done by machine.

This photo was supposed to have been taken in the Gay Fad Studio. Notice all the different decorations and types of glass sold by the studio.

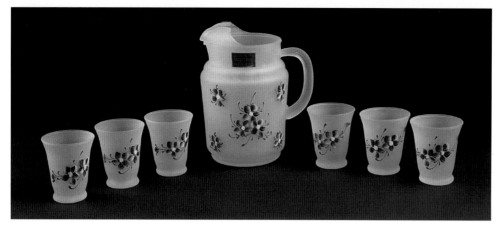

Hansetta-Artware Company hand painted pitcher and glasses. The set consisted of a Federal 85 oz. pitcher and six Anchor Hocking 3 1/2 oz., 3" cocktail glasses, $75-100 for the set with label.

Close-up of the Hansetta-Artware Company label.

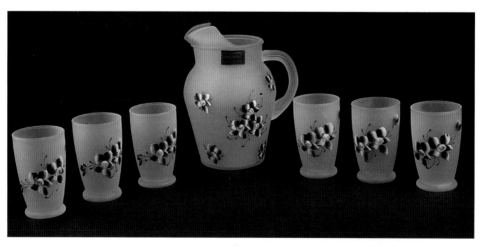

Hansetta-Artware Company hand painted pitcher and glasses. The set consisted of an Anchor Hocking 40 oz. juice pitcher and six Baltic 5 oz., 3 3/4" juice glasses, $75-100 for the set with the label.

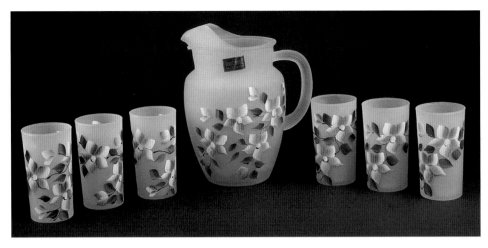

Hansetta-Artware Company hand painted pitcher and glasses. The set consisted of a Federal 85 oz. ice lip pitcher with six Anchor Hocking 11 oz., 4 3/4" straight shell glasses, $75-100 for the set with the label.

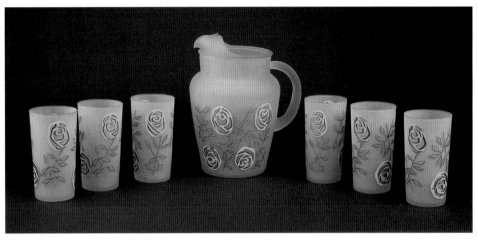

Gay Fad Studio machine decorated pitcher and glasses. The set consisted of an Anchor Hocking 86 oz. upright pitcher with the 15 oz., 5 1/4" straight shell glasses, $75-85 for the set with the Gay Fad marking.

Close-up of the Gay Fad signature on the pitcher.

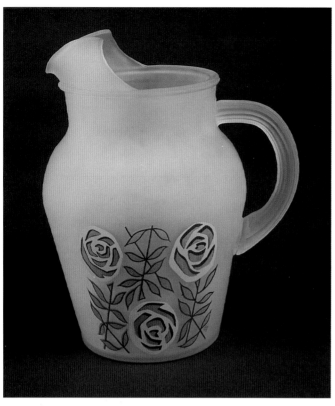

The Gay Fad marking on the juice pitcher was only the "GF" initials.

A 40 oz. juice pitcher with the same design as the 86 oz. upright pitcher, $25-35 for the pitcher alone.

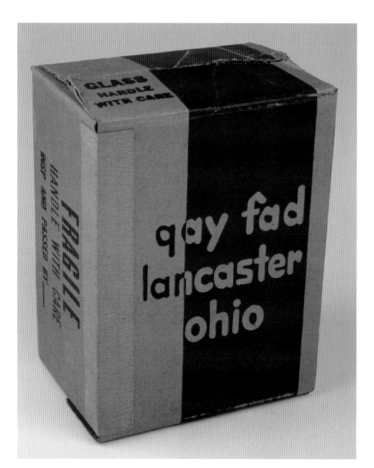

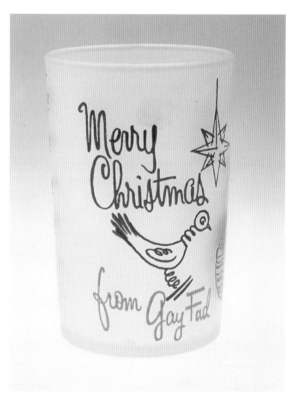

A Christmas glass from Gay Fad Studio. The design was applied by machine to a Hazel Atlas 3" glass, $5-7.

Box containing a Gay Fad 7-Piece Juice Set, $80-100 for the complete set, $25-30 for the box only.

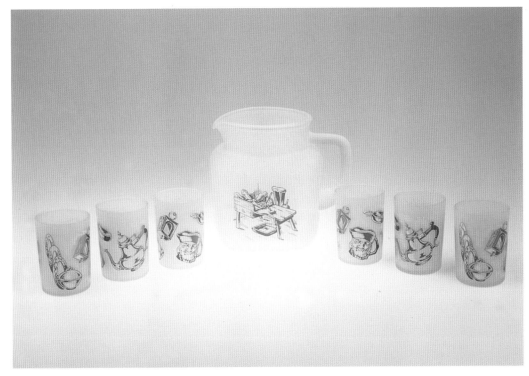

The 7-Piece Juice Set removed from the box. The set consisted of a Federal 36 oz. juice jug #2604 with six 3" glasses with machine applied designs, $60-70 for the set without the box.

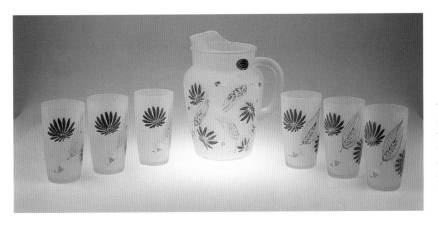

The 7-Piece Beverage Set was hand painted by United Glass Industries, yet it was sold in a box marked with Gay Fad Studios. The set consisted of one 86 oz. pitcher and six 10 oz., 5" tapered glasses, $80-100 for the set without the box.

Another 7-Piece Beverage Set sold by Gay Fad Studio, $100-125 for the complete set, $25-30 for the box only.

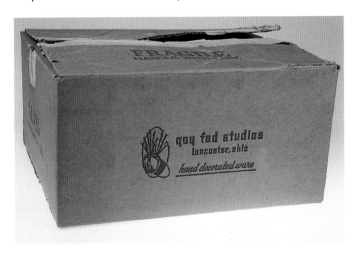

Close-up of the United Glass Industries label. I have been unable to find out where the company was located or how long it was in business. If you have any information about the company, its history or products, please let me know.

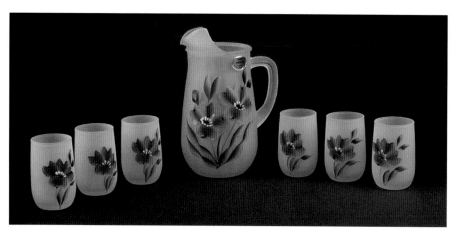

United Glass Industries hand painted pitcher and glasses. The set consisted of the Anchor Hocking 36 oz. juice pitcher with six Anchor Hocking 5 oz., 3 3/8" Roly Poly fruit juice glasses, $80-100 for the set with the label.

Close-up of the United Glass Industries label.

United Glass Industries hand painted pitcher and glasses with the quail design. The set consisted of an Anchor Hocking 36 oz. juice pitcher with six Anchor Hocking 6 oz., 3 3/4" juice glasses, $80-100 for the set with the label.

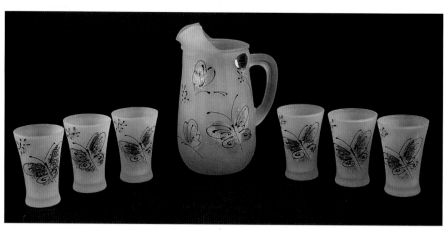

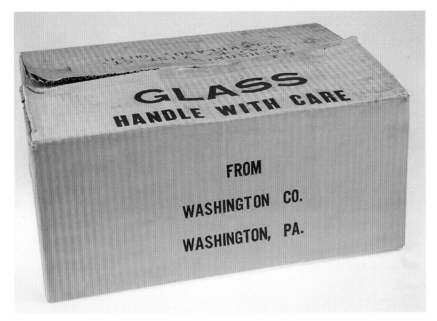

Boxed Beverage Set made by Washington Company of Washington, Pennsylvania, $100-125 for the complete set with the box, $30-35 for the box only. The Washington Company did hand paint and color treat glassware from many different companies, but mainly Hazel Atlas. Some of the more common pieces were pitcher sets, salad sets, and serving pieces. The company employed about a dozen women as artists. Like the Gay Fad Studios, they did not produce any glassware. The company was located near the Hazel Atlas plant number 1. The Washington Company was in business from the late 1940s until the late 1960s and they were probably a subsidiary of Hazel Atlas(?).

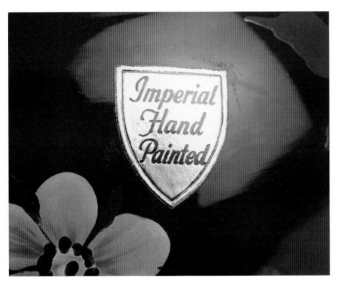

This hand painted Royal Ruby ivy ball brings up an interesting point. There may be yet another company that hand painted pitchers and glasses, as well as Royal Ruby items. This is the only piece of glass I have found with this label. If you have any information about the company, please contact me.

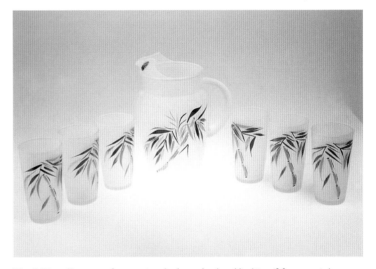

The 7-Piece Beverage Set consisted of one Anchor Hocking 86 oz. upright pitcher and six 10 oz., 5" tapered glasses, $80-100 for the set with the label.

Close-up of the Washington Company label.

Chapter Four.
Cracking in Anchor
Hocking Pitchers

I have noticed that Anchor Hocking pitchers, especially the pitchers made prior to 1970, may have cracks at the base of the handles. When glass cools in an open environment (not in a controlled furnace or lehr), it has a tendency to cool unevenly. The thicker portions of the pitcher (i.e., the handle) retain the heat longer. This uneven cooling may cause stress points to form in the glass. The stress can only be relieved in two ways. First, you can reheat the pitcher and control and extend the cooling process to eliminate the stress points. If that was not done, glass will inherently relieve the stress points through the second method of stress relief . . . cracking. Most of the pitchers produced by Anchor Hocking were allowed to air cool, thereby promoting uneven cooling and handle cracking. The cracks did not affect the use of the pitcher since many of the pitchers were used for over fifty years without the handle falling off or the pitcher leaking.

Cracked handle on a Swirl design tilt ball pitcher produced in the 1950s.

Cracked handle on a Tree of Life design pitcher produced in 1933.

Cracked handle on a Lido (Milano) design Laser Blue pitcher produced in the 1970s. With the darker colored pitchers, the cracks may be very difficult to see.

Chapter Five.
Chateau Design Pitchers

A multitude of decorations were applied to the Chateau design pitcher over the years. When the decoration was applied, the pitcher was no longer called Chateau. The pitcher was given the name of the applied pattern. The glass pictured in this chapter is only the undecorated items. Also, notice that the Newport™ design glasses were placed in the refreshment sets. Only the earlier decorated pitchers used the Chateau design glasses.

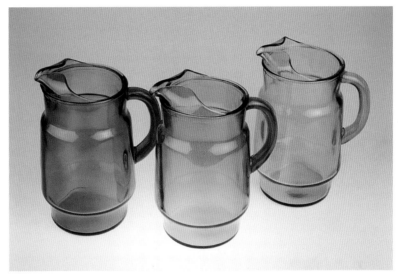

Left to right: Spicy Brown 74 oz. pitcher #Y3364; Avocado Green 74 oz. pitcher #T3364; Honey Gold 74 oz. pitcher #N3364; $15-20 each pitcher.

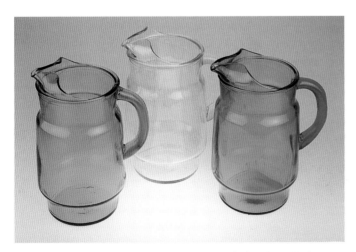

Left to right: Spearmint Green 74 oz. pitcher #G3364; Crystal 74 oz. pitcher #3364; Laser Blue 74 oz. pitcher #F3364, $15-20 each pitcher.

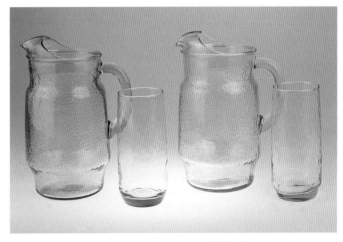

Left to right: Sapphire Blue 74 oz. pitcher, $10-20; 23 oz. Newport cooler, 6 7/8", $1-2; Crystal 74 oz. pitcher #3364, $10-20; 23 oz. Newport cooler, 6 7/8", $1-2.

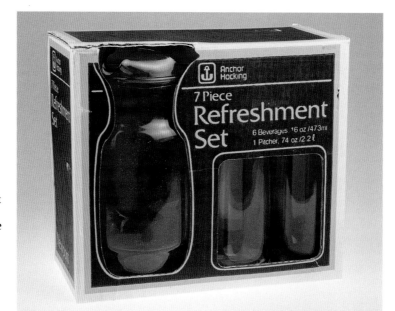

The 7-Piece Refreshment Set in Honey Gold, $30-35 for the entire set, $5-10 for the box only.

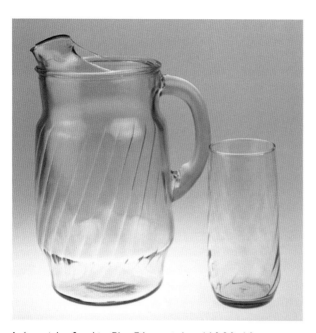

Left to right: Sapphire Blue 74 oz. pitcher, $10-20; 16 oz. Newport iced tea, 6", $1-2. Notice that there are a series of single lines on the inside of the pitcher and the glass.

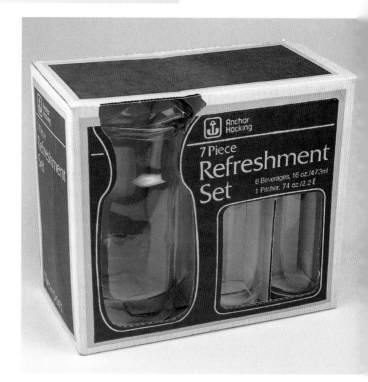

The 7-Piece Refreshment Set in Crystal, $30-35 for the entire set, $5-10 for the box only.

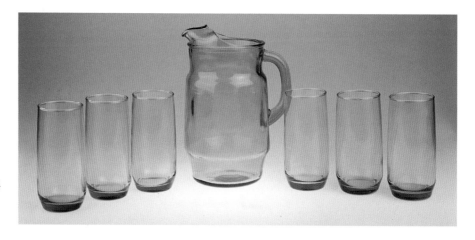

The 7-Piece Refreshment Sets included one 74 oz. pitcher and six 16 oz., 6" Newport iced teas.

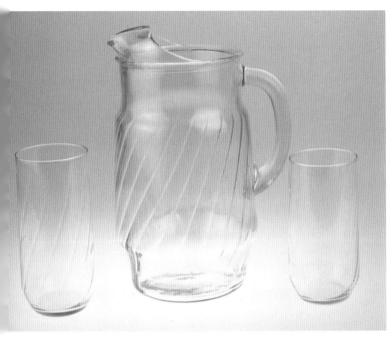

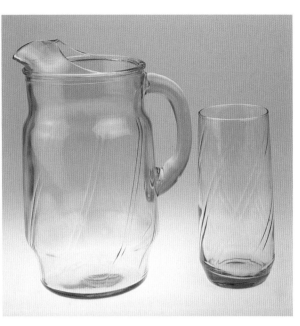

Left to right: Sapphire Blue 74 oz. pitcher, $10-20; 23 oz. Newport cooler, 6 7/8", $1-2. Notice that there are a series of double lines on the inside of the pitcher and the glass.

Left to right: 23 oz. Newport cooler, 6 7/8", $1-2; Crystal #3364, 74 oz. pitcher, $10-20; 16 oz. Newport iced tea, 6", $1-2. Notice that there are a series of single lines on the inside of the pitcher and the glasses.

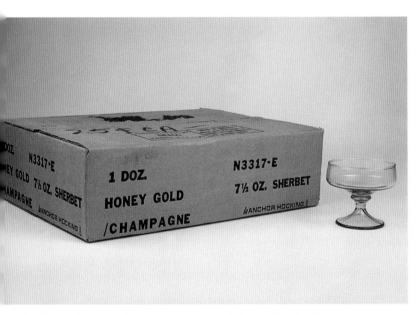

The Chateau Pattern had three sizes of stemmed glasses. Here is a boxed set of the 7 1/2 oz. sherbet/champagnes, $40-50 for the dozen glasses in the box, $10-15 for the box only.

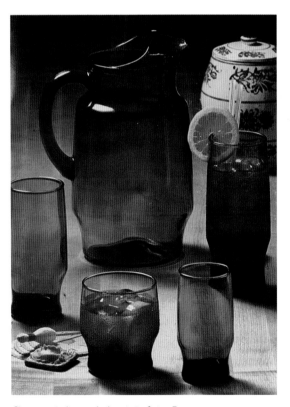

Chateau pitcher and glasses in Spicy Brown.

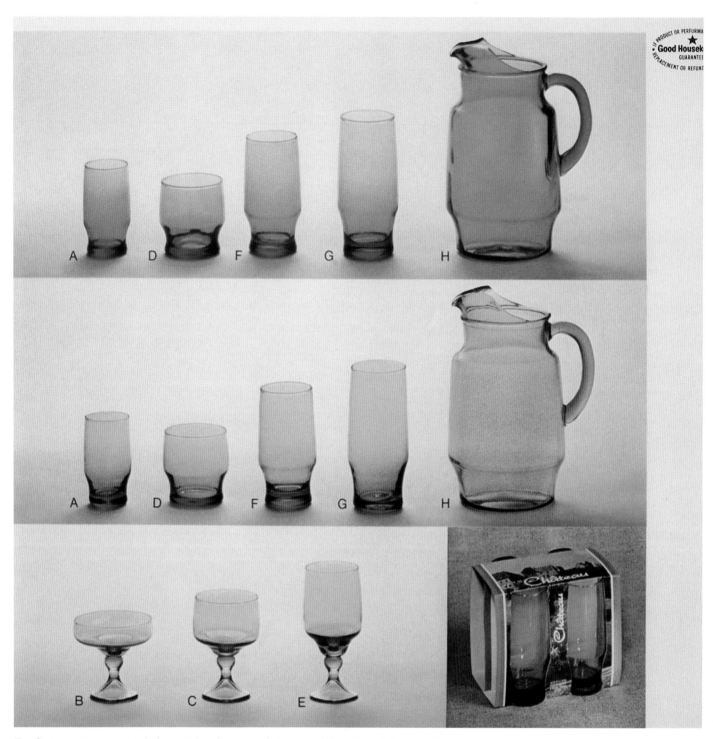

The Chateau pattern consisted of one pitcher, four sizes of glasses, and three sizes of stemmed glasses.
The stemmed glasses are rather difficult to find.

Chapter Six.
Chateau Decorated Pitchers

You will notice that the decorated Chateau pitchers were sold with Esprit™, Newport, Roly Poly™, Chateau, and several other designs of glasses. In fact, the Chateau design glasses are relatively hard to find. Probably the most common color for the Chateau design glasses is the Royal Ruby™.

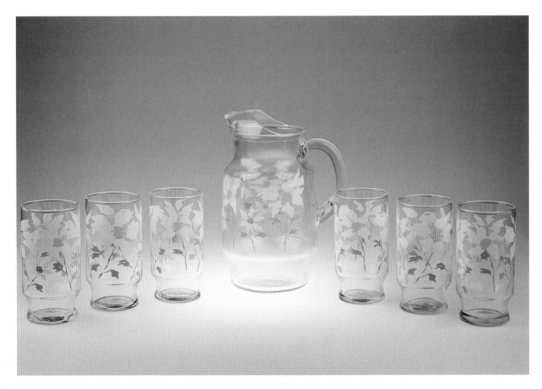

Windflower decoration 74 oz. pitcher #3364/7218 (1974), $15-20, with six 17 1/2 oz. iced tea #3618/7218, 5 3/4", $2-4 for each glass.

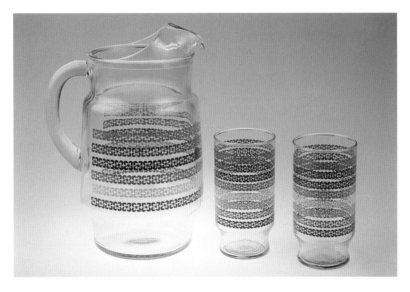

Floral Buttons decoration 74 oz. pitcher #3364/7303 (1974), $20-25, with two 13 oz. beverage glasses #3624/7303, 5 1/4", $2-4 for each glass

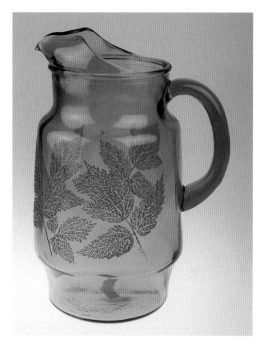

September Blue decoration 74 oz. pitcher #F3364/7407 (1974), $25-30.

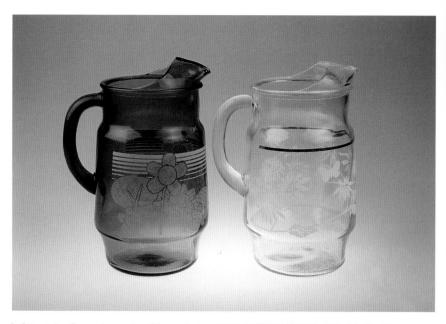

Left to right: Bravo decoration 74 oz. pitcher #Y3364/7920 (1979), $20-25; Tea House decoration 74 oz. pitcher #3364/7301 (1974), $20-25.

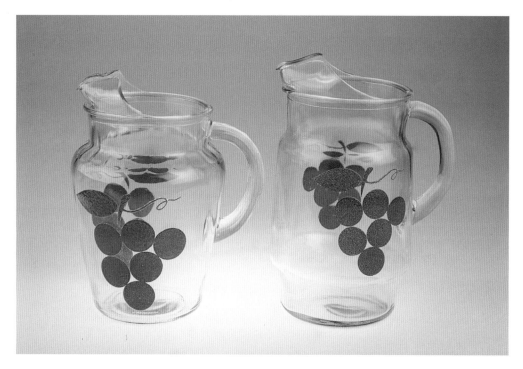

Left to right: Super Fruit decoration 86 oz. pitcher #Y3364/7920, $20-25; Super Fruit decoration 74 oz. pitcher #3364/7211 (1974), $20-25. This Super Fruit decoration was also applied to the 40 oz. juice pitcher produced in the early 1960s.

Stripes decoration on a crystal 74 oz. pitcher #3364/7660 (1978), $15-20, with two Newport design 12 oz. beverage glasses #3672E/7660 (1979), 5", $3-4 for each glass.

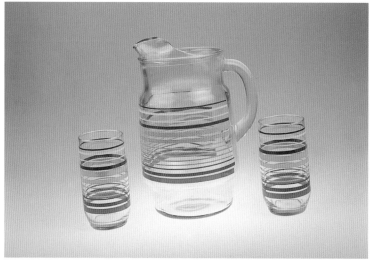

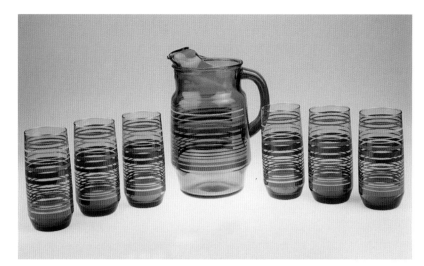

Stripes decoration on a Spicy Brown 74 oz. pitcher #Y3364/7661 (1978), $15-20, with six Newport design 16 oz. iced teas #Y3676E/7661 (1979), 5 7/8", $3-4 for each glass.

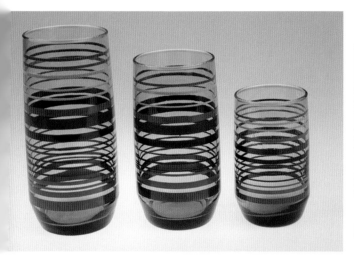

Stripes decoration glasses. Left to right: 16 oz. iced teas #Y3676E/7661, 5 7/8", $3-4; 12 oz. beverage #Y3672E/7661, 5", $2-4; 7 oz. juice #Y3377E/7661, 3 7/8", $2-3.

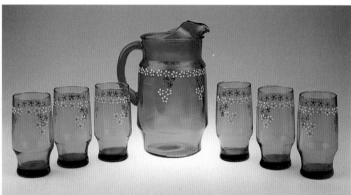

Rare hand painted Chateau 74 oz. pitcher in Laser Blue, $80-100, with six 12 oz. beverage glasses, 5 1/2", $12-15 for each glass. The pitcher and glasses are signed with the initials "FZ."

Lucy's Lemonade Stand 74 oz. pitcher #3364/7872 (1979), $35-50, with six 13 oz. beverage glasses #3624E/7872, 5 1/4", $8-10 for each glass.

Yellow Foxy Flowers decoration 74 oz. pitcher #3364/7809 (1979), $20-25, with six 13 oz. beverage glasses #3624E/7809, 5 1/8", $2-3 for each glass.

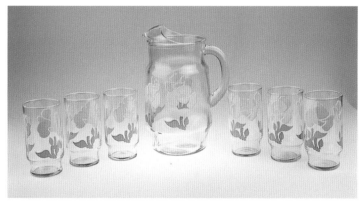

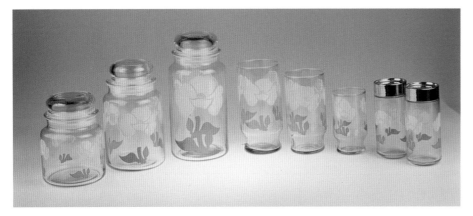

Many items were made with the Yellow Foxy Flowers decoration. Left to right: 16 oz. jar #3281/7623, 5 3/4", $2-4; 26 oz. jar #3282/7623, 6 1/4", $2-4; 36 oz. jar #3283/7623, 8", $2-4; 17 1/2 oz. iced tea #3618E/7809, 5 3/4", $2-4; 13 oz. beverage #3624E/7809, 5 1/8", $2-3; 7 oz. juice #3607E/7809, 4", $2-3; salt and pepper shakers, $8-10 for the pair of shakers.

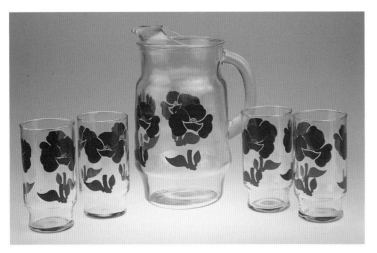

Red Foxy Flowers decoration 74 oz. pitcher #3364/7808 (1979), $20-25, with four 13 oz. beverage glasses #3624E/7808, 5 1/8", $2-3 for each glass.

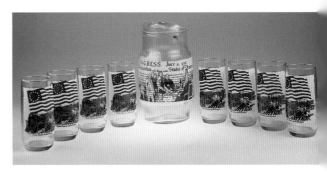

Bicentennial 74 oz. pitcher, $30-40, with eight 12 oz. beverage glasses, 5 7/8", $4-5 for each glass.

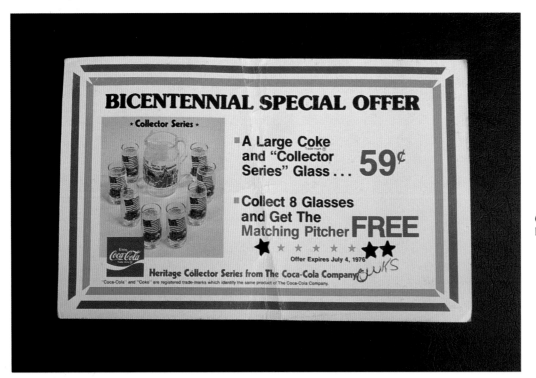

Original card for Coca Cola's Bicentennial Special Offer, $15-20.

36

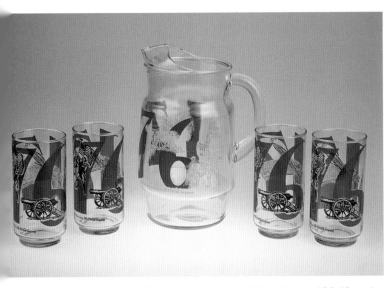

Another bicentennial design from Coca Cola with a 74 oz. pitcher, $30-40, and four 15 oz. beverage glasses, 5 5/8", $4-5 for each glass.

Left to right: Yellow Roses decoration 74 oz. pitcher #3364/415 (1982), $20-25; Red Roses decoration 74 oz. pitcher #3364/240 (1982), $20-25.

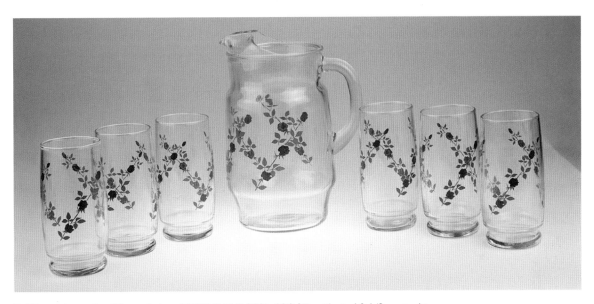

Red Roses decoration 74 oz. pitcher #3364/240 (1982), $20-25, with six 16 1/2 oz. iced teas #2156E/240, 5 7/8", $2-3 for each glass.

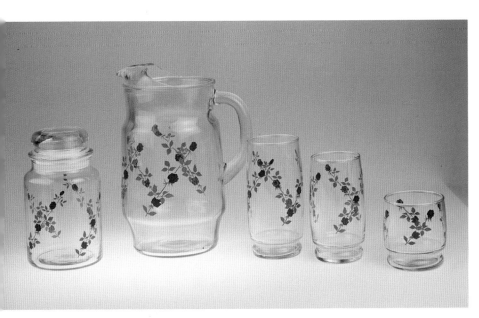

As with many of the patterns, Anchor Hocking made a number of sizes of glasses and numerous accessory pieces. Left to right: 26 oz. jar #3283/240, 6 1/4", $2-4; 74 oz. pitcher #3364/240, $20-25; 16 1/2 oz. iced tea #2156/240, 5 7/8", $2-3; 12 oz. beverage #2152E/240, 5 1/8", $2-3; 10 oz. double juice #2150E/240, 3 1/4", $2-3.

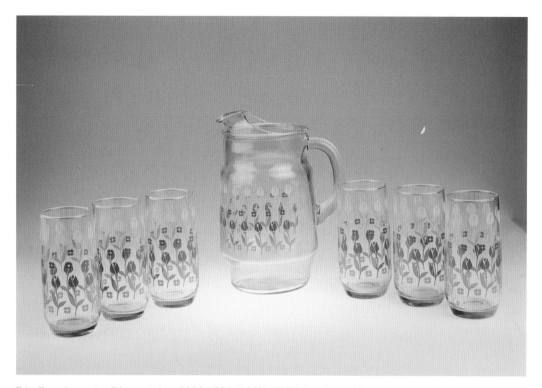

Tulip Time decoration 74 oz. pitcher #3364/321 (1982), $20-25, with six 16 oz. iced teas #3676E/321, 5 7/8", $2-3 for each glass.

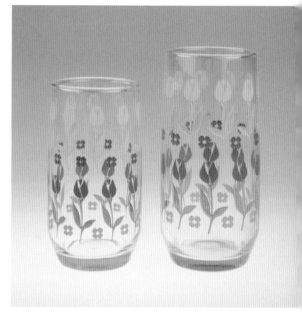

Left to right: 12 oz. beverage #3672E/321, 5", $2-3; 16 oz. iced teas #3676E/321, 5 7/8", $2-3.

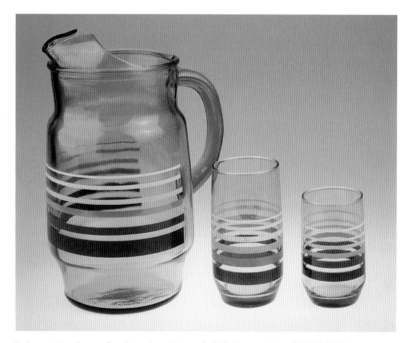

Left to right: Brown Bandstand on Honey Gold 74 oz. pitcher #N3364/305 (1982), $20-25; 12 oz. beverage #N3672/305, 5", $2-3; 7 oz. juice #N3677/305, 4", $2-3.

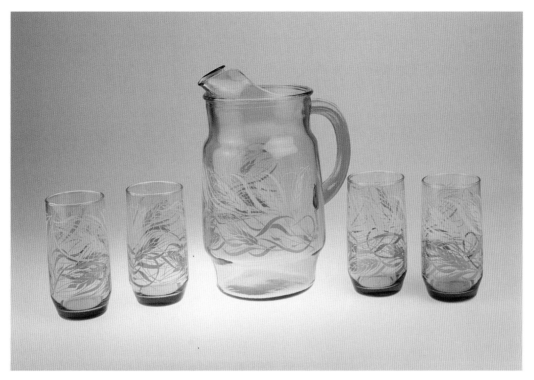

Autumn Harvest on Honey Gold decoration 74 oz. pitcher #N3364/226 (1982), $20-25, with four 12 oz. beverage glasses #N3672E/226, 5 1/8", $2-3 for each glass.

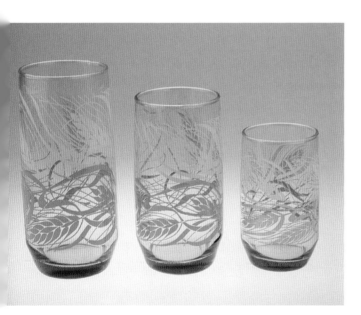

Autumn Harvest glasses. Left to right: 16 oz. iced tea #N3676E/226, 5 7/8", $2-3; 12 oz. beverage #N3672E/226, 5 1/8", $2-3; 7 oz. juice #N3677E/226, 4", $2-3.

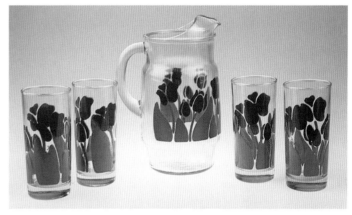

Tulips decoration 74 oz. pitcher #3364/693 (1985), $20-25, with four 15 oz. iced teas #N3175E/693, 6 1/4", $2-3 for each glass.

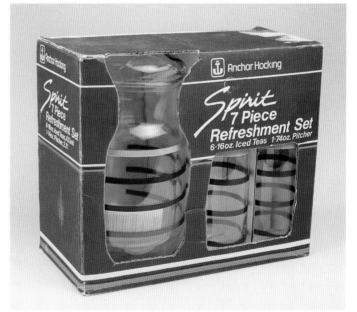

The #3600/852 Spirit Refreshment Set (1993), $35-40 for the complete set, $5-10 for the box only.

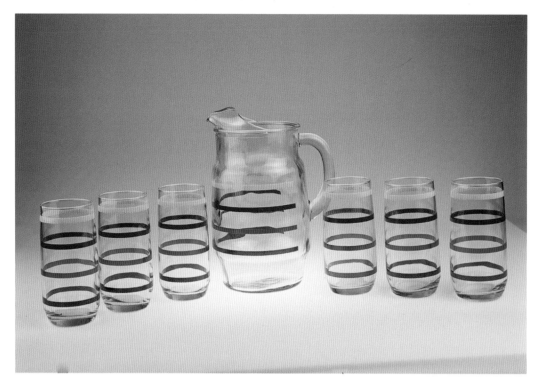

The Spirit Refreshment Set included one 74 oz. pitcher, $20-25, and six 16 oz. iced teas, 5 7/8",
$2-3 for each glass.

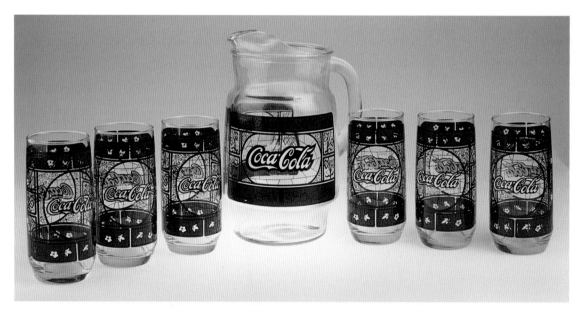

Coca Cola Refreshment Set with one 74 oz. pitcher, $20-25, and six 16 oz. iced teas, 5 7/8",
$3-4 for each glass.

Coca Cola Refreshment Set with one 74 oz.
pitcher, $20-25, and six 16 oz. iced teas, 5 7/8",
$3-4 for each glass.

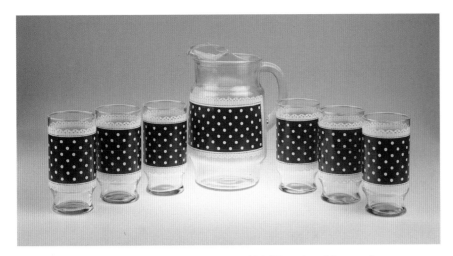

Red Picnic Refreshment Set with one 74 oz. pitcher, $20-25, and six 16 oz. iced teas, 5 7/8", $3-4 for each glass.

Brown Picnic decoration 26 oz. jar #3282/7554 (1976), 6 1/4", $2-4, and six 16 oz. iced teas, 5 7/8", $3-4 for each glass. This pattern also comes in blue.

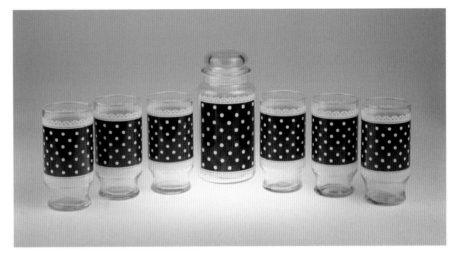

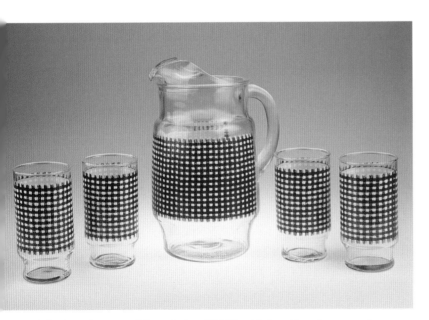

Red Gingham decoration 74 oz. pitcher, $20-25, with four 13 oz. beverage glasses, 5 1/4", $2-4 for each glass.

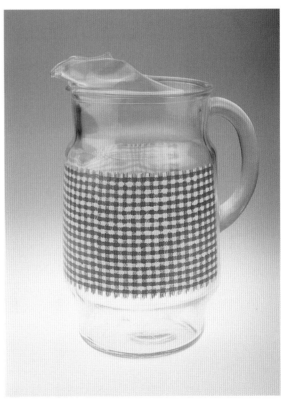

Blue Gingham decoration 74 oz. pitcher, $20-25.

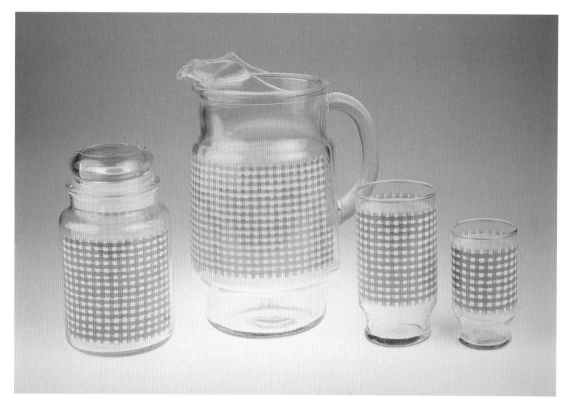

Left to right: Green Gingham 26 oz. jar, 6 1/4", $3-5; 74 oz. pitcher, $20-25; 13 oz. beverage glass, 5 1/4", $2-4; 7 oz. juice, 4", $2-4. There is also a Yellow Gingham pitcher (not shown).

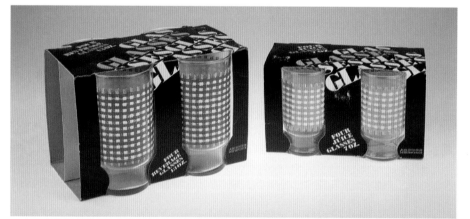

Left to right: 4-pack of Blue Gingham 13 oz. beverage glasses, $15-20; 4-pack of Green Gingham 7 oz. juice glasses, $15-20.

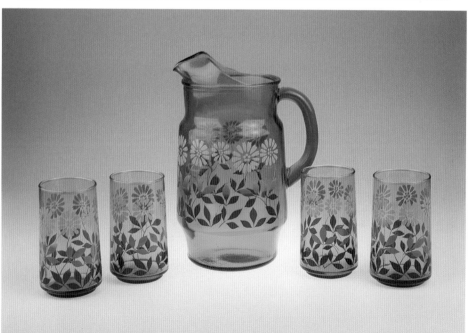

Pom Pom decoration 74 oz. pitcher, $30-35, with four 12 oz. tumblers, 4 3/4", $4-5 for each glass.

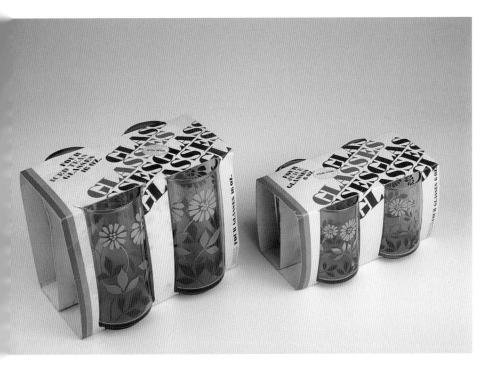

Left to right: 4-pack of Pom Pom 15 oz., 5 3/4" beverage glasses, $20-30; 4-pack of Pom Pom 6 oz. juice glasses, $20-25. This style of glass was also sold with the Pom Pom decoration applied to the Finlandia design pitchers. The Chateau and Finlandia design Pom Pom decoration pitchers and glasses were available in the same colors.

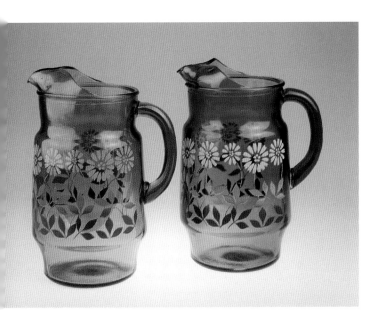

Left to right: Avocado Green Pom Pom decoration 74 oz. pitcher, $25-30; Spicy Brown Pom Pom 74 oz. pitcher, $35-40.

4-pack of Spicy Brown Pom Pom 15 oz. beverage glasses, 5 3/4", $20-30.

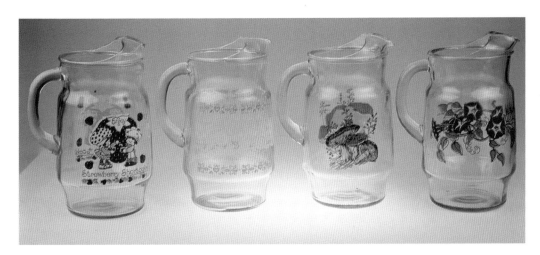

Left to right: Strawberry decoration 74 oz. pitcher, $40-50; Pantry decoration 74 oz. pitcher #3364/7656 (1976), $20-25; Mushroom decoration 74 oz. pitcher, $20-25; Morning Glory decoration 74 oz. pitcher, $20-25.

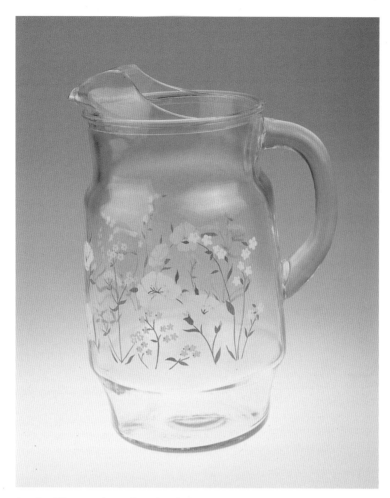

Another 74 oz. pitcher with unidentified designs, $20-25.

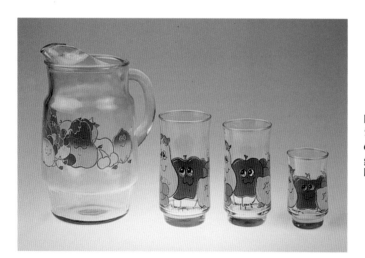

Left to right: 74 oz. pitcher with happy fruit decoration, $20-25; 17 oz. iced tea Esprit design glass with happy fruit decoration, 6", $2-3; 12 1/2 oz. beverage Esprit design glass with happy fruit decoration, 5 1/2", $2-3; 7 oz. juice Esprit design glass with happy fruit decoration, 4", $2-3.

A multitude of decorations were applied to Chateau glasses. Here are just a few to illustrate the point, $3-5 for each glass.

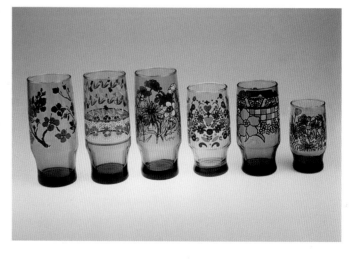

Chapter Seven.
Finlandia Design
Pitchers

The Finlandia design plain and decorated pitchers and glasses were made for many years. The catalogs list six sizes of stemmed glasses; however, all sizes are not usually listed in the same catalog. The 1974 catalog does list all six sizes. Most of the stemmed glasses are reasonably hard to find, probably because the base and stems chip and break easily. Be sure to look for the large cursive "L" on the bottom of some of the straight-sided glasses, because Libbey Glass™ did make a similar design.

Finlandia

pictorial code	description	color	BULK PACKED item number	dozen/carton	lbs/carton	ANCHOR PACKED item number	sets/carton	lbs/carton	CARTON item number	dozen/carton	lbs/carton
A	9 oz. on-the-rocks	Avocado	T3579	3	15	T3579CD	6	10	T3579G	1	5
		Honey Gold	N3579	3	15	N3579CD	6	10	N3579G	1	5
		Laser Blue	F3579	3	15						
		Crystal	3579	3	15						
		Spicy Brown	Y3579	3	15						
B	6 oz. juice	Avocado	T3576	3	11	T3576CD	6	8	T3576G	1	4
		Honey Gold	N3576	3	11	N3576CD	6	8	N3576G	1	4
		Laser Blue	F3576	3	11						
		Crystal	3576	3	11						
		Spicy Brown	Y3576	3	11						
C	16 oz. iced tea	Avocado	T3585	3	23	T3585CD	6	16	T3585G	1	7
		Honey Gold	N3585	3	23	N3585CD	6	16	N3585G	1	7
		Laser Blue	F3585	3	23						
		Crystal	3585	3	23						
		Spicy Brown	Y3585	3	23						
D	2½ qt. ice lip pitcher	Avocado	T3580	½	20						
		Honey Gold	N3580	½	20						
		Laser Blue	F3580	½	20						
		Spicy Brown	Y3580	½	20						
E	12 oz. beverage	Avocado	T3582	3	16	T3582CD	6	11	T3582G	1	6
		Honey Gold	N3582	3	16	N3582CD	6	11	N3582G	1	6
		Laser Blue	F3582	3	16						
		Crystal	3582	3	16						
		Spicy Brown	Y3582	3	16						

NOTE: *See Index for additional listings of Finlandia bulk and gift items.*

Catalog listing the plain Finlandia pitcher and glasses in several colors.

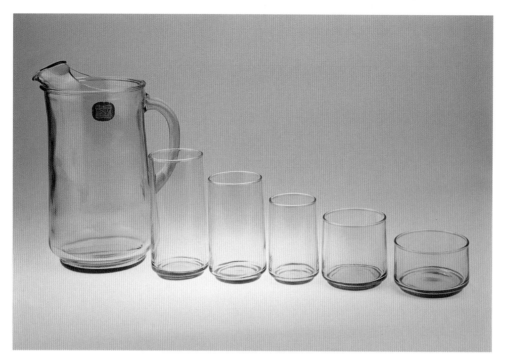

Honey Gold Finlandia glassware. Left to right: 2 1/2 qt. pitcher #N3580, $15-20; 16 oz. beverage #N3585, 5 3/4", $1-2; 12 oz. tumbler #N3583, 4 3/4", $1-2; 6 oz. juice #N3576, 3 7/8", $1-2; 9 oz. on-the-rocks #N3579, 3 1/8", $1-2; 6 oz. juice #N3577, 2 1/8", $1-2.

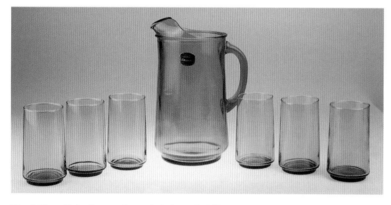

The 7-Piece Refreshment Set included one 2 1/2 qt. pitcher and six 12 oz., 4 3/4" beverage glasses.

The 7-Piece Refreshment Set in Avocado Green, $30-35 for the entire set, $5-10 for the box only.

Close-up of the Avocado Green label applied to the pitcher in the refreshment set. I have never found labels on any Finlandia beverage glass.

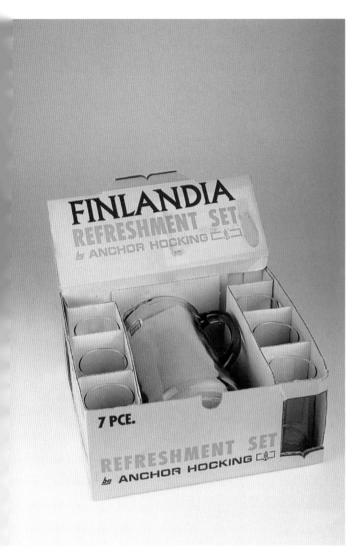

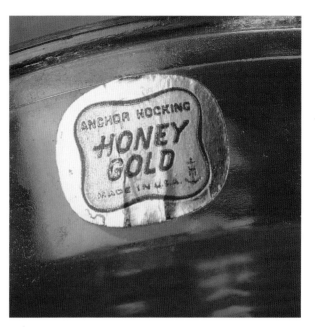

Close-up of the Honey Gold label applied to the pitcher in the refreshment set. I have never found labels on any Finlandia glass.

The 7-Piece Refreshment Set in Honey Gold, $30-35 for the entire set, $5-10 for the box only.

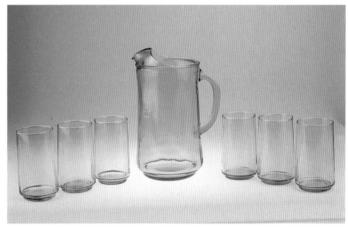

The 7-Piece Refreshment Set in Aquamarine, $40-50 for the entire set.

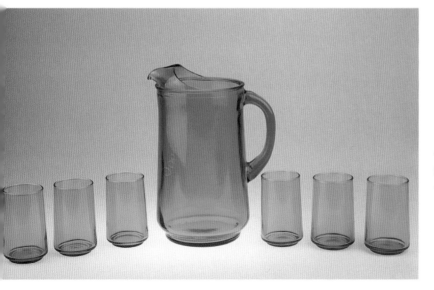

The 7-Piece Refreshment Set in Laser Blue, $40-50 for the entire set. This set is shown with the 6 oz., 3 3/4" juice glass #F3576.

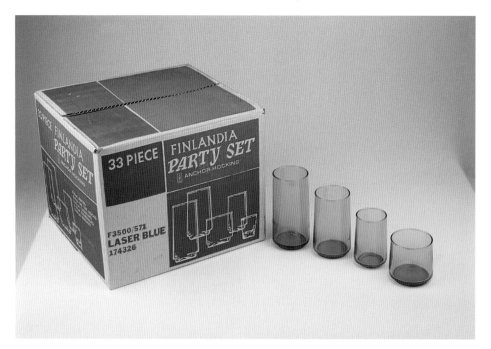

Finlandia glasses were sold in a number of different combinations. Here is the 33-Piece Finlandia Party Set that included: eight 15 oz., 5 3/4" iced teas; eight 12 oz., 4 3/4" beverage glasses; eight 7 oz., 3 3/4" juice; eight 9 oz., 3 1/8" on-the-rocks; and one shot glass (not pictured); $75-80 for the entire set, $15-20 for the box only.

Four-pack of Honey Gold 7 1/2 oz., 3" sherbet/champagnes, $20-30 in the original box, $5-8 for the box only.

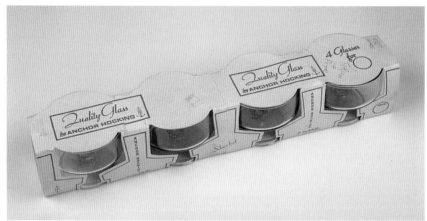

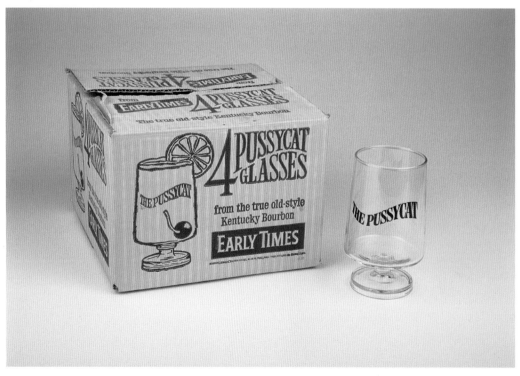

Finlandia 10 1/2 oz., 5" goblets with the Pussycat decoration. These glasses were sold by the company that made Early Times bourbon, $30-40 for the set, $10-15 for the box only.

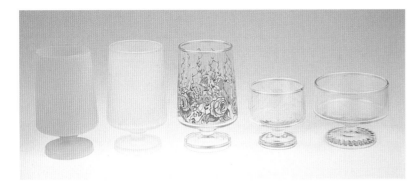

Finlandia stemmed glasses. Left to right: yellow fired-on 10 1/2 oz. goblet, 5", $3-4; frosted 10 1/2 oz. goblet, 5", $1-2; patterned 10 1/2 oz. goblet, 5", $1-2; unusual ribbed base 4 1/2 oz. cocktail, 3", $3-5; unusual ribbed base 7 1/2 oz. sherbet/champagne, 3", $3-5.

Close-up of the label on an etched Finlandia stemmed glass. The glass was sold at the Hillyard's Gift Shop in Bremen, Ohio. It was my understanding that Anchor Hocking did not own the facility in Bremen; however, I later bought a set of etched glasses from Bremen that were packed in an box marked with Anchor Hocking symbols and the company name. Some company employees also confirmed that Anchor Hocking did own the facility.

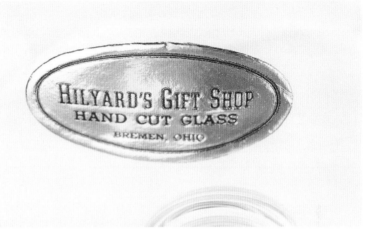

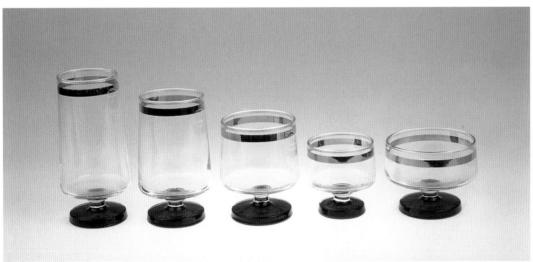

Finlandia stemmed glasses. Left to right: 12 oz. glass, 5 3/4", $6-8; 10 1/2 oz. goblet, 5", $5-6; 9 oz. on-the-rocks, 4", $5-6; 4 1/2 oz. cocktail, 3", $5-6; 7 1/2 oz. sherbet/champagne, 3", $5-6.
This is a rare set since each glass has a platinum-coated rim and fired-on black base.

Finlandia stemmed glasses. Left to right: 10 1/2 oz. goblet #T2610, 5", $6-8; 10 1/2 oz. goblet #N2610, $5-6; 5 oz. juice/whiskey sour #T2606, 4", $5-6; 4 1/2 oz. cocktail #N2604, 3", $5-6; 7 1/2 oz. sherbet/champagne #N2608, 3", $5-6.

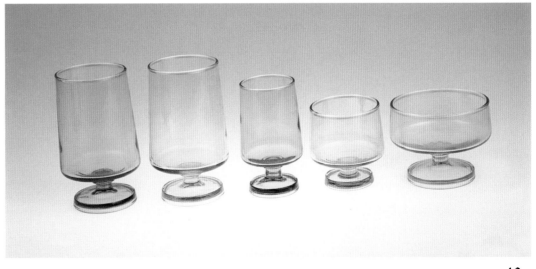

Chapter Eight.
Finlandia Decorated
Pitchers

Many of the decorations applied to the Finlandia design pitchers and glasses were also applied to the Chateau design pitchers and glasses. The decorations retained the same name when applied to either the Chateau or Finlandia glassware.

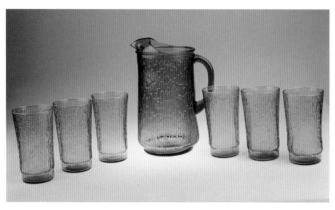

This is a 2 1/2 qt. Finlandia design pitcher with the Pagoda finish, $30-35, with six 16 oz. large iced teas #T4237, $8-10 for each glass.

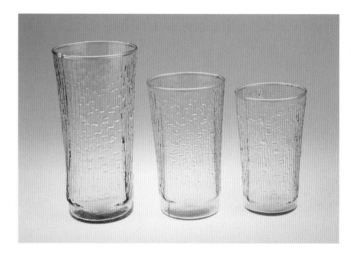

Left to right: 23 oz. cooler #N4224, 6 7/8", $5-8; 16 oz. iced tea #N4237, 5 1/2", $4-5; 12 oz. beverage #N4232, 5", $4-5.

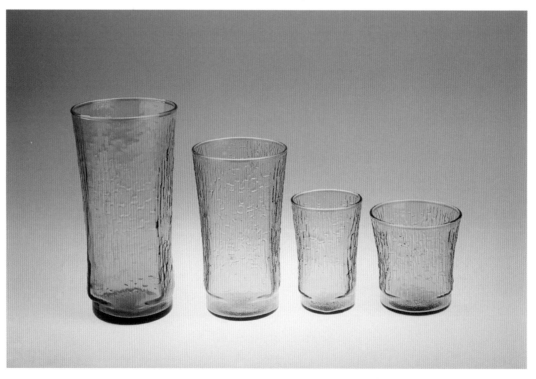

Left to right: 23 oz. cooler #T4224, 6 7/8", $5-8; 16 oz. iced tea #T4237, 5 1/2", $4-5; 5 1/2 oz. juice #T4226, 3 3/4", $2-3; 8 oz. on-the-rocks #T4230, 3 1/4", $2-3.

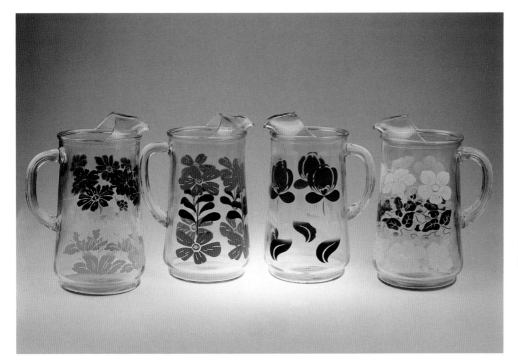

Four floral decoration 2 1/2 qt. pitchers, $30-35 for each pitcher.

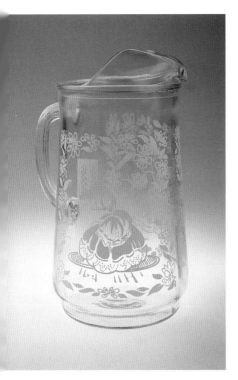

Colonial Lady decoration 2 1/2 qt. pitcher, $30-35.

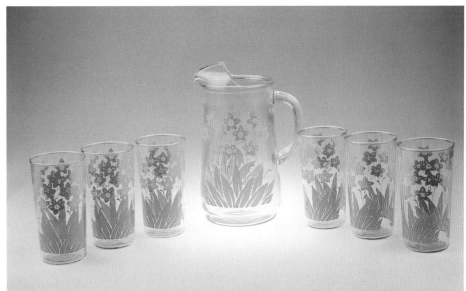

Floral decoration 2 1/2 qt. pitcher, $30-35, with six 19 oz., 5 1/2" large iced teas, $8-10 for each glass.

Left to right: 23 oz. cooler, 6 7/8", $8-10; 9 oz. large iced tea, 5 1/2", $6-8; 12 oz. beverage, 4 3/4", $6-8.

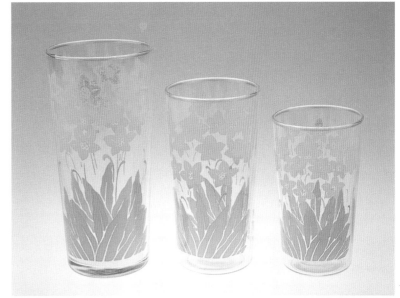

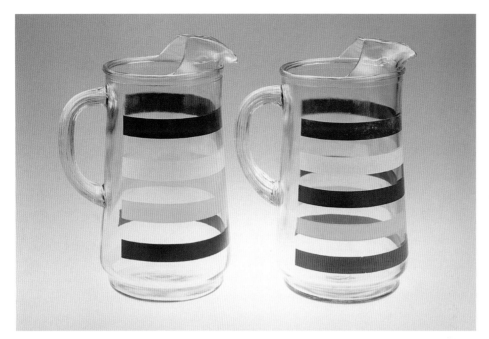

Two different versions of the Fiesta Stripe decoration, $30-35 for each version.

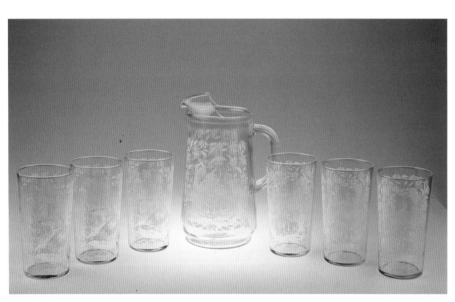

Colonial Lady decoration 2 1/2 qt. pitcher, $30-35, with six 22 oz., 6" large iced teas, $8-10 for each glass.

The opposite side of the Colonial Lady decoration 2 1/2 qt. pitcher.

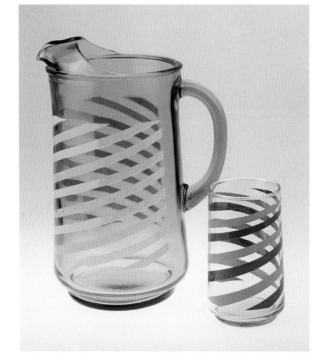

Finlandia Twist decoration 2 1/2 qt. pitcher #T3580/6912 (1970), $35-40, with the 12 oz., 3 3/4" tumbler #N3582-G/6913, $3-5. This pattern comes in orange/red, turquoise/green, and yellow/green combinations.

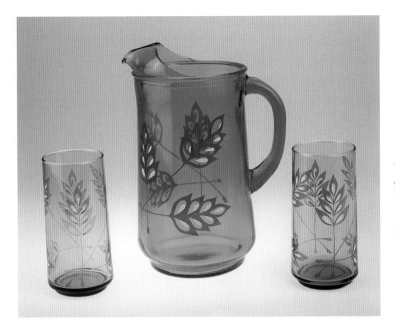

This is the Butternut decoration 2 1/2 qt. pitcher #F3580/7198 (1972), $35-40, with two 15 oz., 5 3/4" iced teas #T3585G/7198, $3-5 for each glass. The Butternut pattern can also be found in Honey Gold and Spicy Brown.

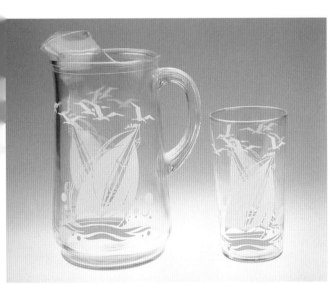

Sailing Ships decoration 2 1/2 qt. pitcher, $45-50, with one 19 oz., 6" large iced tea, $5-8.

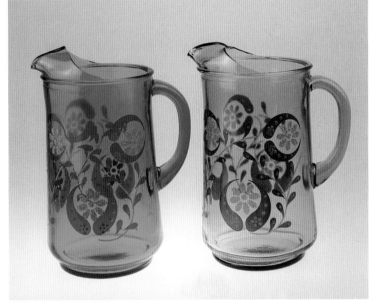

Left to right: Plain N' Fancy decoration pitcher #F3580/7198 (1972), $40-50; Plain N' Fancy decoration pitcher #N3580/7198, $40-50. This pattern can also be found in Avocado Green and Spicy Brown. It was also applied to the Chateau design pitchers.

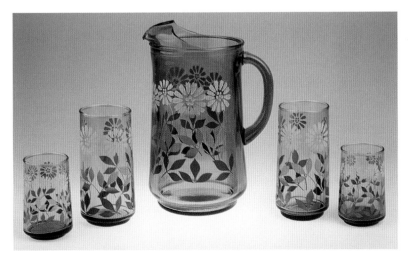

Pom Pom decoration 2 1/2 qt. pitcher, $35-40, with the 16 oz., 5 3/4" iced tea, $1-3, and the 9 oz., 3 3/4" on-the-rocks, $1-3 glass. This decoration was also applied to the Chateau design pitchers in the early 1970s.

53

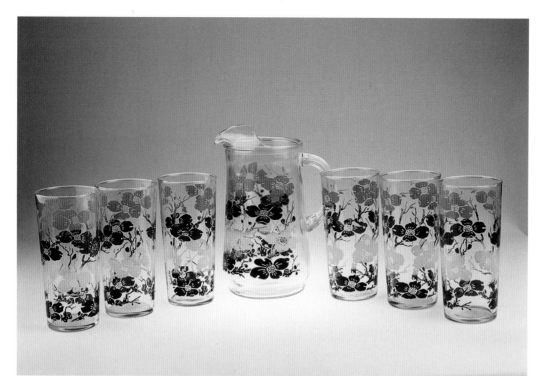

Dogwood decoration 2 1/2 qt. pitcher, $35-40, with six 19 oz., 5 5/8" large iced teas, $5-8 for each glass.

Six-pack of Dutch Windmill decoration 12 oz., 4 3/4" tumblers, $35-40.

Left to right: Dogwood decoration 19 oz. large iced tea, 5 5/8", $5-8; 12 oz. tumbler, 4 3/4", $4-5. There is also a 23 oz., 6 7/8" cooler in this decoration (not shown).

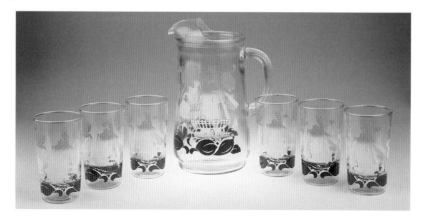

Dutch Windmill decoration 2 1/2 qt. pitcher, $30-40, with six 12 oz., 4 3/4" tumblers, $4-5 for each glass.

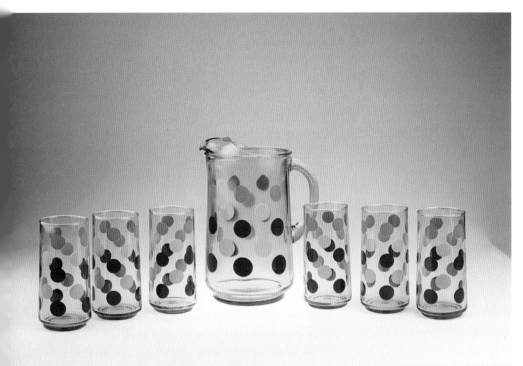

Finlandia Polka Dot decoration
2 1/2 qt. pitcher #F3580G/7020
(1972), $30-40, with six 12 oz.,
4 3/4" tumblers #F3582G/7020,
$2-4 for each glass.

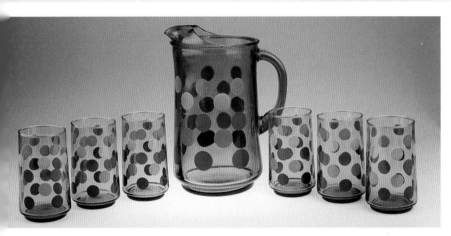

Finlandia Polka Dot decoration 2 1/2 qt. pitcher
#N3580G/7019 (1972), $30-40, with six 16 oz.,
5 3/4" iced teas #N3585G/7019, $2-4
for each glass.

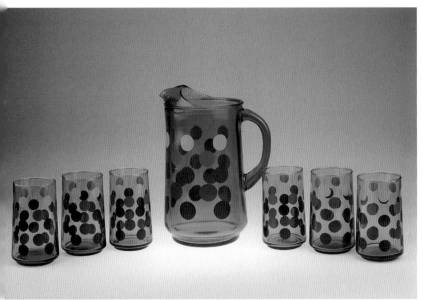

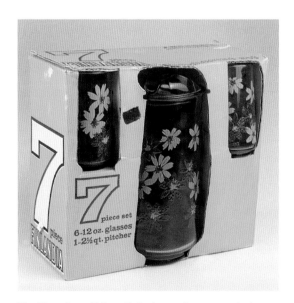

Finlandia Polka Dot decoration 2 1/2 qt. pitcher #T3580G/7021 (1972), $30-40, with six 12 oz., 4 3/4" tumblers #T3582G/7021, $2-4 for each glass. There is also an Aquamarine Polka Dot decoration pitcher and glasses (not shown) set that is very difficult to find.

The Misty Daisy 7-Piece Refreshment Set consisted of one 2 1/2 qt. pitcher #T3580/7014 (1971), $30-40, with six 12 oz., 4 3/4" tumblers #T3582G/7014, $3-4 for each glass.

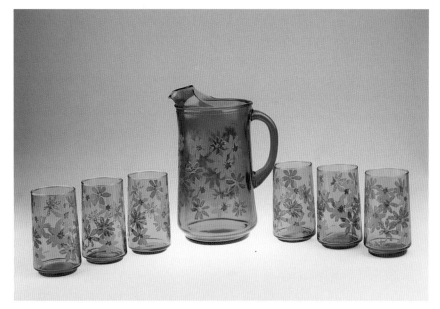

Misty Daisy decoration 2 1/2 qt. pitcher, $40-50, with six 12 oz.,
4 3/4" tumblers, $3-5 for each glass. This pattern was produced in Crystal, Honey Gold,
Avocado Green, Laser Blue, and Aquamarine.

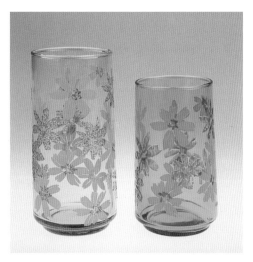

Left to right: 16 oz. iced tea #B3585G/7013,
5 3/4", $3-4; 12 oz. tumbler, 4 3/4", $3-5. Notice
the tumbler on the left is Aquamarine in color. There
may be a matching Misty Daisy pitcher.

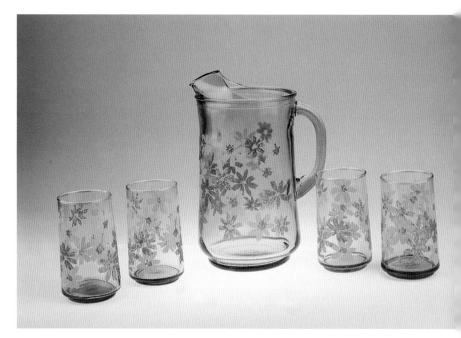

Misty Daisy decoration 2 1/2 qt. pitcher #N3580G/7050 (1971), $30-40, with six 12 oz.,
4 3/4" tumblers #N3582G/7050, $2-4 for each glass.

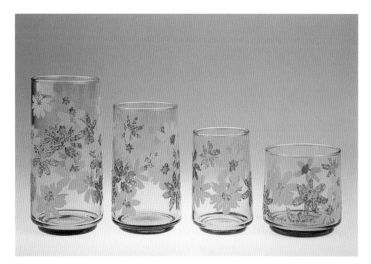

Left to right: 16 oz. iced tea
#N3585G/7050, 5 3/4", $3-4;
12 oz. tumbler #N3582G/7050,
4 3/4", $2-4; 9 oz. on-the-rocks
#N3579G/7050, 3 3/4", $2-4;
6 oz. juice #N3576G/7050, 3 1/8",
$2-4.

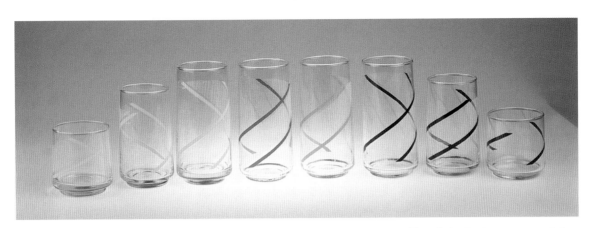

These Finlandia glasses were made by a number of companies. Most of the glasses found will have the mark "CHINA" on the bottom. Anchor Hocking also made this pattern and the glasses are marked with the "anchor in the square" mark.

Some of the glasses being sold today that look like the Finlandia design were actually made in China. Those glasses may also have a paper label on the bottom.

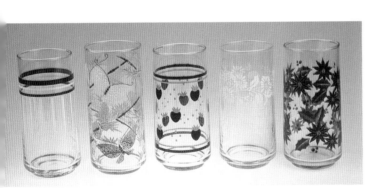

There was an assortment of patterns applied to the Finlandia design 16 oz., 5 7/8" iced tea glasses, $1-2 for each glass.

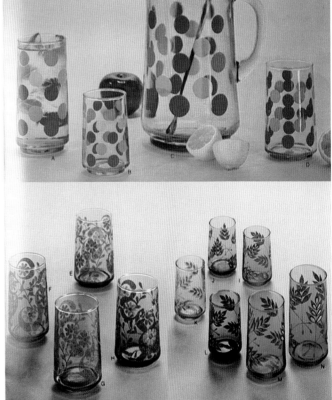

Catalog listing some of the decorated Finlandia patterns.

Decorated

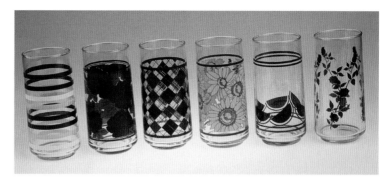

There was an assortment of patterns applied to the Finlandia design 16 oz., 5 7/8" iced tea glasses, $1-2 for each glass.

pictorial code	description	BULK PACKED			ANCHOR PACKED		
		item number	dozen/carton	lbs/carton	item number	sets/carton	lbs/carton
	Finlandia Polka Dot						
A	16 oz. iced tea	T3585G/7021	1	8	T3585CD/7021	6	16
		N3585G/7019	1	8	N3585CD/7019	6	16
		F3585G/7020	1	8	F3585CD/7020	6	16
		Y3585G/7130	1	8	Y3585CD/7130	6	16
B	6 oz. fruit juice	T3576G/7021	1	4	T3576CD/7021	6	9
		N3576G/7019	1	4	N3576CD/7019	6	9
		F3576G/7020	1	4	F3576CD/7020	6	9
		Y3576G/7130	1	4	Y3576CD/7130	6	9
C	2½ qt. ice lip pitcher	T3580/7021	½	23			
		N3580/7019	½	23			
		F3580/7020	½	23			
		Y3580/7130	½	23			
D	12 oz. beverage	T3582G/7021	1	5	T3582CD/7021	6	13
		N3582G/7019	1	5	N3582CD/7019	6	13
		F3582G/7020	1	5	F3582CD/7020	6	13
		Y3582G/7130	1	5	Y3582CD/7130	6	13
	Plain & Fancy						
E	12 oz. beverage	T3582G/7203	1	5	T3582CD/7203	6	13
F	12 oz. beverage	F3582G/7202	1	5	F3582CD/7202	6	13
G	12 oz. beverage	N3582G/7204	1	5	N3582CD/7204	6	13
H	12 oz. beverage	Y3582G/7205	1	5	Y3582CD/7205	6	13
	6 oz. fruit juice (not illus.)	T3576G/7203	1	4	T3576CD/7203	6	9
		F3576G/7202	1	4	F3576CD/7202	6	9
		N3576G/7204	1	4	N3576CD/7204	6	9
		Y3576G/7205	1	4	Y3576CD/7205	6	9
	15 oz. iced tea (not illus.)	T3585G/7203	1	8	T3585CD/7203	6	16
		F3585G/7202	1	8	F3585CD/7202	6	16
		N3585G/7204	1	8	N3585CD/7204	6	16
		Y3585G/7205	1	8	Y3585CD/7205	6	16
	2½ qt. pitcher (not illus.)	T3580/7203	½	23			
		F3580/7202	½	23			
		N3580/7204	½	23			
		Y3580/7205	½	23			
	Butternut						
I	6 oz. juice	F3576G/7198	1	4	F3576CD/7198	6	9
J	6 oz. juice	T3576G/7199	1	4	T3576CD/7199	6	9
K	6 oz. juice	N3576G/7200	1	4	N3576CD/7200	6	9
L	6 oz. juice	Y3576G/7201	1	4	Y3576CD/7201	6	9
M	12 oz. beverage	F3582G/7198	1	5	F3582CD/7198	6	13
		T3582G/7199	1	5	T3582CD/7199	6	13
		N3582G/7200	1	5	N3582CD/7200	6	13
		Y3582G/7201	1	5	Y3582CD/7201	6	13
N	15 oz. iced tea	F3585G/7198	1	8	F3585CD/7198	6	16
		T3585G/7199	1	8	T3585CD/7199	6	16
		N3585G/7200	1	8	N3585CD/7200	6	16
		Y3585G/7201	1	8	Y3585CD/7201	6	16
	2½ qt. pitcher (not illus.)	F3580/7198	½	23			
		T3580/7199	½	23			
		N3580/7200	½	23			
		Y3580/7201	½	23			

NOTE: See Index for additional listings of Finlandia bulk and gift items.

Catalog listing for Polka Dot, Plain & Fancy, and Butternut decorations.

There was an assortment of patterns applied to the Finlandia design 12 oz., 4 3/4" beverage glasses, $1-2 for each glass.

There was an assortment of patterns applied to the Finlandia design 9 oz., 3" on-the-rocks glasses, $1-2 for each glass.

Chapter Nine.
Established Patterns

Annapolis™

This pattern is currently being sold in Wal-Mart stores. The 1996 catalog lists the pattern only in Crystal. Only three sizes of glasses are listed: the 14 oz. goblet, the 16 oz. iced tea, and the 12 oz. rocks.

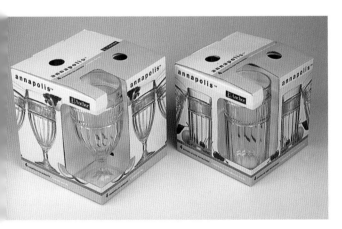

Left to right: 4-pack of 14 oz., 7" goblets; 4-pack of 16 oz., 6 1/4" iced teas.

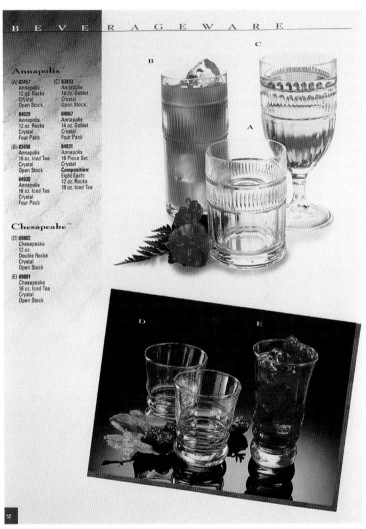

Annapolis listing in the 1996 Beverageware Catalog.

Aurora™

Aurora is an interesting name for Anchor Hocking to use. Aurora will cause some confusion among collectors because the company used the name to describe a finish, glass pattern, and an applied design. Most collectors are familiar with the pearl-like, iridescent coating applied to snack set, glasses, cups, saucers, plates, and a host of other pieces of glass. Few collectors are familiar with the design called Aurora.

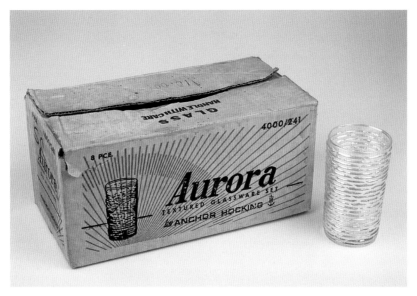

Soreno Aurora finish 12 oz., 4 3/4" glasses, $40-50 for the entire set, $10-15 for the box only.

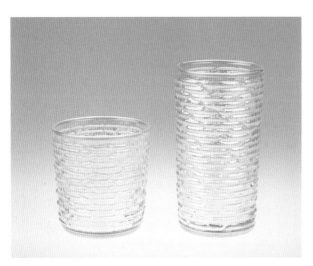

Left to right: 8 oz. on-the-rocks, 3", $4-5; 12 oz. tumbler, 4 3/4", $5-8.

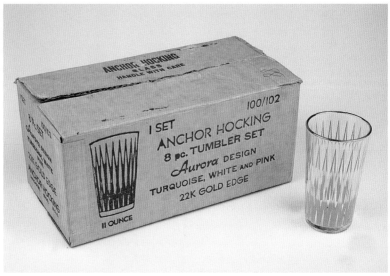

Aurora design 8-piece tumbler set, $30-40 for the complete set, $10-15 for the box only.

Breezes™

This pattern is reasonably hard to find. The 1985 catalog only lists the pattern in Crystal and Honey Gold for both the pitcher and five sizes of glasses.

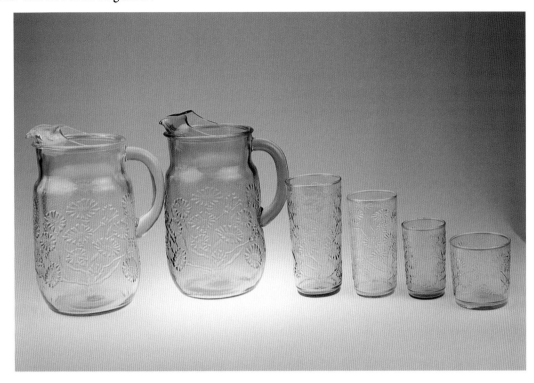

Left to right: Crystal 74 oz. pitcher #4070 (1985), $15-20; Honey Gold 74 oz. pitcher #N4070; 16 1/2 oz. iced tea #N4074, 6", $2-3; 11 1/4 oz. beverage #4073, 5", $2-3; 6 oz. juice, 3 1/2", $1-2; 9 1/2 oz. on-the-rocks, 3", $1-2.

Bristol Park™

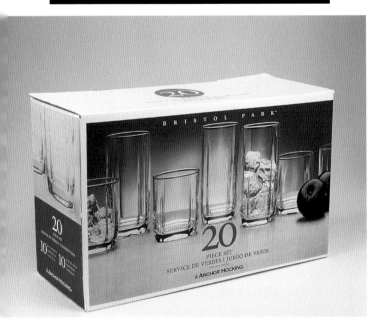

Bristol Park 20-Piece Refreshment Set contained ten 16 oz., 6" iced teas and ten 12 oz., 3 5/8" double rocks, $15-20.

Bristol Park 64 oz. pitcher, $10-12 in the box.

Bristol Park glasses. Left to right: 16 oz. iced tea, 6", $1-2; 12 oz. double rocks, 3 5/8", $1-2; 12 oz. double rocks, 3 5/8", $1-2.

Canfield™

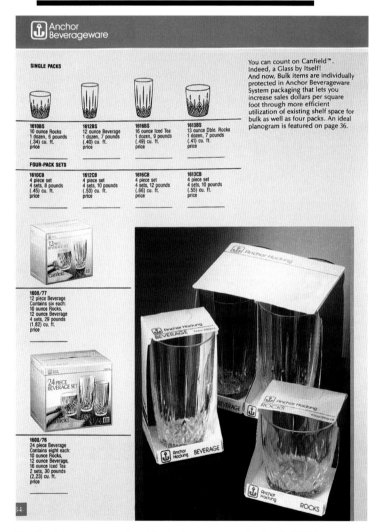

Anchor Beverageware

SINGLE PACKS

1610BS	1612BS	1616BS	1613BS
10 ounce Rocks	12 ounce Beverage	16 ounce Iced Tea	13 ounce Dble. Rocks
1 dozen, 6 pounds	1 dozen, 7 pounds	1 dozen, 9 pounds	1 dozen, 7 pounds
(.34) cu. ft.	(.40) cu. ft.	(.49) cu. ft.	(.41) cu. ft.
price	price	price	price

FOUR-PACK SETS

1610CB	1612CB	1616CB	1613CB
4 piece set	4 piece set	4 piece set	4 piece set
4 sets, 8 pounds	4 sets, 10 pounds	4 sets, 12 pounds	4 sets, 10 pounds
(.45) cu. ft.	(.53) cu. ft.	(.66) cu. ft.	(.55) cu. ft.
price	price	price	price

You can count on Canfield™. Indeed, a Glass by Itself! And now, Bulk items are individually protected in Anchor Beverageware System packaging that lets you increase sales dollars per square foot through more efficient utilization of existing shelf space for bulk as well as four packs. An ideal planogram is featured on page 36.

1600/77
12 piece Beverage
Contains six each:
10 ounce Rocks,
12 ounce Beverage
4 sets, 29 pounds
(1.82) cu. ft.
price

1600/76
24 piece Beverage
Contains eight each:
10 ounce Rocks,
12 ounce Beverage,
16 ounce Iced Tea
2 sets, 30 pounds
(2.23) cu. ft.
price

The Canfield pattern was listed in the *Beverageware Catalog A-40/58*.

The Canfield pattern was listed in the *Beverageware Catalog A-40/58*.

Canfield™

The Canfield™ Collection has the look and feel of fine leaded traditional crystal in a popular affordable design. See the Collections Catalog also.

Choose from rocks, wine, champagne, beverage and iced tea glasses, decanter, bowls or servingware. Your customers will appreciate the versatility and variety of individual items and beautifully packaged sets perfect for gift-giving and entertaining.

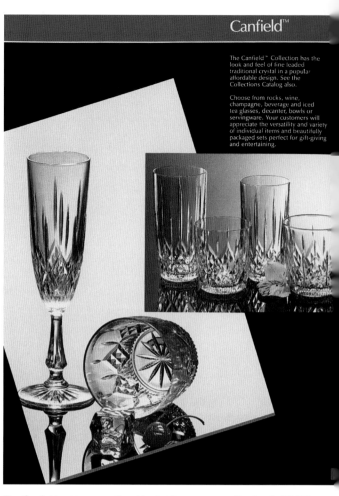

The Canfield pattern was listed in the *Beverageware Catalog A-40/58*.

Canfield™

Anchor Beverageware

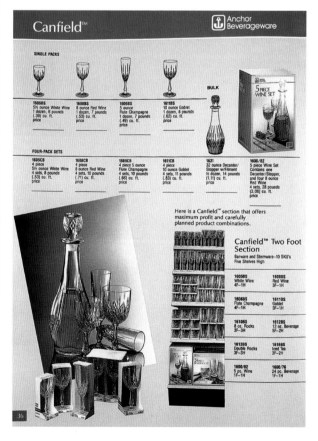

SINGLE PACKS

1605BS	1608BS	1606BS	1611BS	BULK
5½ ounce White Wine	8 ounce Red Wine	5 ounce Flute Champagne	10 ounce Goblet	
1 dozen, 6 pounds	1 dozen, 7 pounds	1 dozen, 7 pounds	1 dozen, 8 pounds	
(.39) cu. ft.	(.53) cu. ft.	(.49) cu. ft.	(.62) cu. ft.	
price	price	price	price	

5 PIECE WINE SET

FOUR-PACK SETS

1605CB	1608CB	1606CB	1611CB	1631	1600/82
4 piece	4 piece	4 piece	4 piece	32 ounce Decanter/	5 piece Wine Set
5½ ounce White Wine	8 ounce Red Wine	5 ounce Flute Champagne	10 ounce Goblet	Stopper w/Fitment	Contains one
4 sets, 8 pounds	4 sets, 10 pounds	4 sets, 10 pounds	4 sets, 11 pounds	½ dozen, 14 pounds	Decanter/Stopper,
(.53) cu. ft.	(.71) cu. ft.	(.66) cu. ft.	(.83) cu. ft.	(1.11) cu. ft.	and four 8 ounce
price	price	price	price	price	Red Wine
					4 sets, 28 pounds
					(3.08) cu. ft.
					price

Here is a Canfield™ section that offers maximum profit and carefully planned product combinations.

Canfield™ Two Foot Section
Barware and Stemware–10 SKU's
Five Shelves High

1605BS	1608BS
White Wine	Red Wine
4F–1H	4F–1H
1606BS	**1611BS**
Flute Champagne	Goblet
4F–1H	3F–1H
1610BS	**1612BS**
8 oz. Rocks	12 oz. Beverage
3F–3H	5F–2H
1613BS	**1616BS**
Double Rocks	Iced Tea
3F–3H	3F–2H
1600/82	**1600/76**
5 pc. Wine	24 pc. Beverage
1F–1H	1F–1H

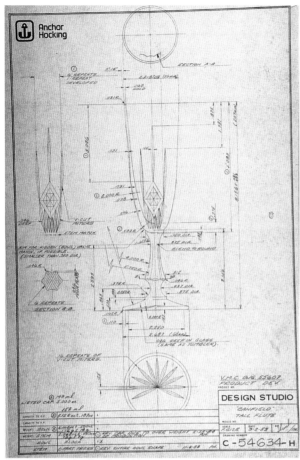

Rare blueprint for the Canfield pattern.

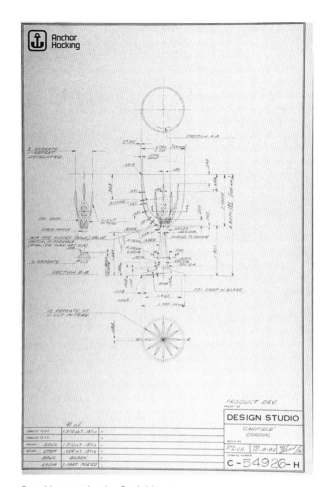

Rare blueprint for the Canfield pattern.

Caprice™

The pattern is listed in the 1969 catalog. The pitcher is listed in Avocado Green, Honey Gold, and Aquamarine. Four sizes of glasses are included: the 15 oz. cooler, the 12 oz. beverage, the 11 oz. on-the-rocks, and the 6 oz. juice. While the pitchers are easy to find, the glasses are reasonably rare.

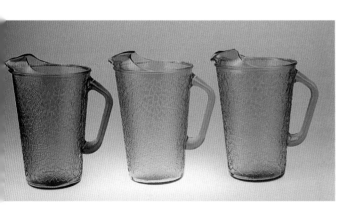

Caprice 60 oz. pitchers (1970). Left to right: Avocado Green pitcher #T2760, $15-20; Aquamarine pitcher #B2760, $15-20; Honey Gold pitcher #N2760, $15-20.

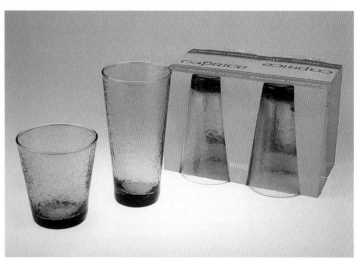

The Caprice glasses came in four sizes. Left to right: 11 oz. on-the-rocks #T2711, 3 3/4", $3-4; 15 oz. beverage #T2714-C, 6 1/4", $3-5; four-pack of 12 oz., 5 1/4" tumblers #N2712-C, $20-25. There is also a 6 oz., 3 5/8" juice glass (not shown).

Celebrate™

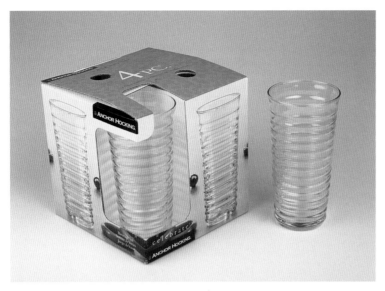

A 4-Pack of 18 oz., 6 1/2" iced teas, $5-8. The glasses were recently purchased at Wal-Mart.

Crown Point™

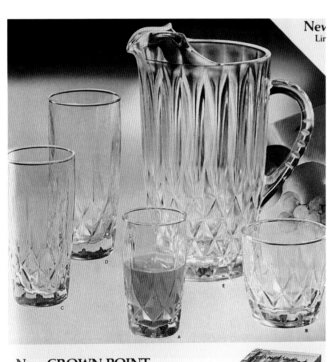

New CROWN POINT

The combination of elegant crystal and intricate diamond pattern of Crown Point make it an overwhelming preference in consumer research studies.

photo ref.	description	BULK PACKED		ANCHOR PACKED (4 Pc. Sets)	
		item order no.	shipper doz. lbs.	set order no.	shipper sets lbs.
	CROWN POINT				
A	New 6 oz. juice	1506	2 9	1506C	6 10
B	New 9 oz. on-the-rocks	1509	2 13	1509C	6 14
C	New 11 oz. beverage	1511	2 16	1511C	6 17
D	New 16 oz. iced tea	1516	2 18	1516C	6 19
E	New 2 qt. pitcher	1567	½ 17		

Beverageware 39

The Crown Point pattern was introduced in the *1978 Bulk Catalog.*

Beverageware Gift Sets

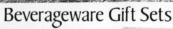

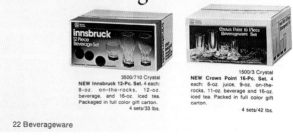

3500/710 Crystal
NEW Innsbruck 12-Pc. Set. 4 each: 8-oz. on-the-rocks, 12-oz. beverage, and 16-oz. iced tea. Packaged in full color gift carton.
4 sets/33 lbs.

1500/3 Crystal
NEW Crown Point 16-Pc. Set. 4 each: 6-oz. juice, 9-oz. on-the-rocks, 11-oz. beverage and 16-oz. iced tea. Packed in full color gift carton.
4 sets/42 lbs.

22 Beverageware

Crown Point was also listed in 16-piece sets.

Colonial Tulip™

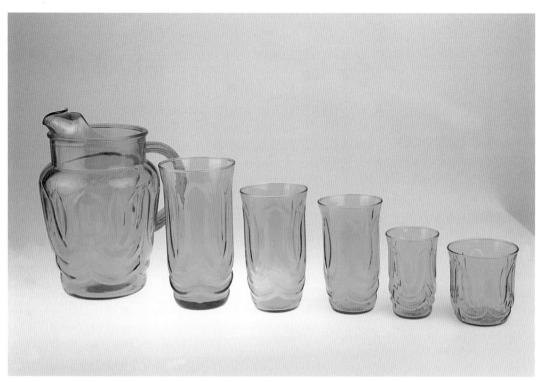

Left to right: Laser Blue 82 oz. pitcher #T4486, $15-20; 25 oz. cooler #F4425, 6 7/8", $5-8; 16 oz. iced tea #F4415, 5 5/8", $3-5; 12 oz. beverage #F4412, 5 1/8", $3-4; 6 oz. juice #F4406, 3 3/4", $2-3; 8 1/2 oz. on-the-rocks #F4412, 3 1/4", $2-3.

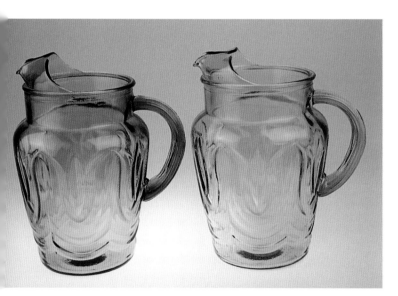

Left to right: Avocado Green 82 oz. pitcher #T4486, $10-15; Honey Gold 82 oz. pitcher #N4486, $20-30.

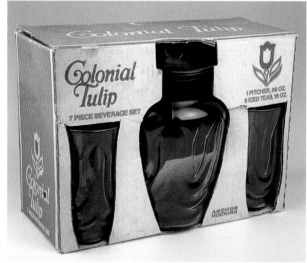

The 7-Piece Refreshment Set #F4400/22 in Laser Blue, $30-35 for the entire set, $5-10 for the box only. The sets consist of one 82 oz. pitcher and six 16 oz. iced teas.

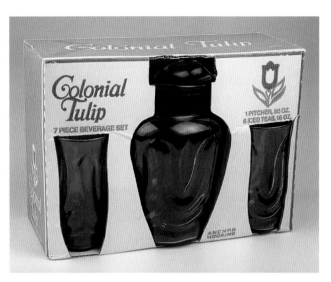

The 7-Piece Refreshment Set #T4400/21 in Avocado Green, $30-35 for the entire set, $5-10 for the box only. The sets consist of one 82 oz. pitcher and six 16 oz. iced teas.

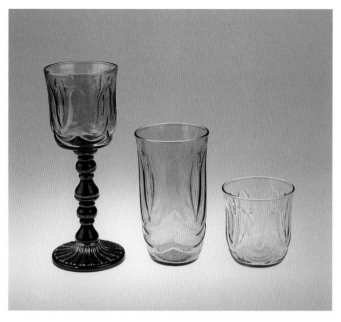

Left to right: Candleholder made with a wooden base and a Spicy Brown on-the-rocks glass, $10-15; Spicy Brown 12 oz. beverage glass, 5 1/2", $8-10; Honey Gold on-the-rocks #N4408, 3", $4-5. The Spicy Brown color seems to be the hardest to find while the Laser Blue is the most common.

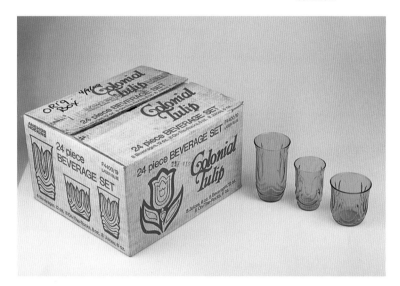

The 24-Piece Beverage Set included eight 12 oz., 5 5/8" beverage glasses, eight 6 oz., 3 3/4" juice glasses, and eight 8 1/2 oz., 3 1/4" on-the-rocks, $60-75 for the set, $10-15 for the box only.

The Colonial Tulip glasses were sold in many different combinations. Here is the four-pack set of 16 oz., 5 5/8" iced teas #F4415, $20-30 for the set, $5-10 for the carrier only.

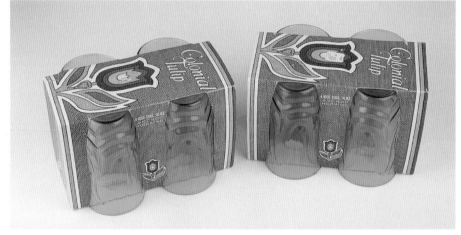

Courtney™

The Courtney pattern was listed in catalogs for several years. The 1985 catalog only lists the pattern in Crystal, while later catalogs list the pattern in Dove Grey and Sapphire Blue. Each catalog lists a different set of glasses, with the 1987 catalog listing all the pieces made in the pattern. This catalog lists eight sizes of glasses, three sizes of stemmed glasses, and two fountain styles (ice cream dish and soda glass).

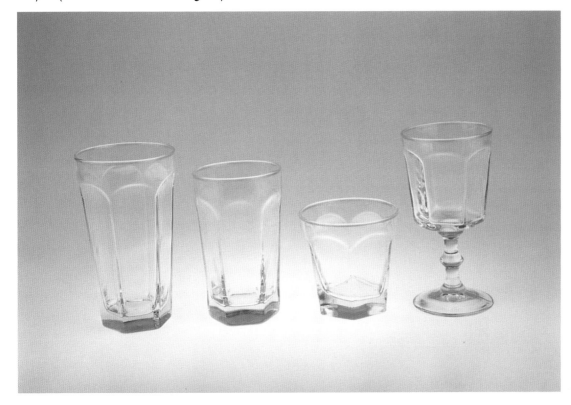

Courtney glasses. Left to right: 14 oz., 6" glass; 10 oz., 5 1/8" glass; 9 oz., 3 1/2" glass; 8 oz., 6 1/8" stemmed glass. Each glass would be $1-2.

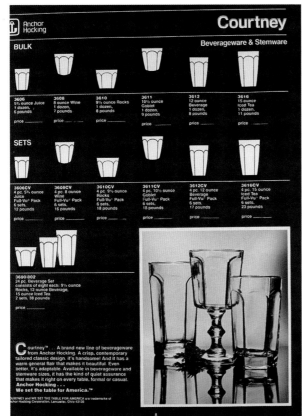

The Courtney pattern was listed in the catalogs in bulk or sets.

Early American Prescut™

This pattern was made by Anchor Hocking for years. I only listed a couple of unusual pitchers and one boxed set. I will expand this pattern when the book is updated. I also included some rare original Anchor Hocking blueprints for the pattern. Some of the pieces (i.e., the cocktail shaker) I have only seen on the occasions when my wife and I visited the morgue in Lancaster, Ohio.

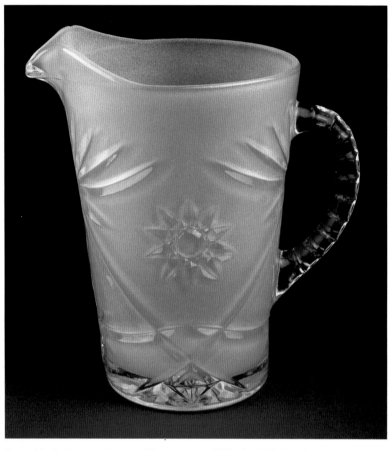

Frosted Early American Prescut 60 oz. pitcher #791, $40-50. The frosting was done on the inside of the pitcher.

Colored Early American Prescut 60 oz. pitcher, $40-50. The colored lacquer was applied to the grooved patterns on the outside of the pitcher. There are several other pieces of Early American Prescut with this same color scheme.

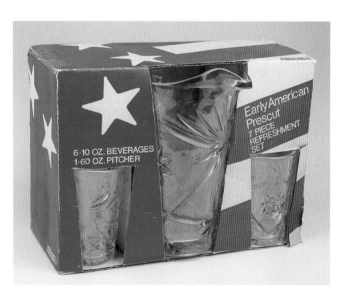

Early American Prescut 7-Piece Refreshment Set, $30-40 for the complete set, $10-15 for the box only.

68

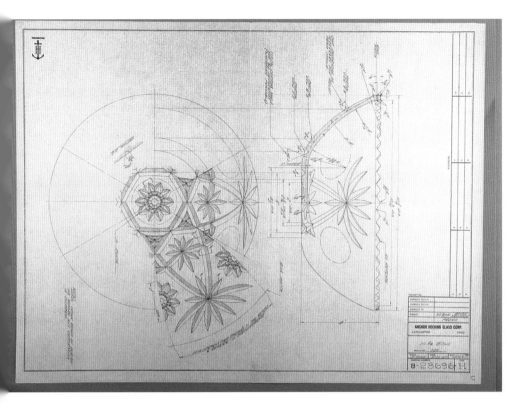

Rare blueprint for the 10 3/4" bowl.

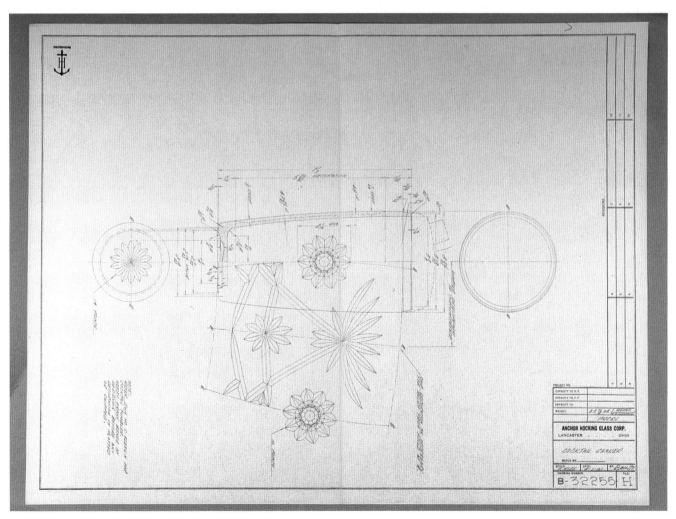

Rare blueprint for the cocktail shaker.

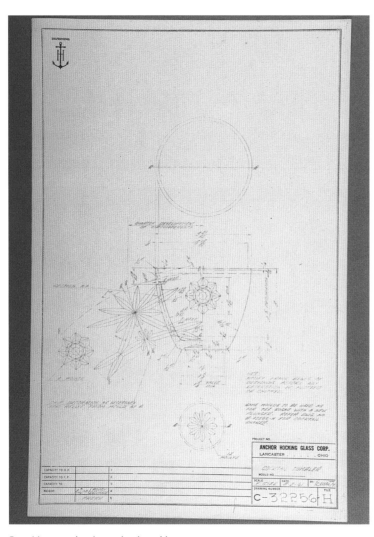

Rare blueprint for the cocktail tumbler.

One of the many rare items on display in the Anchor Hocking Glass Museum. This rare ashtray was made in Laser Blue and only one survives. A similar ashtray in Spicy Brown is also in the museum.

Esprit™

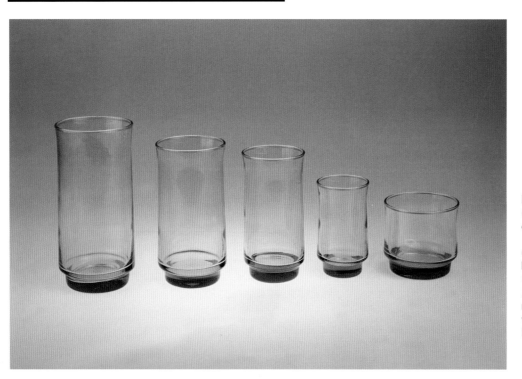

Honey Gold Esprit glasses (1982). Left to right: 25 oz. cooler #N2121, 7", $2-3; 17 oz. iced tea #N2117, 6 1/2", $2-3; 12 1/2 oz. beverage #N2112, 5", $2-3; 6 oz. juice #N2106, 3 1/2", $1-2; 9 oz. on-the-rocks, 3", $1-2. This pattern was also available in Spicy Brown, Slate, and Crystal.

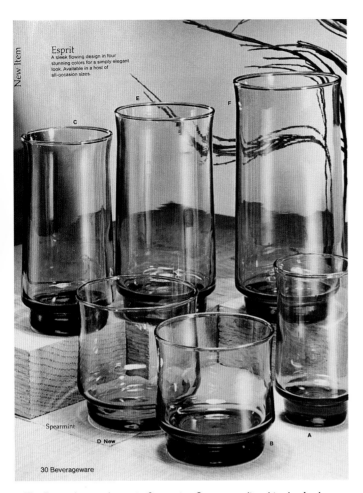

Esprit

photo ret.	description	glass color	BULK order no.	shipper doz. lbs.	price doz.	4 Pc. SETS order no.	shipper sets lbs.	price sets
A	6 oz. juice	New Crystal	2106	2	8	2106C	6	9
		Spearmint	G2106	2	8	G2106C	6	9
		Honey Gold	N2106	2	8	N2106C	6	9
		Spicy Brown	Y2106	2	8	Y2106C	6	9
B	9 oz. on-the-rocks	New Crystal	2109	2	13	2109C	6	14
		Spearmint	G2109	2	13	G2109C	6	14
		Honey Gold	N2109	2	13	N2109C	6	14
		Spicy Brown	Y2109	2	13	Y2109C	6	14
C	12½ oz. beverage	New Crystal	2112	2	16	2112C	6	17
		Spearmint	G2112	2	16	G2112C	6	17
		Honey Gold	N2112	2	16	N2112C	6	17
		Spicy Brown	Y2112	2	16	Y2112C	6	17
D	13 oz. dbl. rocks	New Crystal	2113	2	17	2113C	6	18
		New Spearmint	G2113	2	17	G2113C	6	18
		New Honey Gold	N2113	2	17	N2113C	6	18
		New Spicy Brown	Y2113	2	17	Y2113C	6	18
E	17 oz. iced tea	New Crystal	2117	2	18	2117C	6	20
		Spearmint	G2117	2	18	G2117C	6	20
		Honey Gold	N2117	2	18	N2117C	6	20
		Spicy Brown	Y2117	2	18	Y2117C	6	20
F	25 oz. cooler	New Crystal	2125	1	11			
		Spearmint	G2125	1	11			
		Honey Gold	N2125	1	11			
		Spicy Brown	Y2125	1	11			

4 pc. Full-Vu™ Pack

The Esprit design glasses in Spearmint Green were listed in the *Anchor Hocking 1979 Bulk Catalog* A-24.

The Esprit design glasses in Crystal, Honey Gold, and Spicy Brown were listed in the *Anchor Hocking 1979 Bulk Catalog* A-24.

Eden Park™

Essex™

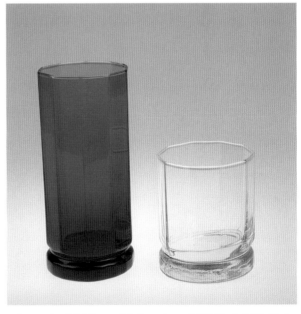

Eden Park 12-piece beverage set #N3000/327 (1985), $30-40 for the complete set, $10-15 for the box only. The set included four 16 oz. iced teas #N3026, 6", $1-2; four 12 1/2 oz. beverage #N3023, 5", $1-2; and four 10 oz. on-the-rocks #N3020, 3 1/2", $1-2. This pattern, listed in the *1985 Designs Catalog*, was also available in Crystal and Caribbean (light pink).

Left to right: 16 1/2 oz. Cobalt iced tea #69365, 6 3/8", $2-4; 9 1/2 oz. Crystal rocks, 3 5/8", $1-2.

71

TUMBLERS

Essex™

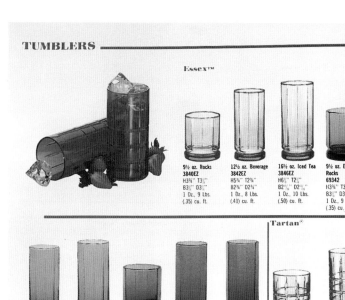

9½ oz. Rocks 3840EZ	12½ oz. Beverage 3842EZ	16½ oz. Iced Tea 3846EZ	9½ oz. Emerald Rocks 69342
H3¾" T3¼"	H5¾" T2¾"	H6" T2⅝"	H3¾" T3¼"
B3⅛" D3¼"	B2¾" D2¾"	B2⅛" D2⅝"	B3⅛" D3¼"
1 Dz., 9 Lbs.	1 Dz., 8 Lbs.	1 Dz., 10 Lbs.	1 Dz., 9 Lbs.
(.35) cu. ft.	(.41) cu. ft.	(.50) cu. ft.	(.35) cu. ft.

Tartan®

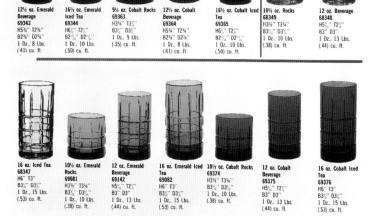

12½ oz. Emerald Beverage 69343	16½ oz. Emerald Iced Tea 69344	9½ oz. Cobalt Rocks 69363	12½ oz. Cobalt Beverage 69364	16½ oz. Cobalt Iced Tea 69365	10½ oz. Rocks 68349	12 oz. Beverage 68348
H5¾" T2¾"	H6" T2⅝"	H3¾" T3¼"	H5¾" T2¾"	H6⅛" T2⅝"	H3½" T3¼"	H5½" T2⅝"
B2¾" D2¾"	B2⅛" D2⅝"	B3⅛" D3¼"	B2¾" D2¾"	B2¼" D2¹¹⁄₁₆"	B3⅛" D3⅛"	B3" D3"
1 Dz., 8 Lbs.	1 Dz., 10 Lbs.	1 Dz., 9 Lbs.	1 Dz., 8 Lbs.	1 Dz., 10 Lbs.	1 Dz., 10 Lbs.	1 Dz., 13 Lbs.
(.41) cu. ft.	(.50) cu. ft.	(.35) cu. ft.	(.41) cu. ft.	(.50) cu. ft.	(.38) cu. ft.	(.44) cu. ft.

16 oz. Iced Tea 68347	10½ oz. Emerald Rocks 69081	12 oz. Emerald Beverage 69142	16 oz. Emerald Iced Tea 69082	10½ oz. Cobalt Rocks 69374	12 oz. Cobalt Beverage 69375	16 oz. Cobalt Iced Tea 69376
H6" T3"	H3½" T3¼"	H5½" T2⅝"	H6" T3"	H3½" T3¼"	H5½" T2⅝"	H6" T3"
B3¼" D3⅛"	B3⅛" D3⅛"	B3" D3"	B3⅛" D3⅛"	B3⅛" D3⅛"	B3" D3"	B3⅛" D3⅛"
1 Dz., 15 Lbs.	1 Dz., 10 Lbs.	1 Dz., 13 Lbs.	1 Dz., 15 Lbs.	1 Dz., 10 Lbs.	1 Dz., 13 Lbs.	1 Dz., 15 Lbs.
(.53) cu. ft.	(.38) cu. ft.	(.44) cu. ft.	(.53) cu. ft.	(.38) cu. ft.	(.44) cu. ft.	(.53) cu. ft.

18

The 1995 *Foodservice Catalog* listed the Essex pattern in Crystal, Emerald, and Cobalt. Only three sizes of glasses were listed.

Fairfield™

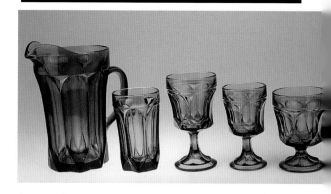

Avocado Green Fairfield glassware. Left to right: 1 1/2 quart pitcher #T1245, $15-20; 10 1/2 oz. beverage #T1211, 5 1/2", $3-4; 10 oz. stemmed goblet #T1209, 6", $3-4; 6 oz. stemmed wine #T1206, 4 1/2", $2-3; 9 oz. stemmed on-the-rocks #T1219, 4", $3-4.

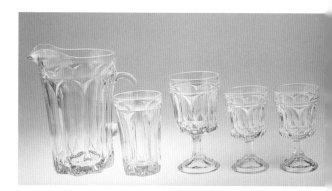

Crystal Fairfield glassware. Left to right: 1 1/2 quart pitcher #1245, $15-20; 10 1/2 oz. beverage #1211, 5 1/2", $3-4; 10 oz. stemmed goblet #1209, 6", $3-4; 6 oz. stemmed wine #1206, 4 1/2", $2-3. I guess we were in such a hurry to get the photo session finished (over 2,000 photographs in three days) that nobody noticed two of the same glasses in this photo. There is an unlisted 6 1/2" goblet (like the Honey Gold goblet) in crystal also.

Honey Gold Fairfield glassware. Left to right: 7 1/2 oz. on-the-rocks #N1208, 3", $1-2; 10 1/2 oz. beverage #N1211, 5 1/2", $3-4; 1 1/2 quart pitcher #N1245, $15-20; unlisted size of stemmed glass, 6 1/2", $25-30; 10 oz. stemmed goblet #N1209, 6", $3-4; 6 oz. stemmed wine #N1206, 4 1/2", $2-3; 9 oz. stemmed on-the-rocks #N1219, 4", $3-4.

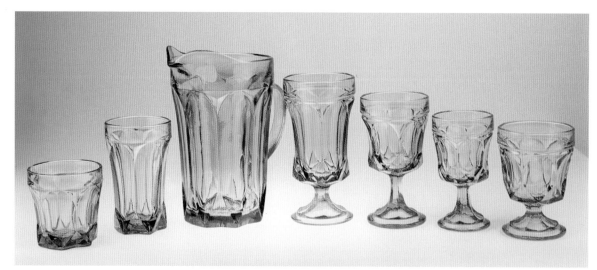

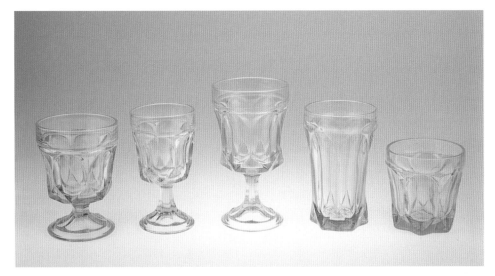

Sky Blue Fairfield glassware. Left to right: 9 oz. stemmed on-the-rocks #F1219, 4", $8-10; 6 oz. stemmed wine #F1206, 4 1/2", $8-10; 10 oz. stemmed goblet #F1209, 6", $10-12; 10 1/2 oz. beverage #F1211, 5 1/2", $12-15; 7 1/2 oz. on-the rocks #F1208, 3", $12-15. No Sky Blue pitcher was listed in the catalogs.

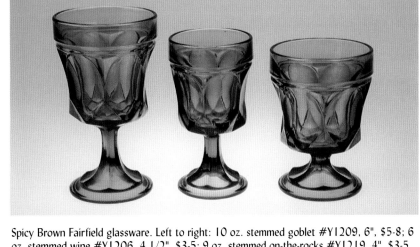

Spicy Brown Fairfield glassware. Left to right: 10 oz. stemmed goblet #Y1209, 6", $5-8; 6 oz. stemmed wine #Y1206, 4 1/2", $3-5; 9 oz. stemmed on-the-rocks #Y1219, 4", $3-5. No Spicy Brown pitcher was listed in the catalogs.

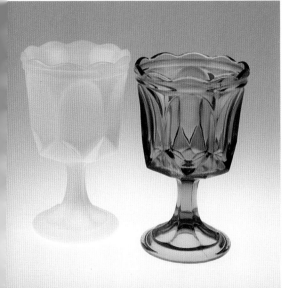

Rare fluted top 10 oz. goblets in Milk White and Spearmint Green, $40-50 for each glass. I also have a rare fluted 6 1/2 oz. sherbet in Avocado Green (not pictured).

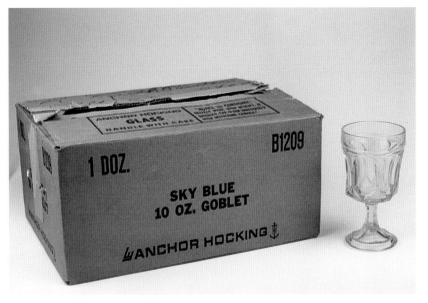

One dozen Sky Blue 10 oz. goblets, $70-80 for the set, $15-20 for the box only.

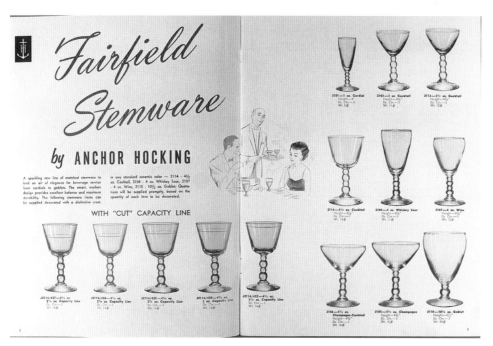

It is interesting to note that, in the early 1960s, Anchor Hocking also used the Fairfield name for some of the institutional glassware. Even earlier, the Fairfield name was first used to denote a line of glasses introduced in 1957 with flashed Forest Green bases.

Fairfield & Georgian

picture ref.	description	glass color	BULK PACKED (BY DOZEN)				ANCHOR PACKED (4 PC. SETS)			
			item order no.	doz. per shipper	lbs. per shipper	price doz.	set order no.	sets per shipper	lbs. per shipper	price per set
	FAIRFIELD									
A	6 oz. stemmed wine	Avocado	T1206	1	8		T1206C	6	17	
		Honey Gold	N1206	1	8		N1206C	6	17	
B	6½ oz. stemmed sherbet	Avocado	T1207	1	9		T1207C	6	19	
		Honey Gold	N1207	1	9		N1207C	6	19	
C	7½ oz. on-the-rocks	Avocado	T1208	1	9		T1208C	6	17	
		Honey Gold	N1208	1	9		N1208C	6	17	
D	9 oz. stemmed on-the-rocks	Avocado	T1219	1	11		T1219C	6	23	
		Honey Gold	N1219	1	11		N1219C	6	23	
E	10 oz. stemmed goblet	Avocado	T1209	1	11		T1209C	6	23	
		Honey Gold	N1209	1	11		N1209C	6	23	
F	10½ oz. beverage	Avocado	T1211	1	11		T1211C	6	21	
		Honey Gold	N1211	1	11		N1211C	6	21	
G	1½ qt. pitcher	Avocado	T1245	½	19					
		Honey Gold	N1245	½	19					
	GEORGIAN									
H	5½ oz. juice	Honey Gold	N46	3	23		N46C	6	16	
I	9 oz. beverage	Avocado	T49	3	32		T49C	6	21	
		Honey Gold	N49	3	32		N49C	6	21	
J	10½ oz. stemmed goblet	Honey Gold	N44	3	32		N44C	6	23	
K	12 oz. beverage	Honey Gold	N48	3	37		N48C	6	26	

NOTE: Blue item number indicates new product and/or packaging.
See index for additional listings of Fairfield and Georgian bulk and gift items.

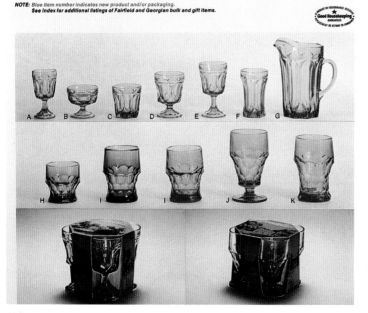

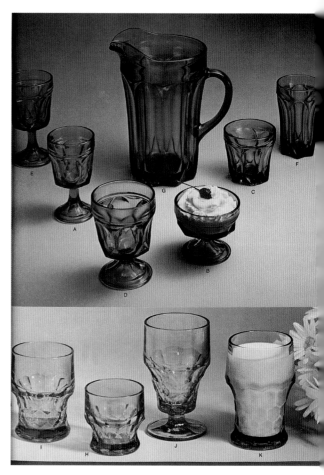

The Fairfield pattern shown in Avocado Green.

No single catalog listed all the Fairfield pattern pieces and colors. The Sky Blue was introduced in a separate catalog published in 1975.

74

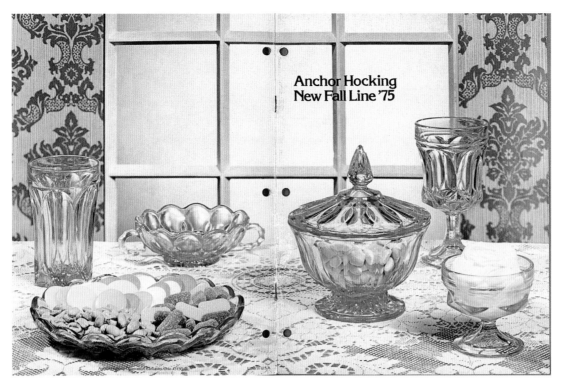

Cover of the 1975 *Fall Line Catalog* showing the Fairfield pattern in *Sky Blue*.

Experimental design Fairfield covered compote. This piece was made in Sapphire Blue, a color that was not produced in quantity for several years. The knob on the lid was redesigned before the pattern was mass-produced. This compote and another made in Cobalt Blue are just a few of the rare Fairfield items on display in the Anchor Hocking Glass Museum.

Rare silver overlay Fairfield plate on display in the Anchor Hocking Glass Museum.

Flair™

The 1976 catalog listed most of the items made in this pattern. Flair was made in Spicy Brown, Avocado Green, Honey Gold, Laser Blue, and Crystal. Eight sizes of glasses, including three stemmed glasses, are shown in the catalog. The stemmed glasses were listed in Honey Gold and Laser Blue only.

Rare flashed Royal Ruby Fairfield bowl mounted on a metal pedestal with a marble base. This is one of the many Fairfield items on pedestals displayed in the museum.

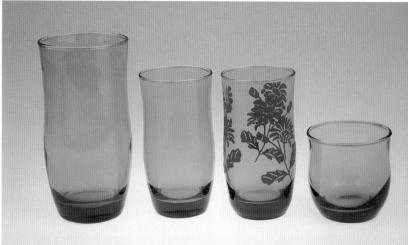

Laser Blue Flair glasses. Left to right: 22 oz. cooler #F3077F, 6 1/2", $3-5; 11 1/2 oz. beverage #F3082F, 5 1/4", $3-4; 11 1/2 oz. beverage #F3082F with applied decoration, 5 1/4", $4-5; 8 oz. on-the-rocks #F3079F, 3", $2-3.

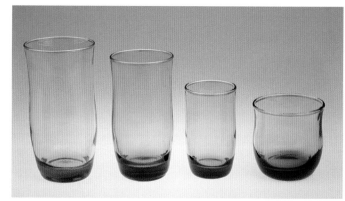

Spicy Brown Flair glasses (1976). Left to right: 15 oz. iced tea #Y3085F, 5 3/4", $3-5; 11 1/2 oz. beverage #Y3082F, 5 1/4", $3-5; 6 oz. juice #Y3076F, 4", $2-3; 8 oz. on-the-rocks #Y3079F, 3", $2-3.

Avocado Green and Honey Gold Flair glasses. Left to right: 15 oz. iced tea #N3085F, 5 3/4", $3-5; 11 1/2 oz. beverage #T3082F, 5 1/4", $3-4; 6 oz. juice #T3076F, 4", $2-3; 8 oz. on-the-rocks #T3079F, 3", $2-3.

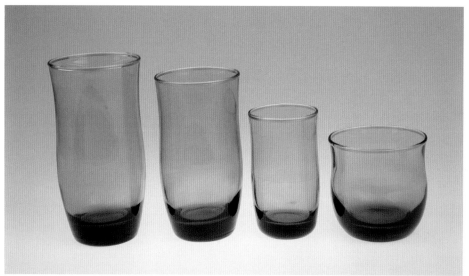

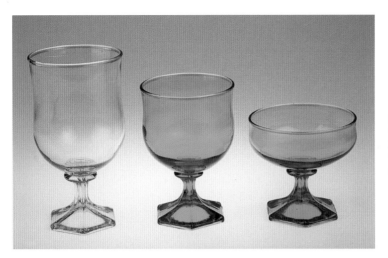

Stemmed Flair glasses are rather hard to find because the stems were easily broken off the glasses. Left to right: 11 1/2 oz. stemmed goblet #N3061, 5 3/4", $8-10; 9 oz. stemmed on-the-rocks/wine, #F3057, 4 1/2", $8-10; 6 1/2 oz. stemmed champagne #N3055, 3 1/2", $8-10.

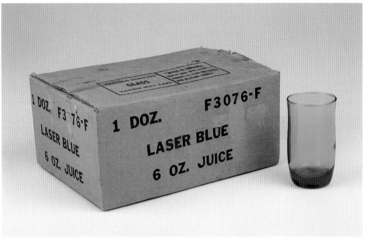

One dozen 6 oz., 4" juice glasses, $30-40 for the set, $8-10 for the box only.

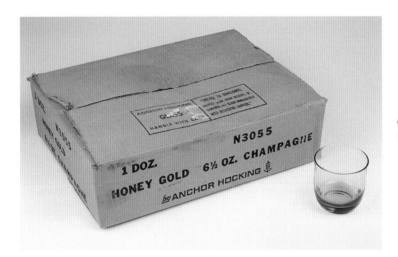

One dozen 6 1/2 oz., 3" champagne glasses, $30-40 for the set, $8-10 for the box only.

Unique set of Laser Blue glasses given out by Mobil Oil Company when they opened a new gas station, $40-50 for the set with the letter from the company, $10-15 for the box only.

Mobil

This is the letter that accompanied the three Laser Blue Flair glasses given as promotional items by Mobil Oil Company.

The 8 oz. on-the-rocks glass was attached to this metal pedestal to make another candleholder, $10-15.

A leather collar and chain were attached to this Flair glass to make a hanging candleholder, $10-15.

picture ref.	description	glass color	BULK PACKED (1 DOZ./SHIPPER)				ANCHOR PACKED (4 PC. SETS)			
			item order no.	doz. per shipper	lbs. per shipper	price doz.	set order no.	sets per shipper	lbs. per shipper	price per set
A	6 oz. juice	Crystal	3076F	1	4		3076C	6	8	
		Avocado	T3076F	1	4		T3076C	6	8	
		Honey Gold	N3076F	1	4		N3076C	6	8	
		Laser Blue	F3076F	1	4		F3076C	6	8	
		Spicy Brown	Y3076F	1	4		Y3076C	6	8	
B	6½ oz. stemmed champagne	Honey Gold	N3055	1	5		N3055C	6	10	
C	8 oz. on-the-rocks	Crystal	3079F	1	6		3079C	6	12	
		Avocado	T3079F	1	6		T3079C	6	12	
		Honey Gold	N3079F	1	6		N3079C	6	12	
		Laser Blue	F3079F	1	6		F3079C	6	12	
		Spicy Brown	Y3079F	1	6		Y3079C	6	12	
D	9 oz. stemmed on-the-rocks/wine	Honey Gold	N3057	1	5		N3057C	6	10	
E	11½ oz. stemmed goblet	Honey Gold	N3061	1	6		N3061C	6	12	
F	11½ oz. beverage	Crystal	3082F	1	6		3082C	6	13	
		Avocado	T3082F	1	6		T3082C	6	13	
		Honey Gold	N3082F	1	6		N3082C	6	13	
		Laser Blue	F3082F	1	6		F3082C	6	13	
		Spicy Brown	Y3082F	1	6		Y3082C	6	13	
G	15 oz. iced tea	Crystal	3085F	1	8		3085C	6	15	
		Avocado	T3085F	1	8		T3085C	6	15	
		Honey Gold	N3085F	1	8		N3085C	6	15	
		Laser Blue	F3085F	1	8		F3085C	6	15	
		Spicy Brown	Y3085F	1	8		Y3085C	6	15	
H	22 oz. cooler	Avocado	T3077F	1	10		T3077C	6	20	
		Laser Blue	F3077F	1	10		F3077C	6	20	
		Spicy Brown	Y3077F	1	10		Y3077C	6	20	

NOTE: Blue item number indicates new product and/or packaging.
See index for additional listing of Flair bulk and gift items.

Flair glasses shown in Honey Gold.

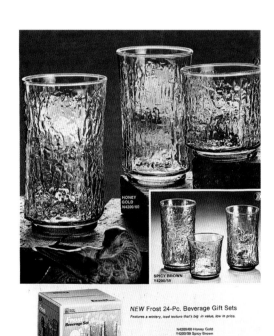

Catalog listing for the Flair pattern. Notice the stemmed glasses were only listed in Honey Gold.

Frost™

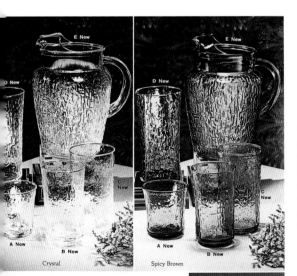

Crystal

Spicy Brown

The 1979 Bulk Catalog A-24 listed Frost in Crystal, Honey Gold, and Spicy Brown. The catalog lists four sizes of glasses and an 86 oz. pitcher.

New Frost

photo ref.	description	glass color	BULK order no.	doz.	price lbs.	4-Pc. SETS order no.	sets	price lbs. sets
A	New 9¼ oz. on-the-rocks	Crystal	4270	3	13	4270C	6	10
		Honey Gold	N4270	3	13	N4270C	6	10
		Spicy Brown	Y4270	3	13	Y4270C	6	10
B	New 13½ oz. beverage	Crystal	4263	3	17	4263C	6	12
		Honey Gold	N4263	3	17	N4263C	6	12
		Spicy Brown	Y4263	3	17	Y4263C	6	12
C	New 17 oz. iced tea	Crystal	4266	3	22	4266C	6	15
		Honey Gold	N4266	3	22	N4266C	6	15
		Spicy Brown	Y4266	3	22	Y4266C	6	15
D	New 24½ oz. cooler	Crystal	4275	3	31	4275C	6	22
		Honey Gold	N4275	3	31	N4275C	6	22
		Spicy Brown	Y4275	3	31	Y4275C	6	22
E	New 82 oz. pitcher	Crystal	4282	½	17			
		Honey Gold	N4282	½	17			
		Spicy Brown	Y4282	½	17			

4 pc. Full-Vu™ Pack

Beverageware 29

HONEY GOLD N4200/60

SPICY BROWN Y4200/59

NEW Frost 24-Pc. Beverage Gift Sets
Features a wintery, iced texture that's big in value, low in price.

N4200/60 Honey Gold
Y4200/59 Spicy Brown
NEW Frost 24-Pc. Set. Includes eight each: 9¼-oz. on-the-rocks, 13½-oz. beverage and 17-oz. iced tea. Set is packaged in a colorful gift carton.
1 set/13 lbs.

28 Beverageware

The Frost pattern was introduced in the 1979 Gift Set Collection catalog. This pattern is reasonably hard to find.

Gemstone™

The Gemstone name was first used in 1967 to describe a completely different design of pitchers and glasses. In 1968, the design was changed but the name was retained. This Gemstone pattern was only listed in the 1968 catalog. The pattern was listed in Honey Gold, Avocado Green, and Aquamarine; however, I have seen the pitcher in Crystal.

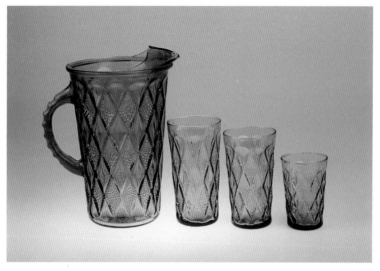

Left to right: Gemstone 70 oz. pitcher #T4270, $20-30; 15 oz. cooler #T4215, 5 7/8", $2-4; 12 oz. beverage #T4212, 5 3/8", $2-4; 6 oz. juice #T4206, 3 7/8", $2-4.

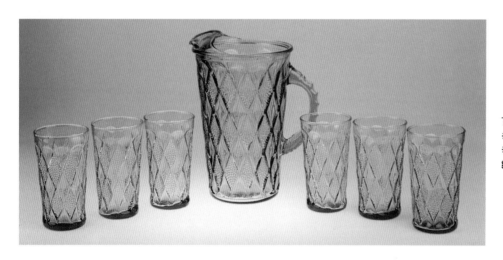

The Gemstone Honey Gold 70 oz. pitcher #N4270, $20-30, with six 12 oz., 5 3/8" #N4212 beverage glasses, $2-4 for each glass.

The Gemstone Aquamarine 70 oz. pitcher #B4270, $25-35, with six 10 oz., 3 3/8" #B4210 on-the-rocks, $3-4 for each glass.

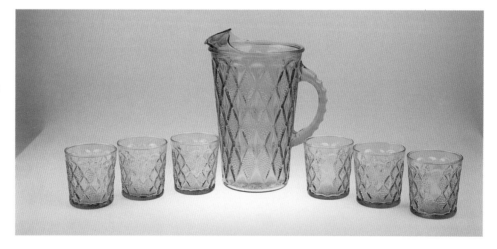

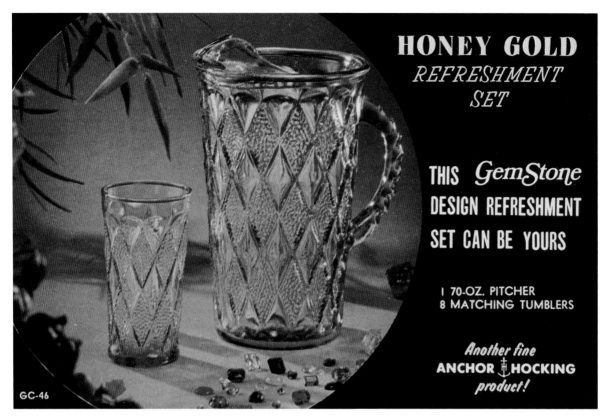

GC-46

Advertisement card introducing the Gemstone pattern, $30-40.

Georgian™

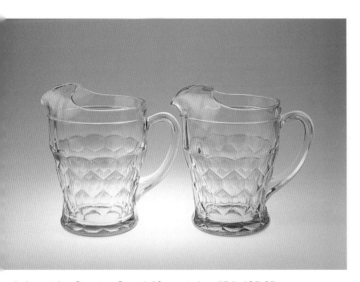

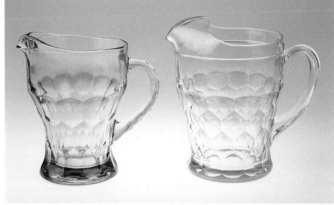

The Honey Gold pitcher on the left was purchased with Honey Gold tumblers marked with the "anchor over H" emblem in the bottom of the glasses. You will notice that the pitcher is much thinner and the handle has some ribbing. Even though the Anchor Hocking catalogs list the pitcher in Honey Gold, they do not show this thinner design. This was either a test design or a set of Anchor Hocking glasses sold with a pitcher from another company.

Left to right: Georgian Crystal 40 oz. pitcher #54, $25-35; green Georgian pitcher, probably made in the late 1940s, $40-50.

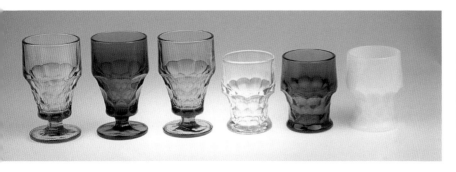

Left to right: Honey Gold 10 1/2 oz. stemmed goblet #N44, 6", $3-4; Slate 10 1/2 oz. stemmed goblet #V44, 6", $3-4; Spearmint 10 1/2 oz. stemmed goblet, 6", $3-4; crystal 9 oz. beverage #49, 4 1/2", $2-3; Slate 9 oz. beverage #V49, 4 1/2", $2-3; Milk White 9 oz. beverage, 4 1/2", $2-3.

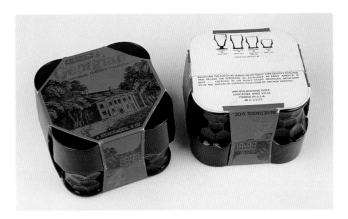

Royal Ruby 9 oz. beverage glasses in 4-packs, $40-50 for each complete set, $5-10 for the container only. These sets were available in the other colors of this pattern. The bottom of the 4-pack listed the sizes available for a particular color.

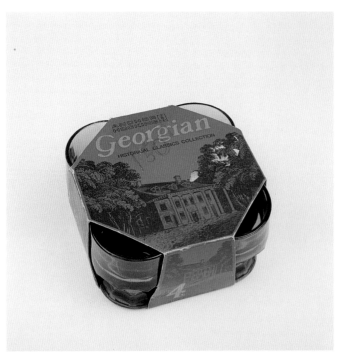

Forest Green 5 1/2 oz. juice glasses in a 4-pack, $30-40 for the complete set, $5-10 for the container only.

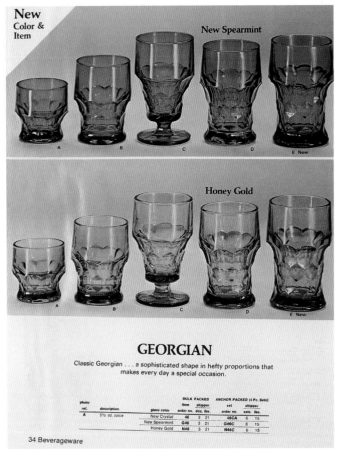

GEORGIAN

Classic Georgian . . . a sophisticated shape in hefty proportions that makes every day a special occasion.

photo ref.	description	glass color	BULK PACKED		ANCHOR PACKED (4 Pc. Sets)	
			item order no.	shipper doz. lbs.	set order no.	shipper sets lbs.
A	5½ oz. juice	New Crystal	46	3 21	46CA	6 15
		New Spearmint	G46	3 21	G46C	6 15
		Honey Gold	N46	3 21	N46C	6 15

34 Beverageware

Catalog listing for the Honey Gold and Spearmint Georgian glasses.

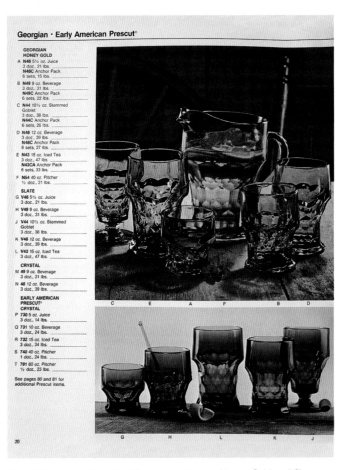

The 1982 catalog listed the Georgian pattern in Honey Gold and Slate.

82

Heritage Hill™

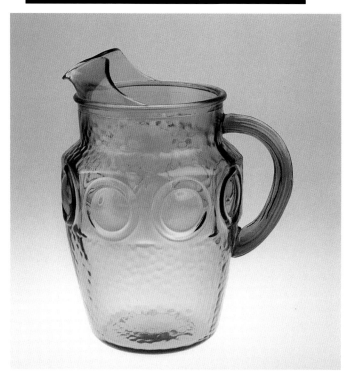

Heritage Hill Avocado Green 82 oz. pitcher #T886 (1976), $20-25.

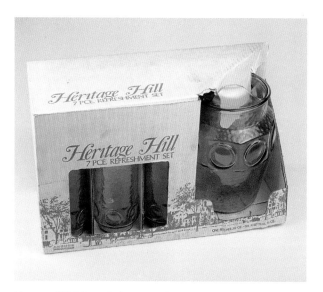

Heritage Hill 7-Piece Refreshment Set, $40-50 for the complete set, $10-15 for the box only.

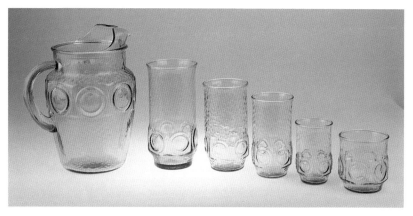

Left to right: Heritage Hill Honey Gold 82 oz. pitcher #N886, $20-25; 25 oz. cooler #N825, 7", $3-4; 16 oz. iced tea #N816, 6 1/2", $3-4; 11 1/2 oz. beverage #N811, 4 3/4", $2-3; 6 oz. juice #N806, 3 1/2", $2-3; 9 oz. on-the-rocks #N809, 3", $2-3.

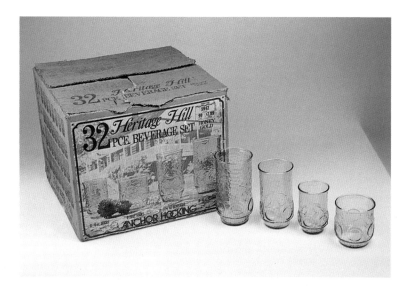

Heritage Hill 32-Piece Beverage Set, $50-60 for the complete set, $10-15 for the box only. This set contains eight 16 oz. iced tea #N816, 6 1/2", $3-4; eight 11 1/2 oz. beverage #N811, 4 3/4", $2-3; eight 6 oz. juice #N806, 3 1/2", $2-3, and eight 9 oz. on-the-rocks #N809, 3", $2-3.

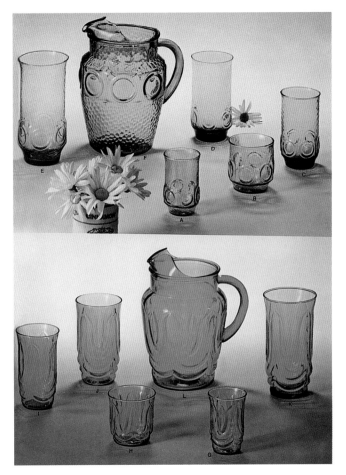

Heritage Hill & Colonial Tulip

picture ref.	description	glass color	BULK PACKED (BY DOZEN)				ANCHOR PACKED (4 PC. SETS)			
			item order no.	doz. per shipper	lbs. per shipper	price doz.	set order no.	sets per shipper	lbs. per shipper	price per set
	HERITAGE HILL									
A	6 oz. juice	Avocado	T806	6	24		T806C	6	8	
		Honey Gold	N806	6	24		N806C	6	8	
B	9 oz. on-the-rocks	Avocado	T809	6	24		T809C	6	8	
		Honey Gold	N809	6	24		N809C	6	8	
C	11½ oz. beverage	Avocado	T811	6	33		T811C	6	11	
		Honey Gold	N811	6	33		N811C	6	11	
D	16 oz. iced tea	Avocado	T816	3	20		T816C	6	14	
		Honey Gold	N816	3	20		N816C	6	14	
E	25 oz. cooler	Avocado	T825	1	11		T825C	6	22	
		Honey Gold	N825	1	11		N825C	6	22	
F	82 oz. pitcher	Avocado	T886	½	17					
		Honey Gold	N886	½	17					
	COLONIAL TULIP									
G	6 oz. juice	Avocado	T4406	6	24		T4406C	6	8	
		Laser Blue	F4406	6	24		F4406C	6	8	
H	8½ oz. on-the-rocks	Avocado	T4408	6	24		T4408C	6	9	
		Laser Blue	F4408	6	24		F4408C	6	9	
I	12 oz. beverage	Avocado	T4412	6	25		T4412C	6	10	
		Laser Blue	F4412	6	25		F4412C	6	10	
J	16 oz. iced tea	Avocado	T4415	3	18		T4415C	6	14	
		Laser Blue	F4415	3	18		F4415C	6	14	
K	25 oz. cooler	Avocado	T4425	1	11		T4425C	6	21	
		Laser Blue	F4425	1	11		F4425C	6	21	
L	82 oz. pitcher	Avocado	T4486	½	17					
		Laser Blue	F4486	½	17					

NOTE: Blue item number indicates new product and/or packaging. **See index for additional listings of Colonial Tulip gift items.**

The Heritage Hill pitcher and glasses in Avocado Green.

The catalog only lists Heritage Hill in Honey Gold and Avocado Green.

Hickory™

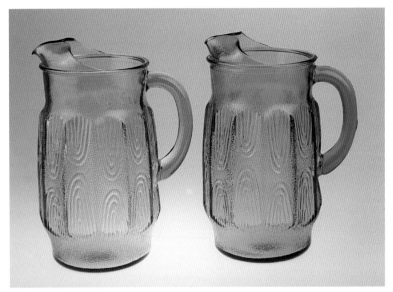

Hickory pitchers (1978). Left to right: Honey Gold 74 oz. pitcher #N4174, $25-30; Spearmint 74 oz. pitcher #G4174, $25-30.

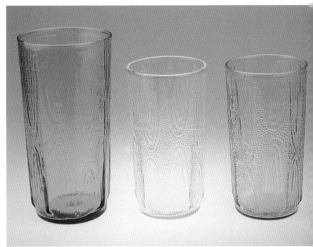

Left to right: Spearmint 25 oz. cooler #G4125, 6 1/2", $5-8; Crystal 12 1/2 oz. beverage #4122, 6", $5-8; Honey Gold 12 1/2 oz. beverage #N4122, 6", $5-8.

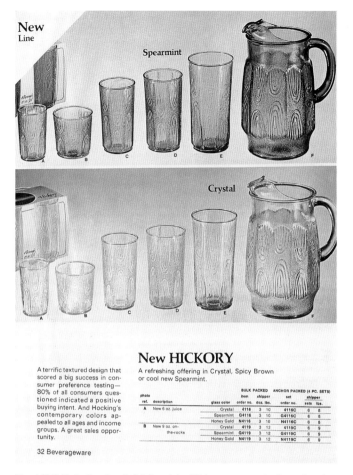

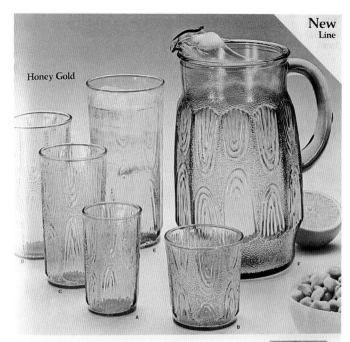

New HICKORY

A terrific textured design that scored a big success in consumer preference testing— 80% of all consumers questioned indicated a positive buying intent. And Hocking's contemporary colors appealed to all ages and income groups. A great sales opportunity.

32 Beverageware

A refreshing offering in Crystal, Spicy Brown or cool new Spearmint.

photo ref.	description	glass color	BULK PACKED item order no.	doz.	lbs.	ANCHOR PACKED (4 PC. SETS) set order no.	sets	lbs.
A	New 6 oz. juice	Crystal	4116	3	10	4116C	6	8
		Spearmint	G4116	3	10	G4116C	6	8
		Honey Gold	N4116	3	10	N4116C	6	8
B	New 9 oz. on-the-rocks	Crystal	4119	3	12	4119C	6	9
		Spearmint	G4119	3	12	G4119C	6	9
		Honey Gold	N4119	3	12	N4119C	6	9

photo ref.	description	glass color	BULK PACKED item order no.	shipper doz.	lbs.	ANCHOR PACKED (4 PC. SETS) set order no.	shipper sets	lbs.
C	New 12½ oz. beverage	Crystal	4122	3	17	4122C	6	13
		Spearmint	G4122	3	17	G4122C	6	13
		Honey Gold	N4122	3	17	N4122C	6	13
D	New 16 oz. iced tea	Crystal	4126	3	19	4126C	6	15
		Spearmint	G4126	3	19	G4126C	6	15
		Honey Gold	N4126	3	19	N4126C	6	15
		Profit-Pac/Honey Gold				N4126E	6	38
E	New 25 oz. cooler	Crystal	4125	2	20	4125C	6	22
		Spearmint	G4125	2	20	G4125C	6	22
		Honey Gold	N4125	2	20	N4125C	6	22
		Profit-Pac/Honey Gold				N4125E	4	40
F	New 74 oz. pitcher	Crystal	4174	½	21			
		Spearmint	G4174	½	21			
		Honey Gold	N4174	½	21			

Profit-Pac.
Convenient idea for easy display

Beverageware 33

The *1979 Bulk Catalog* A-24 listed the Hickory pattern in Crystal and Spearmint. You will notice that there are five sizes of glasses available in this pattern. I have found that the glasses are extremely hard to find.

The *1979 Bulk Catalog* A-24 also listed the Hickory pattern in Honey Gold.

Hobnail™

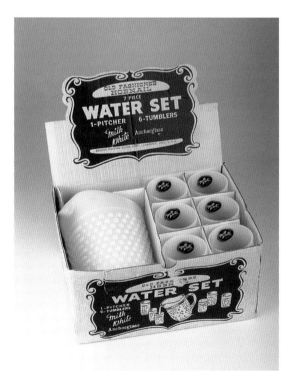

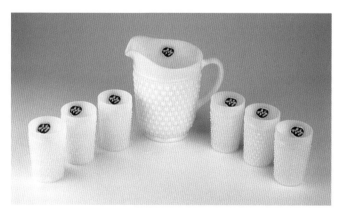

The Hobnail Water Set included one 72 oz. pitcher, $15-20, with six 12 oz. tumblers, 4 3/4", $3-4 for each glass.

Hobnail Water Set, $40-50 for the complete set, $10-15 for the box only.

85

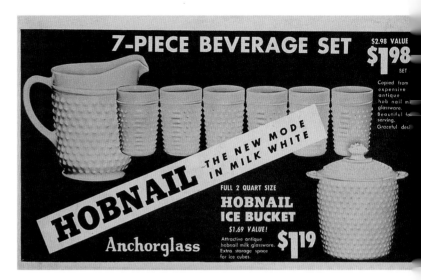

Another box variety of the Hobnail 7-Piece Water Set, $40-50 for the complete set, $10-15 for the box only.

Rare advertisement for Hobnail glassware.

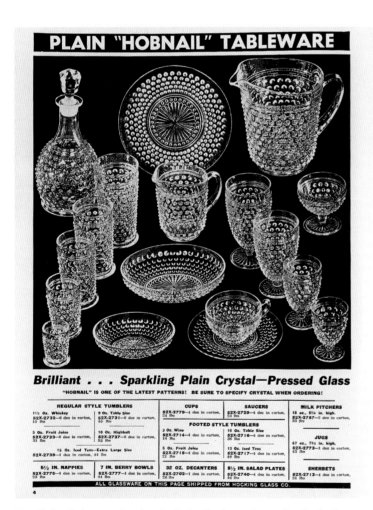

PLAIN "HOBNAIL" TABLEWARE

Brilliant . . . Sparkling Plain Crystal—Pressed Glass

"HOBNAIL" IS ONE OF THE LATEST PATTERNS! BE SURE TO SPECIFY CRYSTAL WHEN ORDERING!

REGULAR STYLE TUMBLERS	CUPS	SAUCERS	MILK PITCHERS	
1½ Oz. Whiskey	9 Oz. Table Size			
52X-2732—6 doz in carton, 16 lbs	52X-2731—6 doz in carton, 45 lbs	52X-2779—4 doz in carton, 24 lbs	52X-2729—6 doz in carton, 23 lbs	5½ in. high, 52X-2737—2 doz in carton, 39 lbs
FOOTED STYLE TUMBLERS				
5 Oz. Fruit Juice	10 Oz. Highball	3 Oz. Wine	10 Oz. Table Size	JUGS
52X-2733—6 doz in carton, 31 lbs	52X-2737—6 doz in carton, 53 lbs	52X-2714—4 doz in carton, 14 lbs	52X-2716—4 doz in carton, 36 lbs	67 oz., 7¾ in. high, 52X-2773—1 doz in carton, 45 lbs
15 Oz. Iced Teas—Extra Large Size	5 Oz. Fruit Juice	13 Oz. Iced Teas		
52X-2739—4 doz in carton, 44 lbs	52X-2715—4 doz in carton, 21 lbs	52X-2717—4 doz in carton, 40 lbs		
6½ IN. NAPPIES	7 IN. BERRY BOWLS	32 OZ. DECANTERS	8½ IN. SALAD PLATES	SHERBETS
52X-2775—4 doz in carton, 23 lbs	52X-2777—4 doz in carton, 44 lbs	52X-2702—1 doz in carton, 26 lbs	52X-2740—4 doz in carton, 34 lbs	52X-2713—4 doz in carton, 24 lbs

ALL GLASSWARE ON THIS PAGE SHIPPED FROM HOCKING GLASS CO.

Plain Hobnail glassware listed in the Butler Brothers sales catalog for Anchor Hocking and Standard Glass Mfg. Company glass.

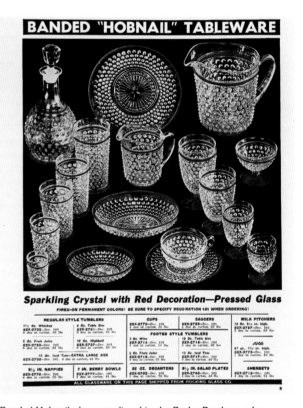

BANDED "HOBNAIL" TABLEWARE

Sparkling Crystal with Red Decoration—Pressed Glass

FIRED-ON PERMANENT COLORS! BE SURE TO SPECIFY DECORATION 101 WHEN ORDERING!

REGULAR STYLE TUMBLERS	CUPS	SAUCERS	MILK PITCHERS	
1½ Oz. Whiskey	9 Oz. Table Size	52X-2779—101	52X-2729—101	16 Oz., 5½ in. high,
52X-2732—101 6 doz in carton, 16 lbs	52X-2731—101 6 doz in carton, 45 lbs	4 doz in carton, 24 lbs	6 doz in carton, 23 lbs	52X-2737—101 2 doz in carton, 39 lbs
FOOTED STYLE TUMBLERS				
5 Oz. Fruit Juice	10 Oz. Highball	3 Oz. Wine	10 Oz. Table Size	JUGS
52X-2733—101 6 doz in carton, 31 lbs	52X-2737—101 6 doz in carton, 53 lbs	52X-2714—101 4 doz in carton, 14 lbs	52X-2716—101 4 doz in carton, 36 lbs	67 oz., 7¾ in. high, 52X-2773—101 1 doz in carton, 45 lbs
15 Oz. Iced Teas—Extra Large Size	5 Oz. Fruit Juice	13 Oz. Iced Teas		
52X-2739—101 4 doz in carton, 44 lbs	52X-2715—101 4 doz in carton, 21 lbs	52X-2717—101 4 doz in carton, 40 lbs		
5½ IN. NAPPIES	7 IN. BERRY BOWLS	32 OZ. DECANTERS	8½ IN. SALAD PLATES	SHERBETS
52X-2775—101 4 doz in carton, 23 lbs	52X-2777—101 4 doz in carton, 44 lbs	52X-2702—101 1 doz in carton, 26 lbs	52X-2740—101 4 doz in carton, 34 lbs	52X-2713—101 4 doz in carton, 24 lbs

ALL GLASSWARE ON THIS PAGE SHIPPED FROM HOCKING GLASS CO.

Banded Hobnail glassware listed in the Butler Brothers sales catalog for Anchor Hocking and Standard Glass Mfg. Company glass.

Rare blueprint for the 9 oz. tumbler.

Rare blueprint for the jardinere.

Rare blueprint for the pitcher.

Honeycomb™

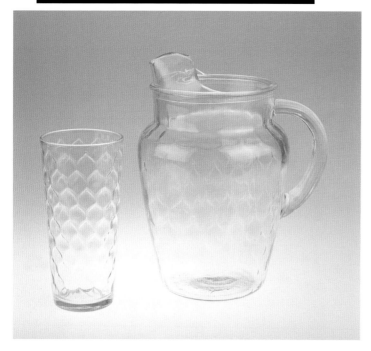

The pattern was also available in Crystal. Left to right: 16 oz. iced tea #826, 6 1/2", $4-5; 82 oz. pitcher #887, $20-25. It is interesting to note that the capacity of the pitcher is listed as only 82 ounces when earlier pitchers of this same style were listed as having a capacity of 86 ounces.

The Honeycomb pattern was only available with two sizes of glasses. Left to right: 23 oz. cooler #N833, 6 1/2", $4-5; 16 oz. iced tea #N826, 6 1/2", $4-5.

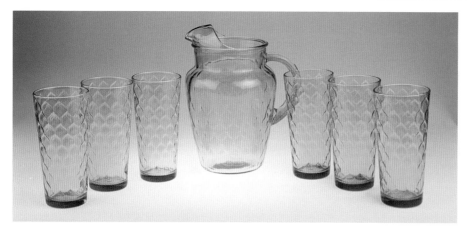

The Honeycomb Honey Gold 82 oz. pitcher #N887 (1982), $20-25, with six 6 1/2", 16 oz. #N826 iced teas, $4-5 for each glass.

Jubilee™

The Jubilee pattern was listed in the 1967 and 1968 catalogs in Avocado Green, Honey Gold, and Crystal. It was not listed in Laser Blue. The two sizes of glasses were made for years and listed in several catalogs in Crystal only. The Crystal glasses were called Quenchers and not called Jubilee.

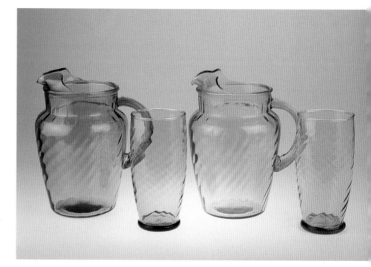

Left to right: Avocado Green Jubilee 86 oz. pitcher, $20-25; 25 oz. cooler #T3374, 8", $5-8; Honey Gold Jubilee 86 oz. pitcher, $20-25; 25 oz. cooler #N3374, 8", $5-8;

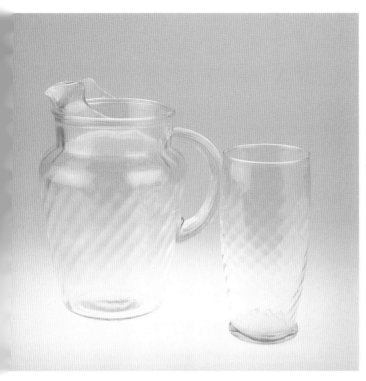

Crystal Jubilee 86 oz. pitcher, #20-25; 25 oz. cooler #3374, 8", $5-8.

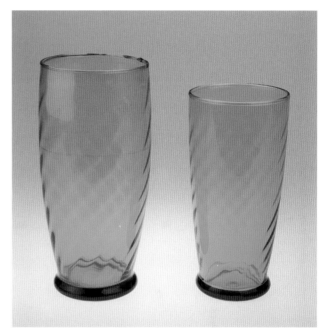

Left to right: Laser Blue 25 oz. cooler #F3374, 8", $8-10; 16 oz. iced tea #F3372, 7", $8-10.

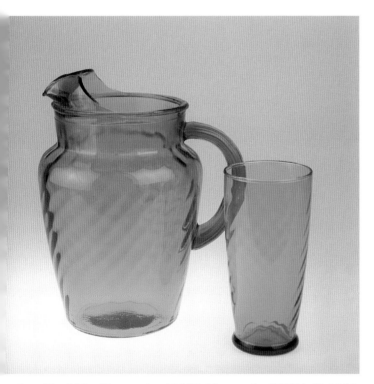

Laser Blue Jubilee 86 oz. pitcher, $30-35; 25 oz. cooler #F3374, 8", $8-10.

The Jubilee Laser Blue 7-Piece Refreshment Set with one 86 oz. pitcher, $30-35, and six 25 oz. coolers #F3374, 8", $8-10 for each glass.

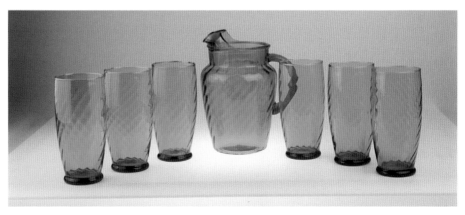

La Reine™

La Reine stemware was listed in the 1964 catalog.

27

La Reine stemware

brand new; distinctive service for all beverages

The catalog listed twenty-three different·La Reine glasses, $1-2 for each glass.

2475	¾ oz cordial · 3 dz/shipper/6 lbs	2.55 dz	**pillar packs · 4 pc sets**
2401	1 oz cordial · 3 dz/shipper/8 lbs	2.55 dz	
2402	2 oz brandy · 3 dz/shipper/9 lbs	2.55 dz	
2412	2 oz sherry · 3 dz/shipper/9 lbs	2.55 dz	
2403	3 oz cocktail · 3 dz/shipper/14 lbs	2.55 dz	
2413	3½ oz cocktail · 3 dz/shipper/14 lbs	2.55 dz	
2414	3½ oz cocktail · 3 dz/shipper/14 lbs	2.55 dz	
2445	4½ oz cocktail · 3 dz/shipper/16 lbs	2.55 dz	
2404	4 oz whiskey sour · 3 dz/shipper/13 lbs	2.55 dz	
2407	7 oz on the rocks · 3 dz/shipper/21 lbs	2.55 dz	
2415	5½ oz sherbet · 3 dz/shipper/14 lbs	2.55 dz	
2424	4 oz wine · 3 dz/shipper/13 lbs	2.55 dz	
2406	6 oz wine · 3 dz/shipper/16 lbs	2.55 dz	
2418	8 oz wine · 3 dz/shipper/20 lbs	2.55 dz	
2446	4½ oz champagne/cocktail · 3 dz/shipper/18 lbs	2.55 dz	
2405	5½ oz champagne · 3 dz/shipper/17 lbs	2.55 dz	
2411	10½ oz goblet · 3 dz/shipper/17 lbs	2.55 dz	
2425	5¼ oz parfait · 3 dz/shipper/13 lbs	2.55 dz	
2417	7 oz beer goblet · 3 dz/shipper/21 lbs	2.55 dz	
2408	8 oz beer goblet · 3 dz/shipper/22 lbs	2.55 dz	
2409	9 oz beer goblet · 3 dz/shipper/23 lbs	2.55 dz	
2410	10 oz beer goblet · 3 dz/shipper/24 lbs	2.55 dz	
2490	15 oz beer goblet · 3 dz/shipper/23 lbs	2.55 dz	

pillar packs · 4 pc sets

2401-D	1 oz cordial · 6 sets/shipper/4 lbs	.95 set
2404-D	4 oz whiskey sour · 6 sets/shipper/9 lbs	.95 set
2446-D	4½ oz champagne/cocktail · 6 sets/shipper/12 lbs	.95 set
2405-D	5½ oz champagne · 6 sets/shipper/12 lbs	.95 set
2424-D	4 oz wine · 6 sets/shipper/9 lbs	.95 set
2407-D	7 oz on the rocks · 6 sets/shipper/15 lbs	.95 set
2445-D	4½ oz cocktail · 6 sets/shipper/11 lbs	.95 set
2425-D	5½ oz parfait · 6 sets/shipper/9 lbs	.95 set
2411-D	10½ oz goblet · 6 sets/shipper/12 lbs	.95 set

home bar line · 8 pc sets · air cell gift ctn

2401-E	1 oz cordial · 4 sets/shipper/9 lbs	1.80 set
2404-E	4 oz whiskey sour · 4 sets/shipper/14 lbs	1.80 set
2445-E	4½ oz cocktail · 4 sets/shipper/17 lbs	1.80 set
2405-E	5½ oz champagne · 4 sets/shipper/19 lbs	1.80 set
2407-E	7 oz on the rocks · 4 sets/shipper/19 lbs	1.80 set
2411-E	10½ oz goblet · 4 sets/shipper/21 lbs	1.80 set
2425-E	5¼ oz parfait · 4 sets/shipper/17 lbs	1.80 set
2424-E	4 oz wine · 4 sets/shipper/15 lbs	1.80 set
2406-E	6 oz wine · 4 sets/shipper/16 lbs	1.80 set
2410-E	10 oz beer goblet · 4 sets/shipper/27 lbs	1.80 set
2490-E	15 oz beer goblet · 4 sets/shipper/25 lbs	1.80 set

26

Live It Up™

The Live It Up 20-Piece Refreshment Set in Sapphire Blue contained ten 12 oz., 5" beverage glasses and ten 16 oz., 5 7/8" iced teas. The set also included a 64 oz. pitcher as a bonus.

Left to right: 12 oz. beverage glass, 5", $1-2; 16 oz. iced tea, 5 7/8", $1-2; 64 oz. pitcher, $5-8.

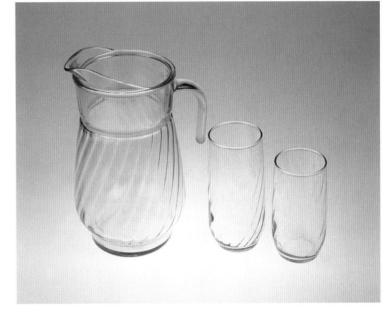

Madrid™

This was the name that was applied to two totally different patterns. The Madrid name was first applied to a pattern made during the 1930s by the Federal Glass Company. Later, when the pattern was listed in the 1971 catalog, the name was resurrected by Anchor Hocking and applied to the glassware below.

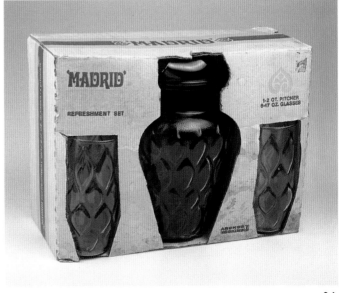

The 7-Piece Refreshment Set in Avocado Green, $40-50 for the complete set, $10-15 for the box only.

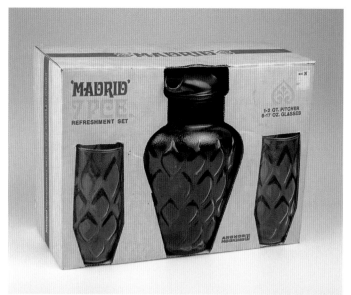

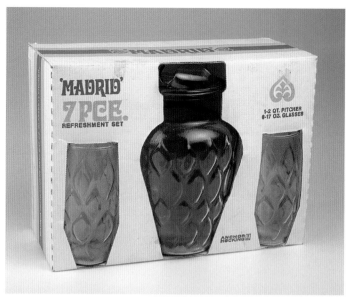

The 7-Piece Refreshment Set in Laser Blue, $40-50 for the complete set, $10-15 for the box only.

The 7-Piece Refreshment Set in Honey Gold, $40-50 for the complete set, $10-15 for the box only.

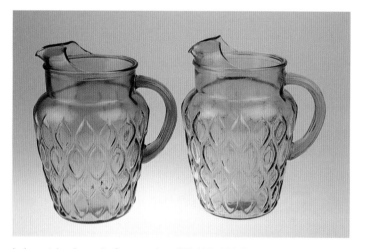

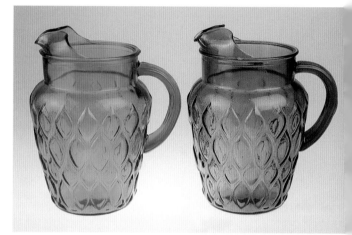

Left to right: Avocado Green pitcher #T1485, $20-25; Honey Gold pitcher #N1485, $30-40.

Left to right: Laser Blue pitcher #F1485, $20-25; Spicy Brown pitcher #Y1485, $40-50.

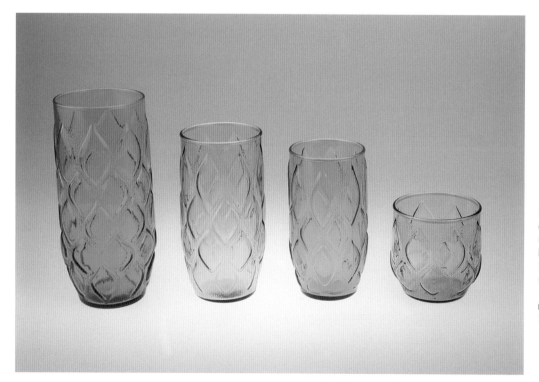

Left to right: 25 oz. cooler #F1435G, 6 1/2", $3-5; 17 oz. iced tea #T1427, 6", $2-3; 13 oz. beverage #F1423, 5", $2-3; 10 oz. double on-the-rocks #Y1420, 3 1/2", $3-5.

Milano™/Lido™

Lido

description	glass color	BULK PACKED (BY DOZEN)				ANCHOR PACKED (4 PC. SETS)			
		item order no.	doz. per shipper	lbs. per shipper	price doz.	set order no.	sets per shipper	lbs. per shipper	price per set
5 oz. juice	Avocado	T4005	3	11		T4005CD	6	8	
	Honey Gold	N4005	3	11		N4005CD	6	8	
	Laser Blue	F4005	3	11		F4005CD	6	8	
8 oz. on-the-rocks	Avocado	T4007	3	16		T4007CD	6	11	
	Honey Gold	N4007	3	16		N4007CD	6	11	
	Laser Blue	F4007	3	16		F4007CD	6	11	
12 oz. beverage	Avocado	T4012	3	22		T4012CD	6	15	
	Honey Gold	N4012	3	22		N4012CD	6	15	
	Laser Blue	F4012	3	22		F4012CD	6	15	
15 oz. iced tea	Avocado	T4015	3	25		T4015CD	6	18	
	Honey Gold	N4015	3	25		N4015CD	6	18	
	Laser Blue	F4015	3	25		F4015CD	6	18	
22 oz. cooler	Avocado	T4032	2	22					
	Honey Gold	N4032	2	22					
3 qt. ice lip pitcher	Avocado	T4087	½	19					
	Honey Gold	N4087	½	19					
	Laser Blue	F4087	½	19					

*: See Index for additional listings of Lido gift items.

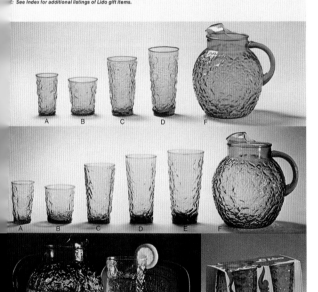

The catalogs list many colors of Lido glassware, but no one catalog lists all the colors or sizes of glasses.

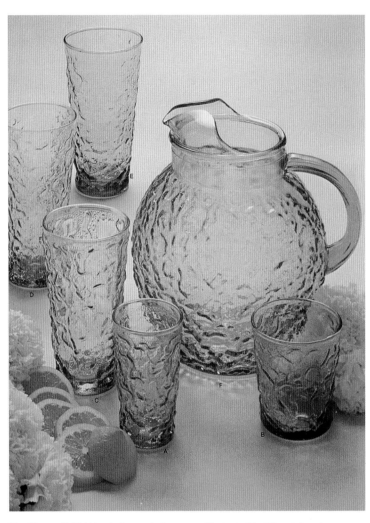

The Honey Gold Lido pitcher and glasses are illustrated in this catalog; however, it does not list the four sizes of stemmed glasses or three sizes of on-the-rocks.

Rare advertising proof for Desert Gold Lido glassware. The Desert Gold color was given away at Phillips 66 gas stations, the Avocado Green given away at financial institutions, and the Forest Green by restaurants.

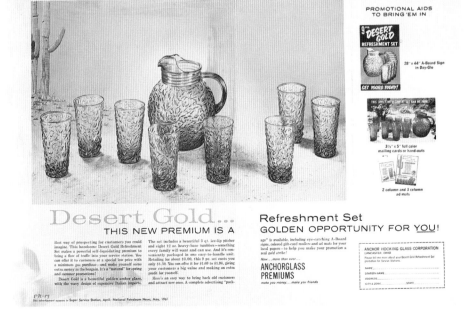

The 7-Piece Refreshment Set #N4000/71 in Honey Gold, $30-35 for the entire set, $5-10 for the box only.

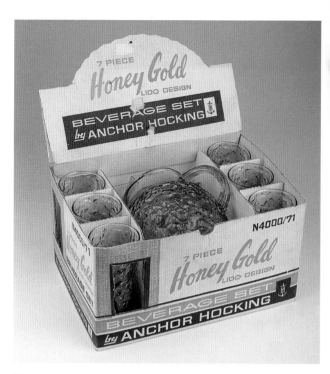

The 7-Piece Refreshment Set in Honey Gold, $30-35 for the entire set, $5-10 for the box only. The top of the box was made to fold and be used to advertise the set in the stores.

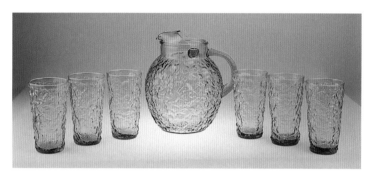

The 7-Piece Refreshment Set included one 3 qt. ice lip pitcher #N4087 with six 12 oz., 5 1/2" beverage glasses #N4012, $15-20 for the pitcher, $2-4 for each glass.

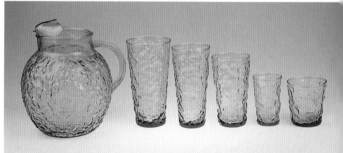

The pitcher and five sizes of tapered glasses made in the Milano/Lido pattern. Left to right: 3 qt. ice lip pitcher #N4087, $15-20; 22 oz. cooler #N4013, 6 7/8", $2-4; 15 oz. iced tea #N4015, 6 3/8", $2-4; 12 oz. beverage #N4012, 5 1/2", $2-3; 5 oz. juice #N4005, 3 7/8", $1-2; 8 oz. on-the-rocks #N4007, 3 3/8", $1-2.

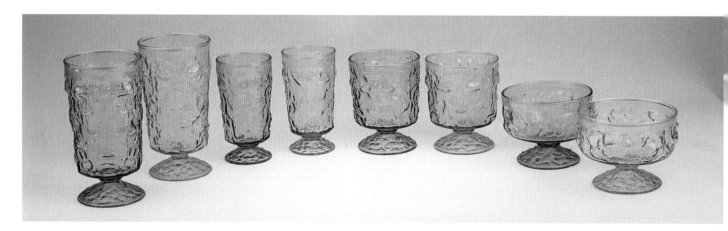

Stemmed glasses were also produced in this pattern in four sizes and three colors. Here are the four sizes in Avocado Green and Honey Gold. Left to right (by size): 12 oz. tumbler, 5 1/2", $8-10 for each color; 6 oz. juice, 4 1/2", $6-8 for each color; 9 oz. on-the-rocks, 3 3/8", $6-8 for each color; 7 oz. sherbet/champagne, 3", $5-6 for each color.

Here are the three colors produced in the stemmed glassware: Avocado Green, Honey Gold, and Aquamarine. The Aquamarine color is harder to find and more popular, therefore the glasses would command a fifty percent greater price that the other colors.

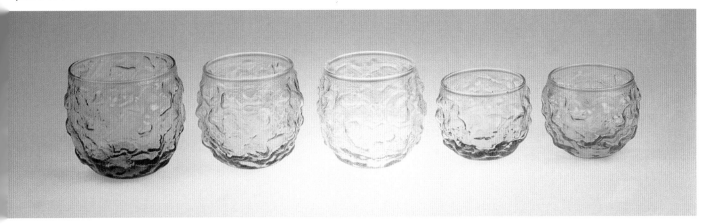

There were also three sizes and four colors produced in the Roly Poly style glass. Left to right (by size): 14 oz. double on-the-rocks, 3 1/4", $1-2; 10 oz. on-the-rocks, 3", $1-2; 6 oz. cocktail, 2 3/8", $1-2. The Aquamarine colored glasses would also command a fifty percent increase in price.

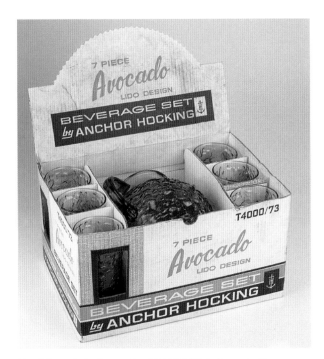

The 7-Piece Refreshment Set #T4000/73 in Avocado Green, $30-35 for the entire set, $5-10 for the box only.

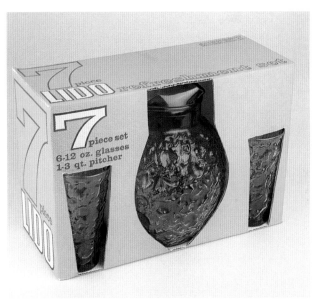

The 7-Piece Refreshment Set #T4000/73 in Avocado Green, $30-35 for the entire set, $5-10 for the box only. This was a later design of box that was introduced in the early 1970s.

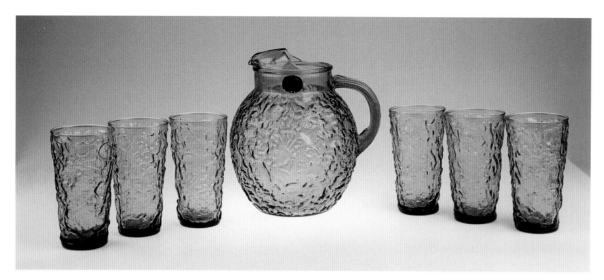

The 7-Piece Refreshment Set included one 3 qt. ice lip pitcher #T4087 with six 12 oz., 5 1/2" tumblers #T4012, $15-20 for the pitcher, $2-4 for each glass.

Close-up of the Avocado Green label placed on the pitcher. I have never found labels on any of the sizes or colors of glasses. In the first years of production of this pattern, the company sold the 9-Piece Refreshment Set #4000/41. The set was called "Crystal Ice" and contained eight 12 oz. glasses marked with the familiar "anchor over H" emblem.

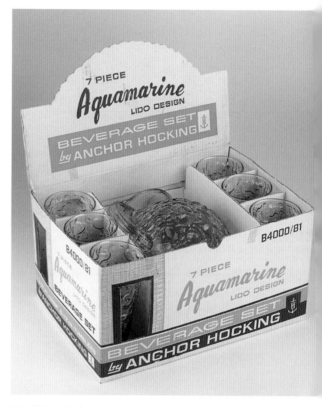

The 7-Piece Refreshment Set #B4000/81 in Aquamarine, $50-60 for the entire set, $5-10 for the box only.

The 7-Piece Refreshment Set in Aquamarine included one 3 qt. ice lip pitcher #B4087 with six 12 oz., 5 1/2" beverages #B4012-N, $20-30 for the pitcher, $5-8 for each glass.

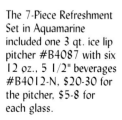

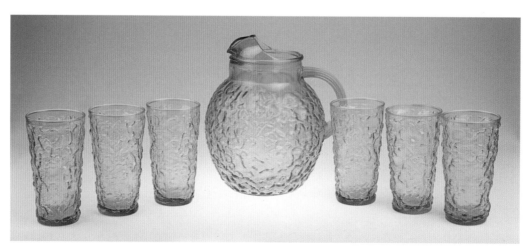

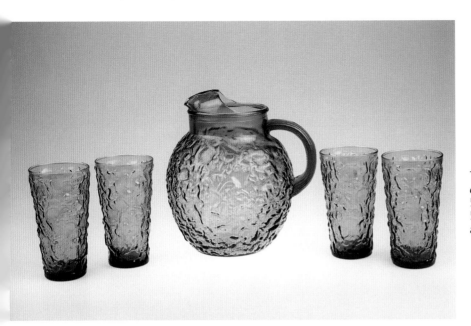

The 7-Piece Refreshment Set in Spicy Brown included one 3 qt. ice lip pitcher #Y4087 with six 12 oz., 5 1/2" beverages #Y4012 (only four shown), $40-50 for the pitcher, $8-10 for each glass. This color and Laser Blue are relatively hard to find.

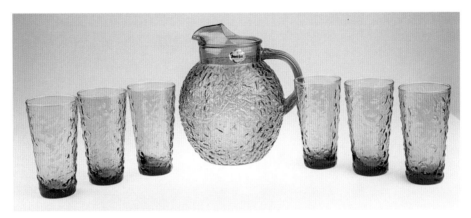

The 7-Piece Refreshment Set in Desert Gold included one 3 qt. ice lip pitcher with six 12 oz., 5 1/2" beverages, $25-30 for the pitcher, $5-8 for each glass.

Close-up of the Desert Gold label placed on the pitcher.

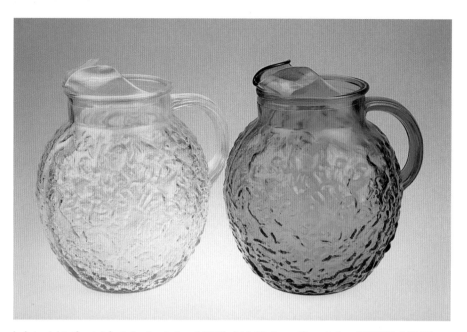

Left to right: Crystal 3 qt. ice lip pitcher #4087, $15-20; Laser Blue pitcher #F4087, $40-50.

Eight piece set of 15 oz., 6 3/8" iced teas, $40-50 for the complete set, $5-10 for the box only.

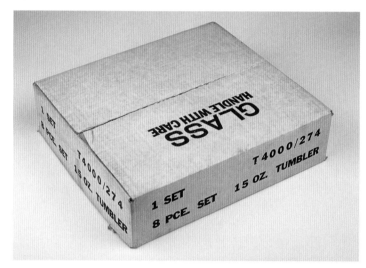

Box open to show the arrangement of the tumblers.

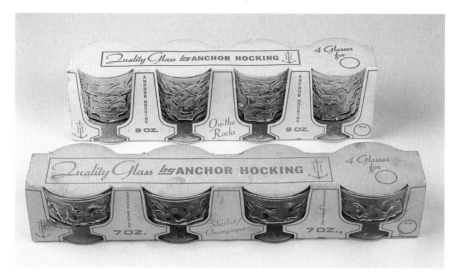

The stemmed glasses were sold in 4-pack combinations, $25-30 for the set in Honey Gold, $30-40 for the set in Aquamarine.

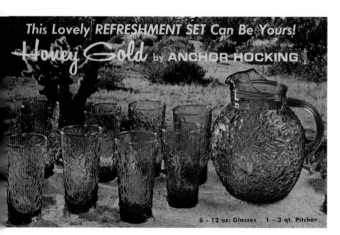

One of the reasons this pattern is so common is because the glassware was given away as premiums at gas stations across the United States. Here is the give-away card used to acquire the glassware, $20-30 for the card.

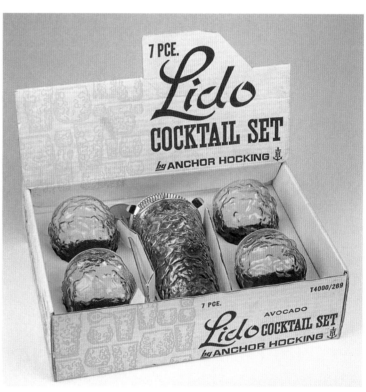

The 7-Piece Cocktail Set included one shaker with metal strainer lid with six 14 oz. double on-the rocks, $35-40 for the complete set, $5-10 for the box only.

The back of the give-away card for the Honey Gold glassware.

Morocco™

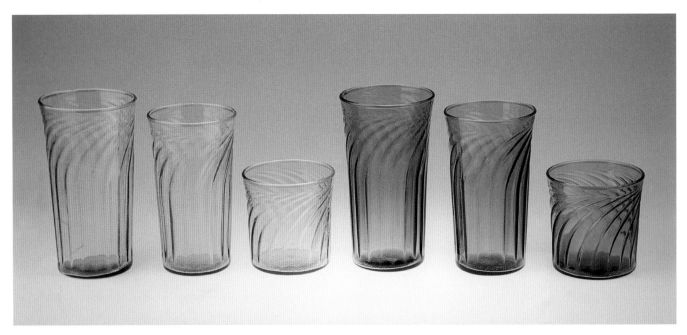

The Morocco glasses were produced in Slate, Crystal, and Honey Gold only. At the time the glasses were produced, the company did not make a matching pitcher. The Morocco pitcher was made in the late 1940s and only in light green and Crystal. Left to right: 23 1/2 oz. cooler #N3433, 6 1/2", $5-6; 15 oz. iced tea #N3425, 6", $5-6; 9 oz. double juice #N3419, 3 1/2", $4-5; 23 1/2 oz. cooler #V3433, 6 1/2", $5-6; 15 oz. iced tea #V3425, 6", $5-6; 9 oz. double juice #V3419, 3 1/2", $4-5.

Pagoda™

The name Pagoda denotes a finish and not a design of pitcher. The Pagoda finish is very similar to the Tree of Life applied to some pitchers produced from 1920 to 1940. This finish was also applied to the Finlandia design pitcher.

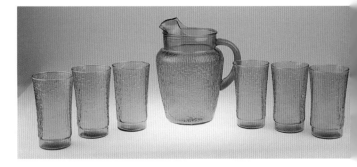

The 7-Piece Refreshment Set included one 2 1/2 qt. ice lip pitcher #F4280 with six 12 oz., 5 1/2" beverage glasses #F4232, $20-30 for the pitcher, $5-8 for each glass.

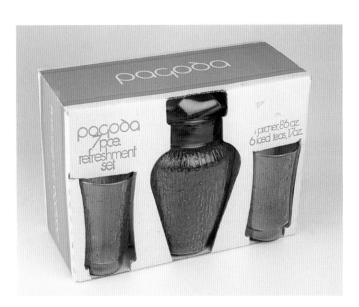

The 7-Piece Refreshment Set in Laser Blue, $40-50 for the complete set, $10-15 for the box only.

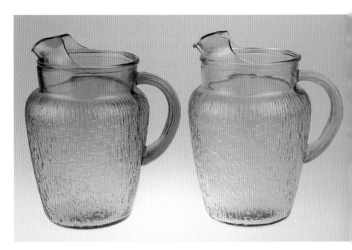

Left to right: Avocado Green pitcher #T4280, $15-20; Honey Gold pitcher #N4280, $15-20.

Plaza™

Plaza glasses were decorated with a myriad of designs. The pattern was available only in Crystal, Plum, and Sapphire. The catalogs list three sizes of glasses: the 16 oz., 5 7/8" iced tea; the 12 oz., 5" beverage; and the 9 1/2 oz., 3 1/8" rocks.

Some of the over fifty decorations applied to Plaza glasses.

The catalogs even included ways to display Anchor Hocking glassware in large store displays.

Single pack of Flora Decoration glasses #BB3119BS/578, $2-4.

Plaza® has an undiluted classic fashion look that is modern, distinctive and refined. Quality characteristics like thin sidewalls and bead enhance this striking shape available in four popular colors. We've added spicy brown! New Anchor Beverageware set packaging plays a most appropriate role...it's bright and beautiful to increase POP shelf impact, and it coordinates with single bulk & four-pack set cartons.

The Plaza glasses were listed in the *Beverageware Catalog* #A-40/58.

Rainflower™

The 7-Piece Refreshment Set #N3400/87 in Honey Gold, $30-35 for the complete set, $10-15 for the box only.

Rain Flower

picture ref.	description	glass color	BULK PACKED (BY DOZEN)				BULK PACKED (1 DOZ./SHIPPER)				ANCHOR PACKED (4 PC. SE...			
			item order no.	doz. per shipper	lbs. per shipper	price doz.	item order no.	doz. per shipper	lbs. per shipper	price doz.	set order no.	sets per shipper	lbs. per shipper	p...
A	6½ oz. juice	Avocado	T3436	3	15						T3436C	6	12	
		Honey Gold	N3436	3	15						N3436C	6	12	
		Laser Blue	F3436	3	15						F3436C	6	12	
B	8½ oz. stemmed sherbet	Honey Gold					N3438	1	7		N3438C	6	14	
C	9½ oz. on-the-rocks	Avocado	T3440	3	21		T3440E	1	7		T3440C	6	15	
		Honey Gold	N3440	3	21		N3440E	1	7		N3440C	6	15	
		Laser Blue	F3440	3	21		F3440E	1	7		F3440C	6	15	
D	10½ oz. stemmed goblet	Honey Gold					N3441	1	8		N3441C +	6	17	
E	12 oz. beverage	Avocado	T3442	3	22		T3442E	1	8		T3442C	6	16	
		Honey Gold	N3442	3	22		N3442E	1	8		N3442C	6	16	
		Laser Blue	F3442	3	22		F3442E	1	8		F3442C	6	16	
F	16 oz. iced tea	Avocado	T3446	3	27		T3446E	1	9		T3446C	6	20	
		Honey Gold	N3446	3	27		N3446E	1	9		N3446C	6	20	
		Laser Blue	F3446	3	27		F3446E	1	9		F3446C	6	20	
G	23 oz. cooler	Avocado	T3452	1	11						T3452C	6	22	
		Honey Gold	N3452	1	11						N3452C	6	22	
		Laser Blue	F3452	1	11						F3452C	6	22	
H	2 qt. pitcher	Avocado	T3464	½	17									
		Honey Gold	N3464	½	17									
		Laser Blue	F3464	½	17									

NOTE: Blue item number indicates new product and/or packaging.
See index for additional listings of Rainflower bulk and gift items.

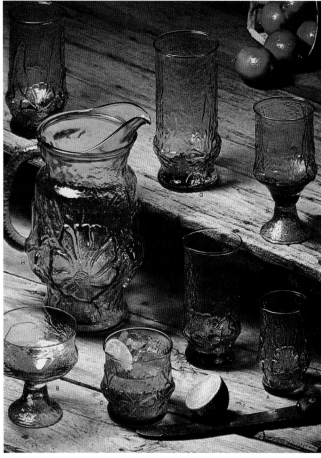

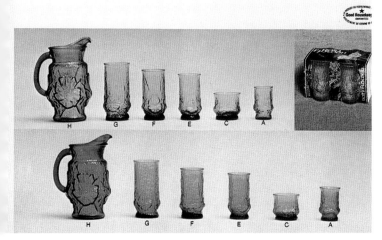

Catalog listing for the Honey Gold, Avocado Green, and Laser Blue colors.

The catalog also shows two of the three stemmed glasses in Honey Gold.

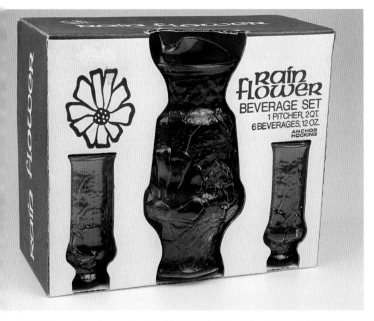

The 7-Piece Refreshment Set #G3400/85 in Spearmint Green, $40-50 for the complete set, $10-15 for the box only.

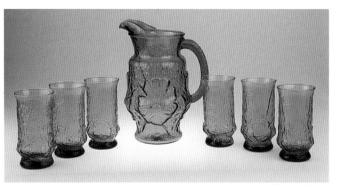

The 7-Piece Refreshment Set in Laser Blue consists of one 2 qt. ice lip pitcher #F3464 with six 12 oz., 5 1/2" beverage glasses #F3442, $25-30 for the pitcher, $5-8 for each glass.

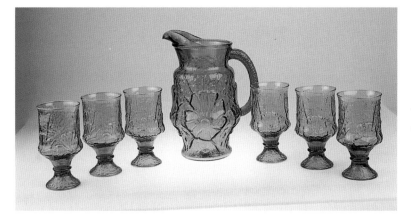

This set was also purchased with the 10 1/2 oz., 5 5/8" stemmed goblet #F3441, $80-100 for the complete set, $25-30 for the pitcher, $10-12 for each glass.

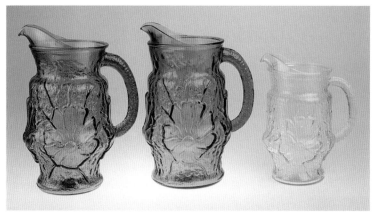

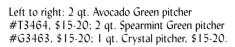

Left to right: 2 qt. Avocado Green pitcher #T3464, $15-20; 2 qt. Spearmint Green pitcher #G3463, $15-20; 1 qt. Crystal pitcher, $15-20.

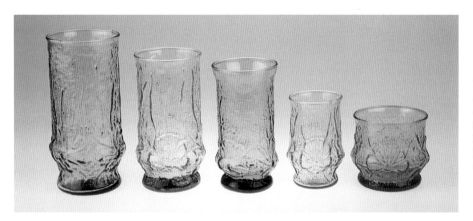

The five sizes of Rainflower glasses in assorted colors. Left to right: 23 oz. cooler in Avocado Green #T3452, 6 3/4", $3-5; 16 oz. iced tea in Honey Gold #N3446, 6", $3-5; 12 oz. beverage in Spearmint Green #G3442, 5 1/2", $3-5; 6 1/2 oz. juice in Honey Gold #N3436, 4", $2-3; 9 1/2 oz. on-the-rocks in Laser Blue #F3440, 3", $5-6.

There were three sizes and three colors (Crystal, Laser Blue, and Honey Gold) of stemmed glasses produced in the Rainflower pattern. The base of the glass was easy to break, so the stemmed glasses are relatively hard to find. Left to right (by size): 10 1/2 oz. stemmed goblet, 5 5/8", $10-12 for all colors; 8 1/2 oz. stemmed sherbet, 4 1/2", $8-10 for all colors; 8 1/2 oz. sherbet, 3 1/2", $8-10 for all colors.

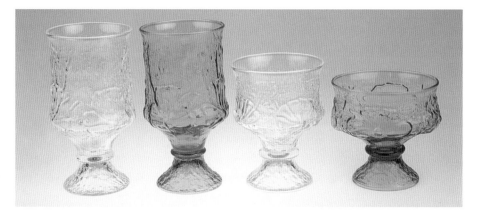

Reflections™

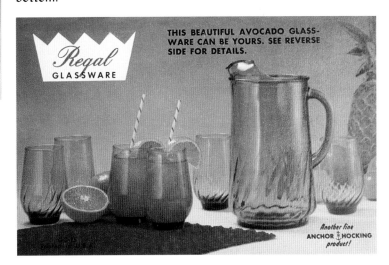

Reflections Sapphire Blue 20-Piece Beverage Set contains ten 16 1/2 oz., 6" iced teas and ten 10 1/2 oz., 3 5/8" rocks, $20-30.

Regal™

The Regal pattern is a modification of the Finlandia design pitcher. Swirled grooves where molded into the inside surface of the Finlandia design pitcher to produce the Regal pattern. The pattern was produced in at least four colors with four sizes of glasses. I have been unable to find the pattern listed in the catalogs; however, the pattern was evidently given away as gas station premiums. Be aware that Libbey also made a similar pattern in the green, gold, and brown colors. Their glasses are marked with the capital cursive "L" on the bottom.

THIS BEAUTIFUL AVOCADO GLASSWARE CAN BE YOURS. SEE REVERSE SIDE FOR DETAILS.

Regal GLASSWARE

Another fine ANCHOR ⚓ HOCKING product!

Anchor Hocking postcard listing the Regal design as a premium giveaway.

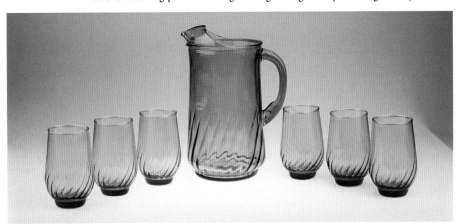

Avocado Green 2 1/2 qt. pitcher with six 11 oz., 4 1/2" glasses, $60-75 for the complete set, $20-30 for the pitcher, $4-5 for each glass.

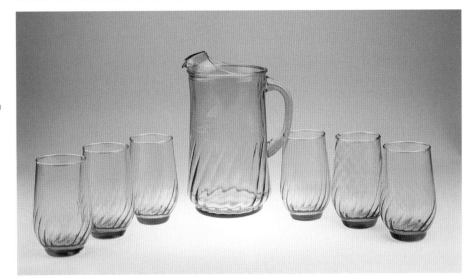

Honey Gold 2 1/2 qt. pitcher with six 14 oz., 5" glasses, $60-75 for the complete set, $20-30 for the pitcher, $4-5 for each glass.

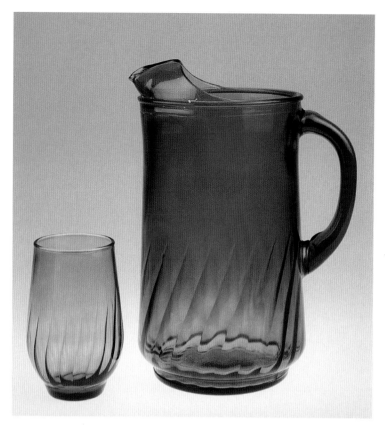

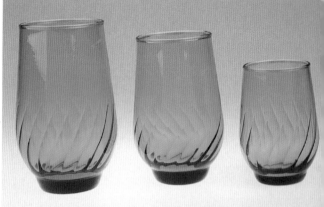

There is a matching pitcher in Laser Blue. All the Laser Blue pitchers I have been able to find came from Canada. Left to right: 14 oz. glass, 5", $8-10; 11 oz. glass, 4 1/2", $8-10; 6 oz. glass, 3 5/8", $5-8.

Spicy Brown is a hard color to find in most Anchor Hocking patterns. Left to right: 11 oz. glass, 4 1/2", $10-12; 2 1/2 qt. pitcher, $50-75.

Avocado Green glasses. Left to right: 14 oz. glass, 5", $4-5; 11 oz. glass, 4 1/2", $4-5; 9 oz. glass, 3 1/8", $3-5.

Roly Poly™

The Roly Poly was widely produced in Royal Ruby and Forest Green; however, these were not include here. I only listed pattern pieces not found in my other reference books.

Dogwood decorations applied to a Roly Poly 3 qt. pitcher with six 13 oz., 5" beverage/iced teas, $60-80 for the complete set, $30-40 for the pitcher, $8-10 for each glass. The glasses were decorated with red, orange, blue, and yellow (not shown) flowers.

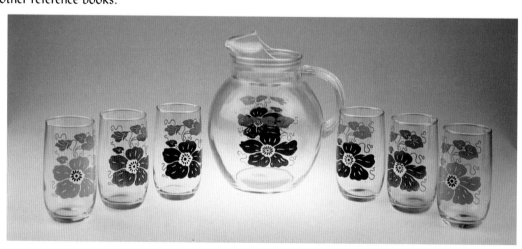

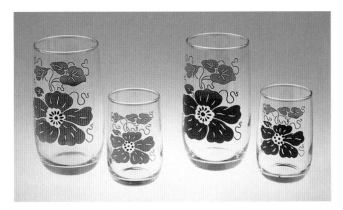

Left to right: 13 oz. beverage/iced tea, 5", $8-10; 5 oz. fruit juice, 3 3/8", $5-8; 13 oz. beverage/ iced tea, 5", $8-10; 5 oz. fruit juice, 3 3/8", $5-8.

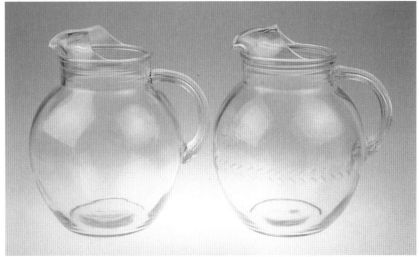

Left to right: Crystal 3 qt. pitcher, $25-30; Crystal 3 qt. pitcher with cut pattern called Silver Laurel, $40-50.

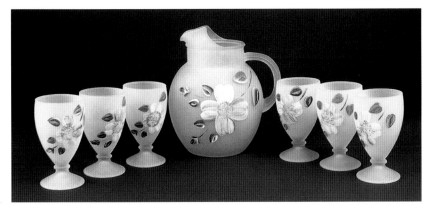

Rare frosted 3 qt. pitcher with six #3555 frosted goblets, $100-125 for the complete set, $60-75 for the pitcher, $10-15 for each glass.

The same design was also applied to a Libbey juice pitcher, shown on the right.

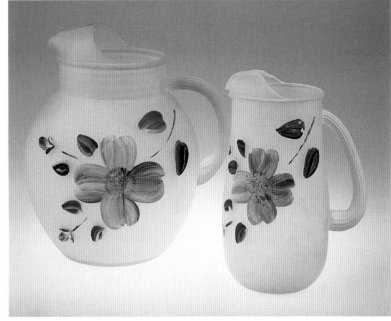

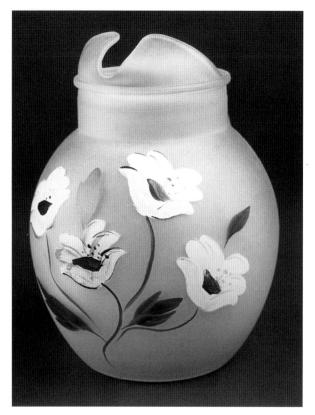

Another rare frosted 3 qt. pitcher, $60-75.

Oklahoma commemorative 13 oz., 5" glasses, $30-40 for the complete set. Left to right: "Fort Gibson," "Old Chisholm Trail," "Will Rogers Memorial," and "Killing Beef Along Indian Trail."

The 1996 *Foodservice Catalog* listed seven sizes of Saturn glasses

Saturn™

Sapphire Blue Saturn glassware. Left to right: 4-pack of 6 oz., 3 1/2" juice glasses; 16 oz., 6" iced tea; 4-pack of 16 oz., 6" iced teas. These glasses were recently purchased at Wal-Mart.

Seabrook™

Left to right: 4-pack of Blueberry 20 oz., 6" iced teas; 20 oz., 6" iced tea; 4-pack of green 20 oz., 6" iced teas. These glasses were recently purchased at Wal-Mart.

Shell™

There were actually five different sizes of glasses listed in the 1979 Bulk Catalog A-24. The glasses, listed in Crystal only, are relatively hard to find. The pattern also included cups, saucers, sugars, creamers, several plates, several bowls, and an ashtray. Many of the pieces were introduced in 1978 and all the pieces were listed in the 1978 Bulk Catalog.

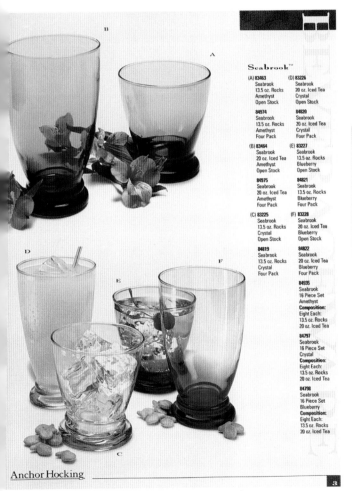

Seabrook™

(A) 83463 Seabrook 13.5 oz. Rocks Amethyst Open Stock	(D) 83226 Seabrook 20 oz. Iced Tea Crystal Open Stock
84974 Seabrook 13.5 oz. Rocks Amethyst Four Pack	84820 Seabrook 20 oz. Iced Tea Crystal Four Pack
(B) 83464 Seabrook 20 oz. Iced Tea Amethyst Open Stock	(E) 83227 Seabrook 13.5 oz. Rocks Blueberry Open Stock
84975 Seabrook 20 oz. Iced Tea Amethyst Four Pack	84821 Seabrook 13.5 oz. Rocks Blueberry Four Pack
(C) 83225 Seabrook 13.5 oz. Rocks Crystal Open Stock	(F) 83228 Seabrook 20 oz. Iced Tea Blueberry Open Stock
84819 Seabrook 13.5 oz. Rocks Crystal Four Pack	84822 Seabrook 20 oz. Iced Tea Blueberry Four Pack
	84935 Seabrook 16 Piece Set Amethyst Composition: Eight Each: 13.5 oz. Rocks 20 oz. Iced Tea
	84797 Seabrook 16 Piece Set Crystal Composition: Eight Each: 13.5 oz. Rocks 20 oz. Iced Tea
	84798 Seabrook 16 Piece Set Blueberry Composition: Eight Each: 13.5 oz. Rocks 20 oz. Iced Tea

Anchor Hocking

The 1999 Beverageware Catalog lists Seabrook in Crystal, Amethyst, and Blueberry.

It is interesting to note that the shell pattern was also applied to the base of the glass.

Left to right: 6 1/2 oz. champagne/sherbet #507, 4", $5-6; 9 3/4 oz. goblet #510, 6", $5-8.

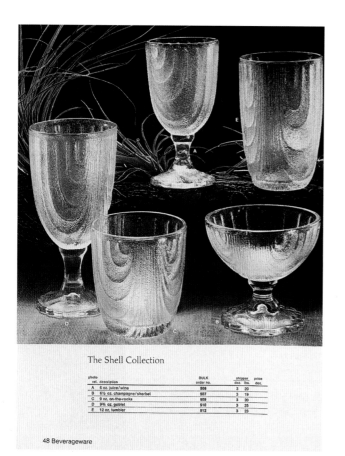

The Shell Collection

photo ref.	description	BULK order no.	shipper doz. lbs.	price doz.
A	6 oz. juice/wine	506	3	20
B	6½ oz. champagne/sherbet	507	3	19
C	9 oz. on-the-rocks	509	3	20
D	9½ oz. goblet	510	3	25
E	12 oz. tumbler	512	3	23

48 Beverageware

The *1979 Bulk Catalog A-24* listed the five sizes of glasses in the Shell collection.

Sherwood™

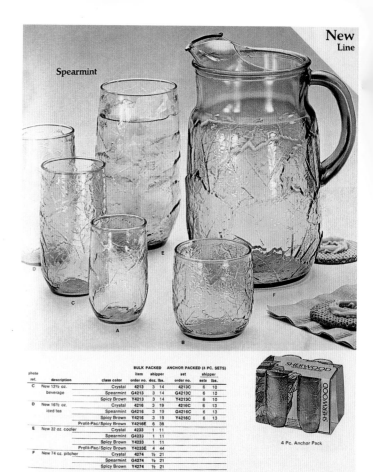

photo ref.	description	glass color	BULK PACKED item order no.	shipper doz. lbs.	ANCHOR PACKED (4 PC. SETS) set order no.	shipper sets lbs.
C	New 12½ oz. beverage	Crystal	4213	3 14	4213C	6 10
		Spearmint	G4213	3 14	G4213C	6 10
		Spicy Brown	Y4213	3 14	Y4213C	6 10
D	New 16½ oz. iced tea	Crystal	4216	3 19	4216C	6 13
		Spearmint	G4216	3 19	G4216C	6 13
		Spicy Brown	Y4216	3 19	Y4216C	6 13
		Profit-Pac/Spicy Brown	Y4216E	6 38		
E	New 32 oz. cooler	Crystal	4233	1 11		
		Spearmint	G4233	1 11		
		Spicy Brown	Y4233	1 11		
		Profit-Pac/Spicy Brown	Y4233E	4 44		
F	New 74 oz. pitcher	Crystal	4274	½ 21		
		Spearmint	G4274	½ 21		
		Spicy Brown	Y4274	½ 21		

4 Pc. Anchor Pack

Beverageware 31

The Sherwood pitcher and glasses in Spearmint Green.

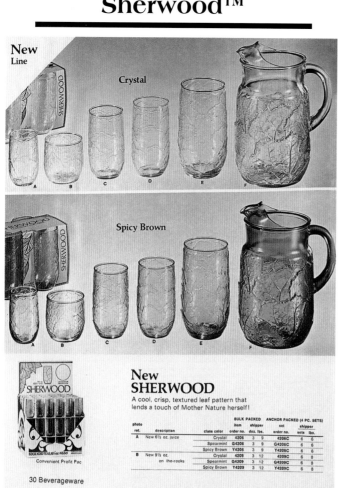

New SHERWOOD

A cool, crisp, textured leaf pattern that lends a touch of Mother Nature herself!

photo ref.	description	glass color	BULK PACKED item order no.	shipper doz. lbs.	ANCHOR PACKED (4 PC. SETS) set order no.	shipper sets lbs.
A	New 6½ oz. juice	Crystal	4206	3 9	4206C	6 6
		Spearmint	G4206	3 9	G4206C	6 6
		Spicy Brown	Y4206	3 9	Y4206C	6 6
B	New 9½ oz. on-the-rocks	Crystal	4209	3 12	4209C	6 8
		Spearmint	G4209	3 12	G4209C	6 8
		Spicy Brown	Y4209	3 12	Y4209C	6 8

Convenient Profit Pac

30 Beverageware

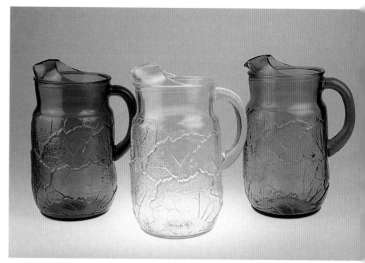

Sherwood pitchers (1978). Left to right: Spicy Brown 74 oz. pitcher #Y4274, $30-35; Crystal 74 oz. pitcher #4274, $20-25; Spearmint Green 74 oz. pitcher #G4274, $20-25.

The Sherwood pattern was introduced in the *1979 Bulk Catalog A-24* in Crystal, Spearmint Green, and Spicy Brown. I have found three of the five sizes of glasses in Honey Gold. I have never seen the pitcher and the catalogs do not list this color (Honey Gold).

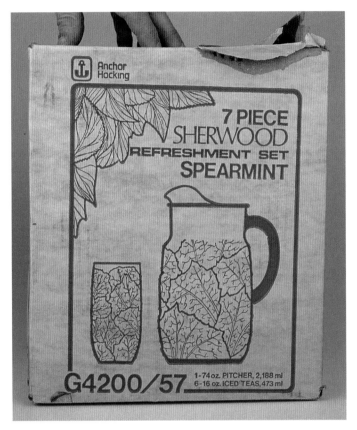

Left to right: Crystal 32 oz. cooler #4233, 7", $5-8; Crystal 16 1/2 oz. iced tea #4216, 6 1/2", $3-4; Honey Gold 12 1/2 oz. beverage #N4213, 4 3/4", $2-3; Spearmint Green 6 1/2 oz. juice #G4206, 4", $2-3; Spicy Brown 9 1/2 oz. on-the-rocks #Y4209, 3 1/2", $1-2.

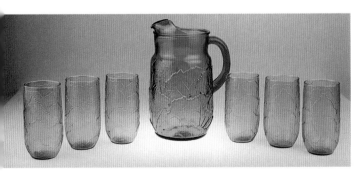

Sherwood 7-Piece Refreshment Set #G4200/57, $50-60 for the complete set, $10-15 for the box only.

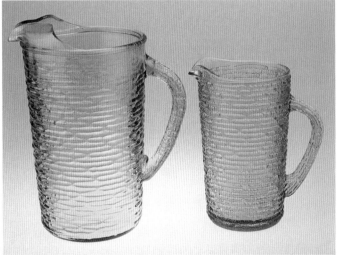

The 7-Piece Refreshment Set includes one 74 oz. pitcher #G4274, $20-25, and six 16 1/2 oz. iced teas #G4216, 4 3/4", $3-4 for each glass.

Soreno™

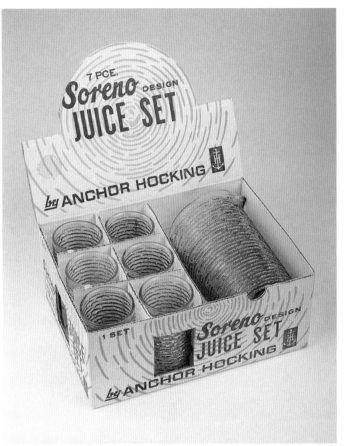

The 7-Piece Refreshment Set in Honey Gold consists of one 2 qt. pitcher #N4064 with six 12 oz., 6" beverage glasses #N4042, $30-35 for the complete set, $5-10 for the box only.

Soreno Honey Gold pitchers. Left to right: 2 qt. pitcher #N4064, $15-20; 28 oz. juice pitcher #N4048, $15-20.

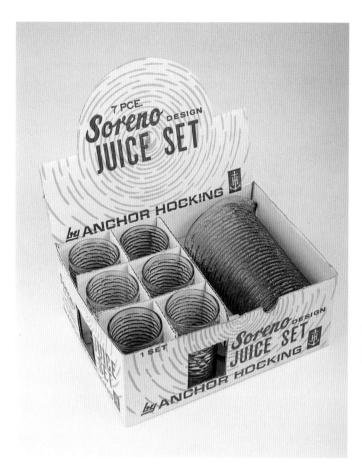

Close-up of Avocado Green label on the top edge of the pitcher.

The 7-Piece Refreshment Set in Avocado Green consists of one 2 qt. pitcher #T4064 with six 12 oz., 6" beverage glasses #T4042, $30-35 for the complete set, $5-10 for the box only.

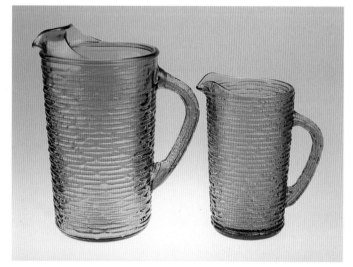

The 7-Piece Refreshment Set in Madri Gras consists of one 2 qt. pitcher with six 12 oz., 6" beverage glasses, $60-80 for the complete set, $10-15 for the box on the left only. The box on the right would have little value since it is covered with masking tape. Pulling off the tape will either rip the box or remove the printing.

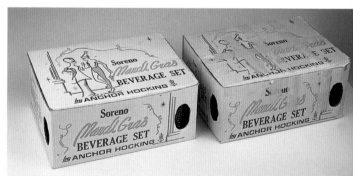

Avocado Green pitchers. Left to right: 2 qt. pitcher #T4064, $15-20; 28 oz. juice pitcher #T4048, $15-20.

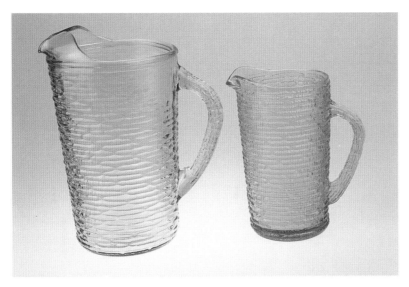

Aquamarine pitchers. Left to right: 2 qt. pitcher #B4064, $20-25; 28 oz. pitcher #B4048, $20-25.

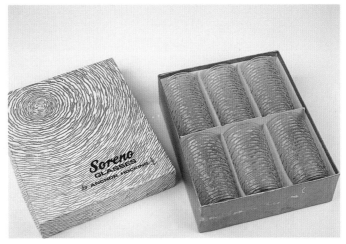

Boxed set #B4000/140 with six 12 oz. beverage glasses, $30-40 for the complete set, $5-10 for the box. The color was also available in six glass sets of 9 oz. on-the-rocks.

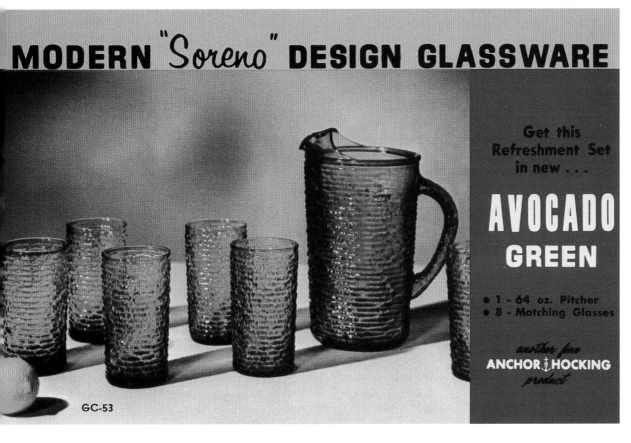

MODERN "Soreno" DESIGN GLASSWARE

Get this
Refreshment Set
in new . . .

AVOCADO
GREEN

● 1 - 64 oz. Pitcher
● 8 - Matching Glasses

another fine
ANCHOR HOCKING
product

GC-53

Avocado Green Soreno glassware was given away as premiums at gas stations everywhere. Here is the postcard for the premium giveaway.

113

Springsong™

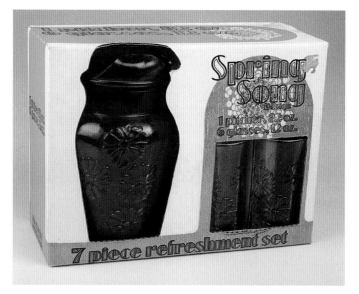

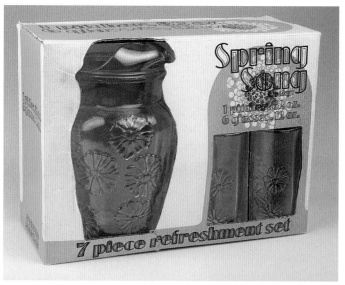

Spring Song 7-Piece Refreshment Set in Honey Gold, $30-40 for the complete set, $5-10 for the box only.

Spring Song 7-Piece Refreshment Set in Crystal, $30-40 for the complete set, $5-10 for the box only.

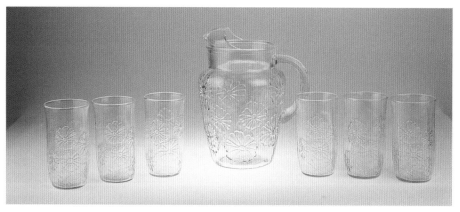

The Crystal 7-Piece Refreshment Set consists of one 86 oz. pitcher #4182, $20-25, with six 12 oz. beverages #4172, 5", $2-3 for each glass.

Left to right: Avocado Green 86 oz. pitcher #T4182, $20-25; Laser Blue 86 oz. pitcher #F4182, $20-25; Honey Gold 86 oz. pitcher #N4182, $20-25.

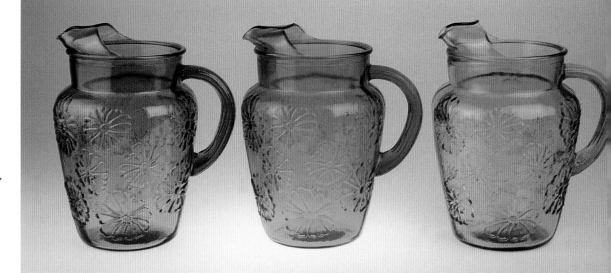

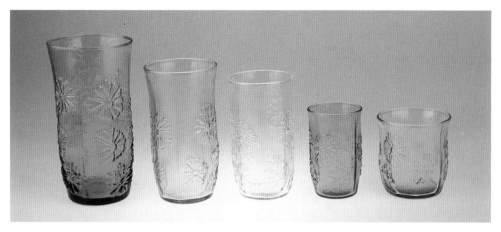

Left to right: Laser Blue 25 oz. cooler #F4175, 6", $1-2; Honey Gold 16 oz. iced tea #N4176, 5 3/4", $1-2; Crystal 12 oz. beverage #4172, 5", $1-2; Laser Blue 5 1/2 oz. juice #F4165, 3 3/4", $1-2; Honey Gold 9 oz. rocks #N4169, 3 1/4", $1-2.

Crystal 6-pack of 12 oz., 5" tumblers, $25-30 for the complete set, $5-10 for the box only.

Sprucewood™

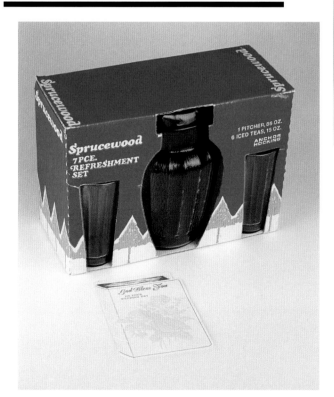

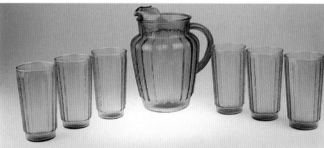

The 7-Piece Refreshment Set consists of one 86 oz. pitcher, $20-25, with six 12 oz., 6" beverage glasses, $3-5 for each glass.

The 7-Piece Refreshment Set in Avocado Green, $30-40 for the complete set, $5-10 for the box

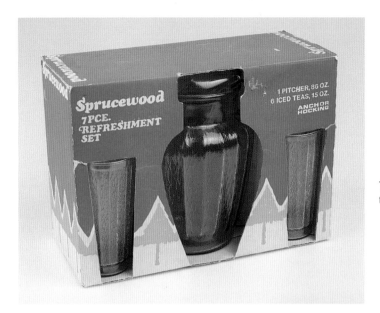

The 7-Piece Refreshment Set in Honey Gold, $30-40 for the complete set, $5-10 for the box only.

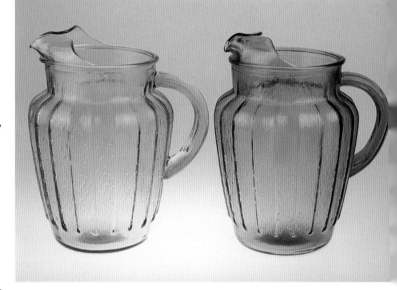

Left to right: Honey Gold 86 oz. pitcher, $20-25; Avocado Green 86 oz. pitcher, $20-25.

Stowaways™

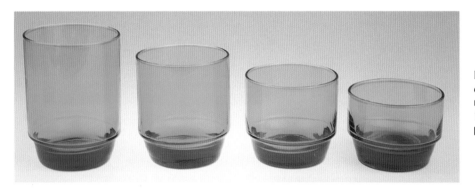

Left to right: 15 oz. iced tea #F3025, 5", $3-5; 12 oz. beverage #F3022, 4 1/2", $3-4; 9 1/2 oz. on-the-rocks #F3009, $2-3; 7 oz. juice/sherbet #F3007, $2-3. There was also an 18 oz. cooler (not shown) produced in all five colors of this pattern.

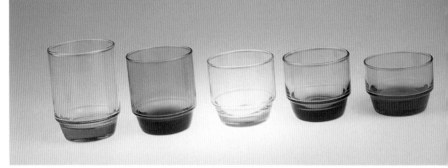

Stowaways (1972) were available in Honey Gold, Spicy Brown, Crystal, Avocado Green, and Laser Blue.

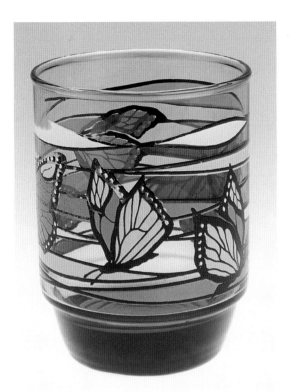

Monarch decoration 15 oz. beverage, 5", $2-3. There was a multitude of decorations applied to the Stowaway design glasses.

Giftware Set #3025-2/3-FA3 with eight 15 oz., 4" glasses, $15-20 for the complete set, $2-4 for the box only.

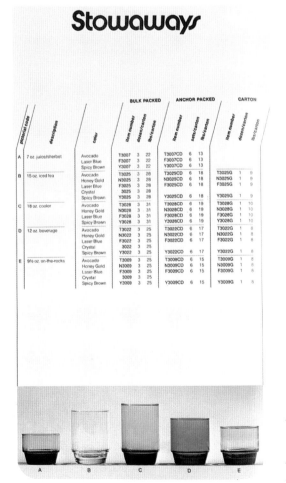

Stowaways

pictorial code	description	color	BULK PACKED			ANCHOR PACKED			CARTON		
			item number	dozen/carton	lbs/carton	item number	sets/carton	lbs/carton	item number	dozen/carton	lbs/carton
A	7 oz. juice/sherbet	Avocado	T3007	3	22	T3007CD	6	13			
		Laser Blue	F3007	3	22	F3007CD	6	13			
		Spicy Brown	Y3007	3	22	Y3007CD	6	13			
B	15 oz. iced tea	Avocado	T3025	3	28	T3025CD	6	18	T3025G	1	9
		Honey Gold	N3025	3	28	N3025CD	6	18	N3025G	1	9
		Laser Blue	F3025	3	28	F3025CD	6	18	F3025G	1	9
		Crystal	3025	3	28						
		Spicy Brown	Y3025	3	28	Y3025CD	6	18	Y3025G	1	9
C	18 oz. cooler	Avocado	T3028	3	31	T3028CD	6	19	T3028G	1	10
		Honey Gold	N3028	3	31	N3028CD	6	19	N3028G	1	10
		Laser Blue	F3028	3	31	F3028CD	6	19	F3028G	1	10
		Spicy Brown	Y3028	3	31	Y3028CD	6	19	Y3028G	1	10
D	12 oz. beverage	Avocado	T3022	3	25	T3022CD	6	17	T3022G	1	8
		Honey Gold	N3022	3	25	N3022CD	6	17	N3022G	1	8
		Laser Blue	F3022	3	25	F3022CD	6	17	F3022G	1	8
		Crystal	3022	3	25						
		Spicy Brown	Y3022	3	25	Y3022CD	6	17	Y3022G	1	8
E	9½ oz. on-the-rocks	Avocado	T3009	3	25	T3009CD	6	15	T3009G	1	8
		Honey Gold	N3009	3	25	N3009CD	6	15	N3009G	1	8
		Laser Blue	F3009	3	25	F3009CD	6	15	F3009G	1	8
		Crystal	3009	3	25						
		Spicy Brown	Y3009	3	25	Y3009CD	6	15	Y3009G	1	8

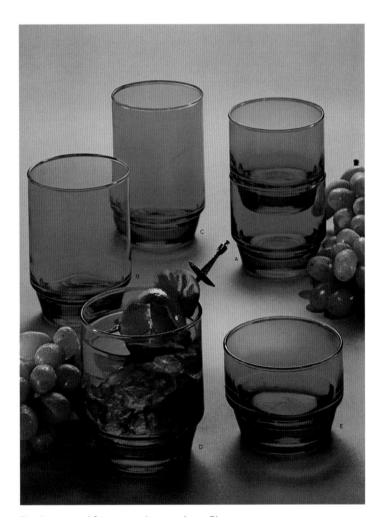

The five sizes of Stowaway glasses in Laser Blue.

The 1972 catalog lists the five sizes of Stowaway glasses. The pattern was made in five colors, yet not all glass sizes were made in all five colors.

117

Starfire™ Swedish Modern™

Left to right: Sea Mist 17 oz. iced tea, 5 7/8", $1-2; Sea Mist 12 oz. double rocks, 3 3/4", $1-2; Crystal 12 oz. double rocks, 3 3/4", $1-2.

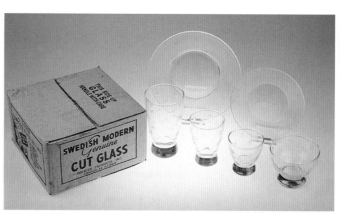

Swedish Modern 6-Piece place setting #399 consisted of one 12 oz., 5 3/8" tumbler #105; one 6 oz., 4" fruit juice #104; one 8 oz., 2 3/4" sherbet #102; one 4 oz., 2 7/8" cocktail #101; one 6 1/4" dessert plate; and one 8" luncheon plate, $30-40 for the complete set, $5-10 for the box only. Some of the dimensions and names of the pieces listed on the side of the box differ from the dimensions and names listed in the company catalogs.

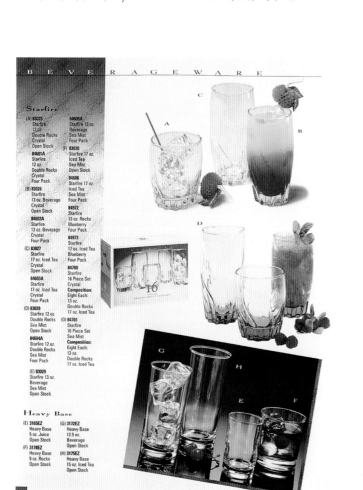

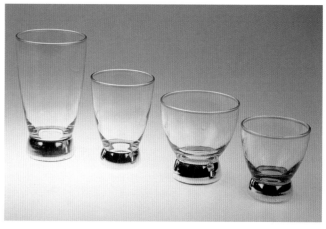

Swedish Modern 22 kt. gold trimmed glasses were listed in the 1956 catalog. Left to right: 12 oz. high ball #105, 5 3/8", $4-5; 6 oz. fruit juice #104, 4", $4-5; 7 1/2 oz. old fashioned #103, 3", $4-5; 4 1/2 oz. cocktail #101, 2 7/8", $4-5.

The 1994 catalog listed three sizes of Starfire pattern glasses in Crystal, Sea Mist, and Blueberry.

Tahiti™

The 7-Piece Refreshment Set in Aquamarine, $40-50 for the complete set, $5-10 for the box only.

The 7-Piece Refreshment Set consisted of one 64 oz. pitcher #B564 with six 16 oz., 5 3/4" beverage glasses #B516-C, $25-30 for the pitcher, $3-5 for each glass.

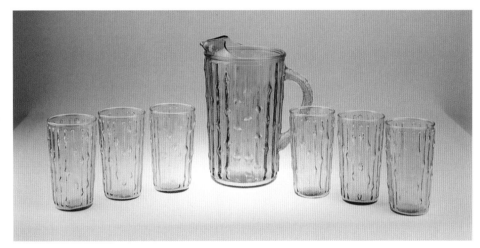

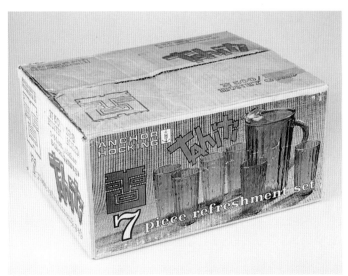

The 7-Piece Refreshment Set in Honey Gold, $35-45 for the complete set, $5-10 for the box only.

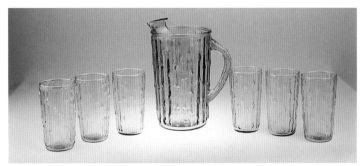

The 7-Piece Refreshment Set consisted of one 64 oz. pitcher #N564 with six 16 oz., 5 3/4" beverage glasses #N516, $20-25 for the pitcher, $3-5 for each glass.

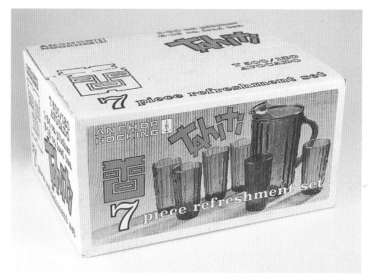

The 7-Piece Refreshment Set in Avocado Green, $35-45 for the complete set, $5-10 for the box only.

The 7-Piece Refreshment Set consisted of one 64 oz. pitcher #F564 with six 16 oz., 5 3/4" beverage glasses #F516, $40-50 for the pitcher, $8-10 for each glass. The Laser Blue color is hard to find in this pattern.

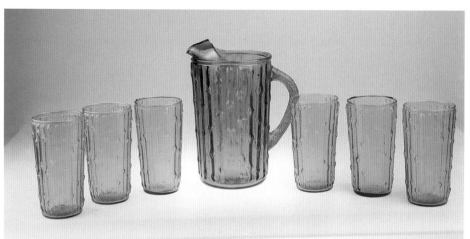

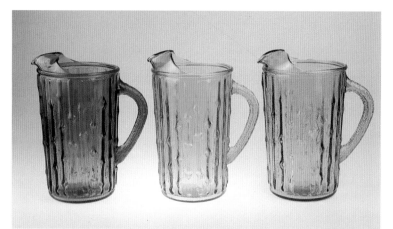

Left to right: Spicy Brown 64 oz. pitcher #Y564, $50-60; Aquamarine 64 oz. pitcher #B564, $15-20; Avocado Green 64 oz. pitcher #T564, $20-25. The Spicy Brown color is very hard to find in this and most other Anchor Hocking patterns.

Boxed set of 12 oz., 5" glasses #N511, $35-40 for the complete set, $5-10 for the box only.

Unusual boxed set of eight Avocado Green 12 oz., 5" tumblers #T511. Each tumbler has a hand-woven "cozy" placed over the bottom of the glass. The "cozies" are numbered from one to eight, $80-100 for the complete set, $5-10 for the box only.

Tartan™

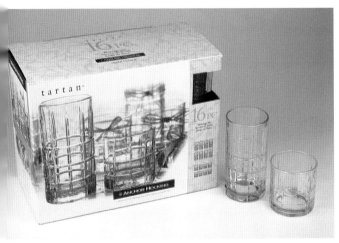

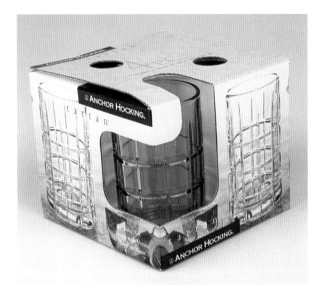

A 4-pack of 7 oz., 4" juice glasses in Sea Mist. These glasses were recently purchased at Wal-Mart.

A 16-Piece Refreshment Set containing eight 16 oz., 6" iced teas and eight 10 1/2 oz., 3 1/2" rocks. This set was recently purchased at Wal-Mart.

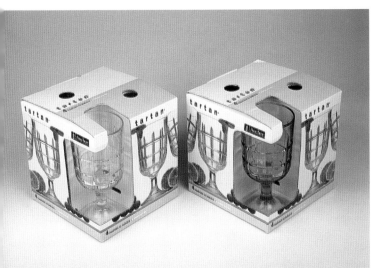

Left to right: 4-pack of 14 oz., 6 3/4" Crystal goblets; 4-pack of 14 oz., 6 3/4" Blueberry goblets. These goblets were recently purchased at Wal-Mart.

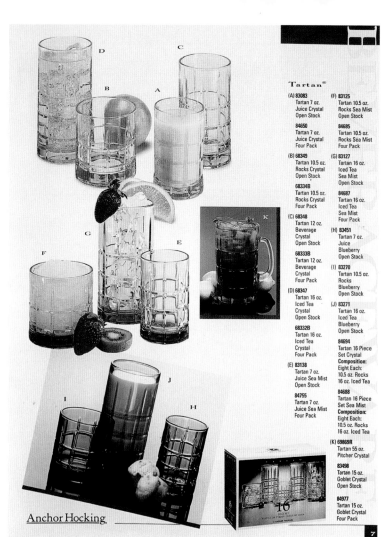

Anchor Hocking

Tartan®

(A) 83083
Tartan 7 oz.
Juice Crystal
Open Stock

84650
Tartan 7 oz.
Juice Crystal
Four Pack

(B) 68349
Tartan 10.5 oz.
Rocks Crystal
Open Stock

68334B
Tartan 10.5 oz.
Rocks Crystal
Four Pack

(C) 68348
Tartan 12 oz.
Beverage
Crystal
Open Stock

68333B
Tartan 12 oz.
Beverage
Crystal
Four Pack

(D) 68347
Tartan 16 oz.
Iced Tea
Crystal
Open Stock

68332B
Tartan 16 oz.
Iced Tea
Crystal
Four Pack

(E) 83138
Tartan 7 oz.
Juice Sea Mist
Open Stock

84755
Tartan 7 oz.
Juice Sea Mist
Four Pack

(F) 83125
Tartan 10.5 oz.
Rocks Sea Mist
Open Stock

84685
Tartan 10.5 oz.
Rocks Sea Mist
Four Pack

(G) 83127
Tartan 16 oz.
Iced Tea
Sea Mist
Open Stock

84687
Tartan 16 oz.
Iced Tea
Sea Mist
Four Pack

(H) 83451
Tartan 7 oz.
Juice
Blueberry
Open Stock

(I) 83270
Tartan 10.5 oz.
Rocks
Blueberry
Open Stock

(J) 83271
Tartan 16 oz.
Iced Tea
Blueberry
Open Stock

84694
Tartan 16 Piece
Set Crystal
Composition:
Eight Each:
10.5 oz. Rocks
16 oz. Iced Tea

84688
Tartan 16 Piece
Set Sea Mist
Composition:
Eight Each:
10.5 oz. Rocks
16 oz. Iced Tea

(K) 69869R
Tartan 55 oz.
Pitcher Crystal

83498
Tartan 15 oz.
Goblet Crystal
Open Stock

84977
Tartan 15 oz.
Goblet Crystal
Four Pack

The catalogs list the Tartan pattern in Crystal, Sea Mist, and Blueberry.

Tempo™

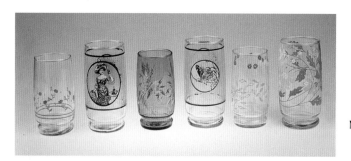

Numerous decorations were applied to Tempo glasses.

A 4-Pack of 6 3/4 oz., 4" juice glasses #2147, $8-10. The bottom of the container lists the five sizes of Tempo glasses.

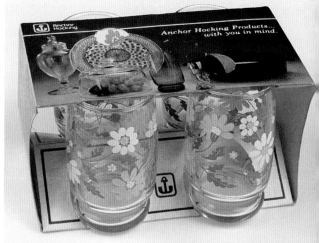

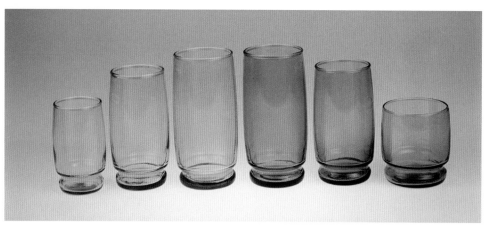

Four of the five sizes
of Tempo glasses.

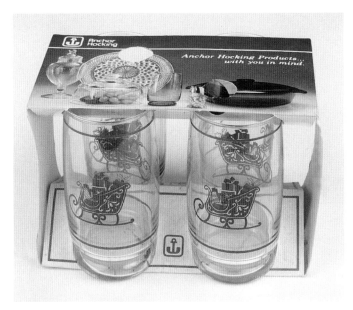

A 4-Pack of 12 oz., 5 1/4" beverage glasses #2152, $8-10. The bottom of the container lists the five sizes of Tempo glasses.

Terrace™

The Terrace pattern was produced in three colors: Crystal, Sapphire, and Caribbean (a light green color). The catalogs list the glasses in all three colors but only the pitcher in Crystal and Sapphire.

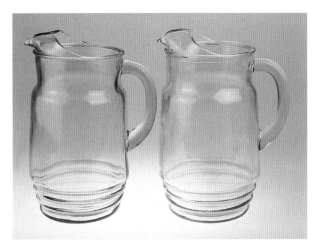

Terrace pitchers. Left to right: Sapphire 74 oz. pitcher #BB3690, $15-20; Crystal 74 oz. pitcher #3690, $15-20.

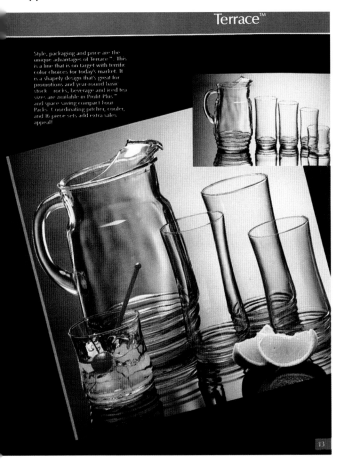

Picture of the *Beverageware Catalog A-40/58* listing the Terrace pattern.

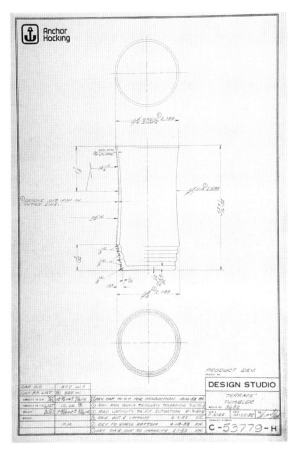

Rare blueprint of the Terrace pattern.

Tivoli™

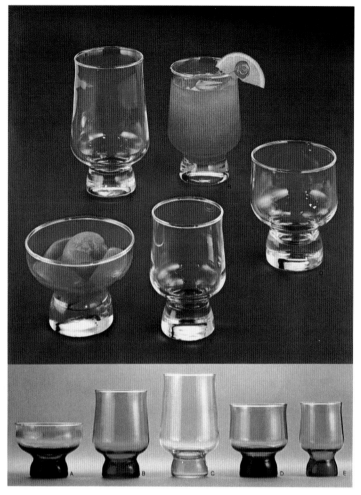

The 1972 catalog listed the Tivoli glasses.

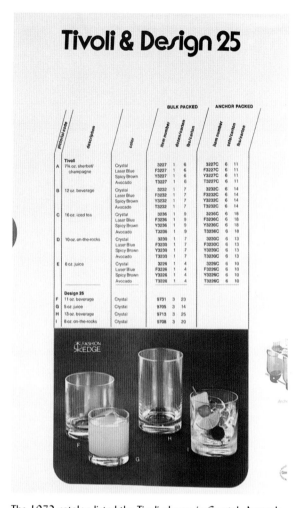

Tivoli & Design 25

pictorial code	description	color	BULK PACKED		ANCHOR PACKED			
			item number	dozen/carton	flats/carton	item number	sets/carton	flats/carton

pictorial code	description	color	item number	dozen/carton	flats/carton	item number	sets/carton	flats/carton
	Tivoli							
A	7¼ oz. sherbet/ champagne	Crystal	3227	1	6	3227C	6	11
		Laser Blue	F3227	1	6	F3227C	6	11
		Spicy Brown	Y3227	1	6	Y3227C	6	11
		Avocado	T3227	1	6	T3227C	6	11
B	12 oz. beverage	Crystal	3232	1	7	3232C	6	14
		Laser Blue	F3232	1	7	F3232C	6	14
		Spicy Brown	Y3232	1	7	Y3232C	6	14
		Avocado	T3232	1	7	T3232C	6	14
C	16 oz. iced tea	Crystal	3236	1	9	3236C	6	18
		Laser Blue	F3236	1	9	F3236C	6	18
		Spicy Brown	Y3236	1	9	Y3236C	6	18
		Avocado	T3236	1	9	T3236C	6	18
D	10 oz. on-the-rocks	Crystal	3230	1	7	3230C	6	13
		Laser Blue	F3230	1	7	F3230C	6	13
		Spicy Brown	Y3230	1	7	Y3230C	6	13
		Avocado	T3230	1	7	T3230C	6	13
E	6 oz. juice	Crystal	3226	1	4	3226C	6	10
		Laser Blue	F3226	1	4	F3226C	6	10
		Spicy Brown	Y3226	1	4	Y3226C	6	10
		Avocado	T3226	1	4	T3226C	6	10
	Design 25							
F	11 oz. beverage	Crystal	9731	3	23			
G	5 oz. juice	Crystal	9705	3	14			
H	13 oz. beverage	Crystal	9713	3	25			
I	8 oz. on-the-rocks	Crystal	9708	3	20			

The 1972 catalog listed the Tivoli glasses in Crystal, Avocado Green, Laser Blue, and Spicy Brown.

Left to right: 12 oz. beverage in Avocado and Crystal, 5", $3-4; 10 1/2 oz. on-the-rocks in Laser Blue, Spicy Brown, and Crystal, 4", $2-3; 6 oz. juice in Laser Blue, 4", $2-3; 8 1/2 oz. sherbet/champagne in Laser Blue, 3 1/2", $2-3. There is also a larger 16 oz. iced tea (not shown).

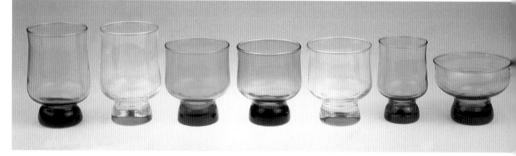

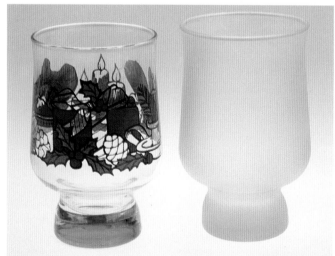

Left to right: Christmas decoration on 12 oz. beverage, 5", $3-4; frosted 12 oz. beverage, 5", $3-4.

Trend™

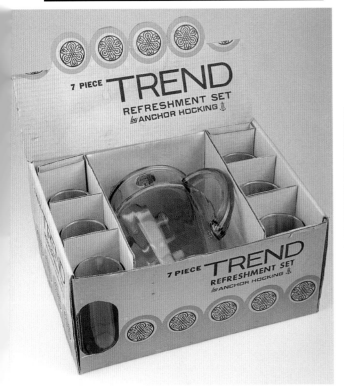

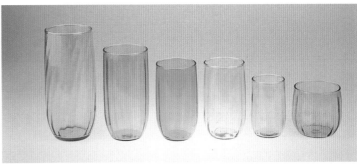

Trend glasses were made in five sizes. The glasses in this pattern are relatively hard to find. Left to right: 24 oz. glass, 6 3/4", $2-5; 16 oz. glass, 5 1/2", $2-5; 12 oz. glass, 4 3/4", $2-5; 6 oz. glass, 3 1/2", $2-5; 10 oz. glass, 3", $2-5.

The Trend 7-Piece Refreshment Set consisted of one 86 oz. pitcher, $20-25, with six 11 oz., 4 3/4" glasses, $4-5 for each glass, $10-15 for the box only.

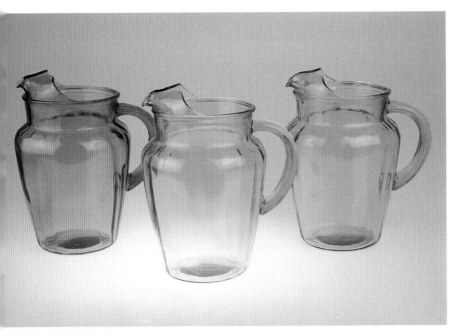

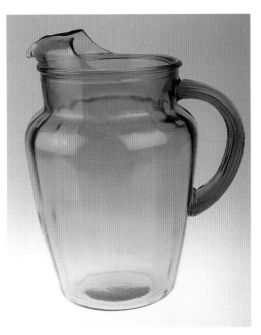

Unusual Avocado Green 86 oz. pitcher with etched farm scenes, $40-50.

Trend pitchers were produced in three colors. Left to right: Avocado Green 86 oz. pitcher, $15-20; Aquamarine 86 oz. pitcher, $20-30; Honey Gold 86 oz. pitcher, $20-25.

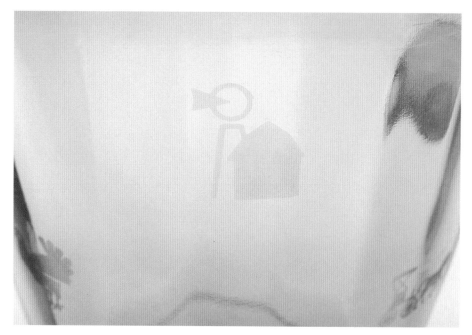

Close-up of one of the etched pictures on the Avocado Green pitcher.

Vista™

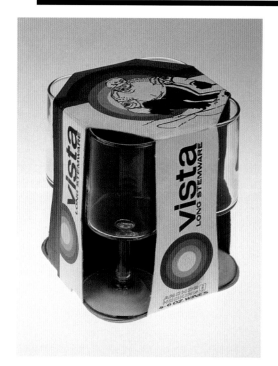

A 4-Pack of 6 oz., 5 1/2" wine glasses #2636, $8-10. The bottom of the carton lists seven other sizes of Vista glasses.

Wexford™

I have only included unusual pitchers and glasses in this pattern. This pattern was made for years and there are myriad pieces on the market.

The 7-Piece Refreshment Set consists of one 2 qt. footed pitcher #4564 with six 12 oz., 6" beverage glasses #4512, $20-30 for the complete set, $10-15 for the pitcher, $3-5 for each glass, $5-10 for the box only.

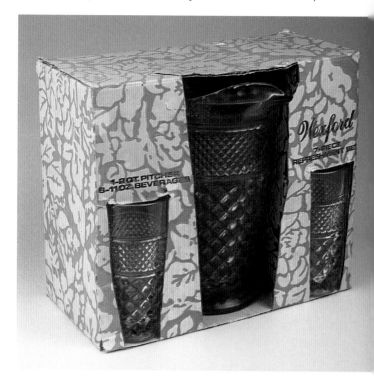

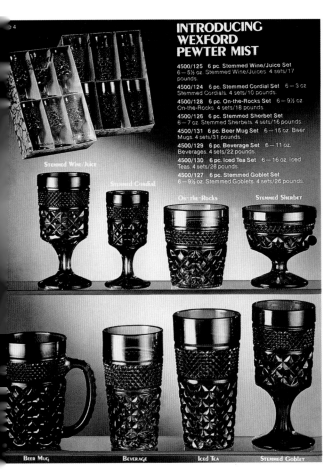

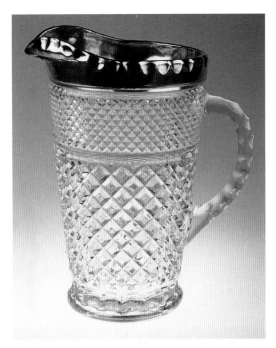

Unusual 2 qt. pitcher with a platinum edge applied to the lip of the pitcher, $35-50. It is hard to find the platinum edge in good condition.

The Pewter Mist version of Wexford was introduced in the 1976-1977 *Gift Supplement*.

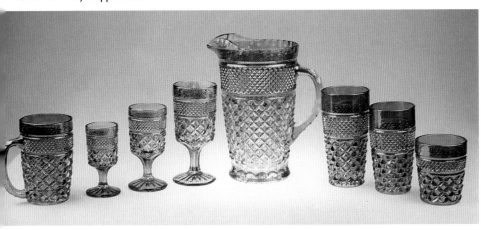

Pewter Mist was a name used to designate a special coating applied to Wexford glassware. It can be difficult to find pieces with even color distribution. Left to right: 15 oz. beer mug #4500/131, 5", $5-10; 3 oz. stemmed cordial #4500/124, 4 1/2", $3-5; 5 1/2 oz. stemmed juice/wine #4500/125, 5 3/8", $3-5; 9 1/2 oz. stemmed goblet #4500/127, 6 1/2", $4-5; 2 qt. footed pitcher, $30-40; 16 oz. iced tea #4500/130, 6 1/4", $4-5; 11 oz. beverage #4500/129, 5 1/2", $4-5; 9 1/2 oz. on-the-rocks #4500/128, 3 3/4", $4-5.

It is interesting to note that the platinum rimmed glasses were not called Wexford. Instead, they were called Oxford. This is a set of six 6 oz., 5 1/2" stemmed wine/juice, $30-40 for the complete set, $5-10 for the box only.

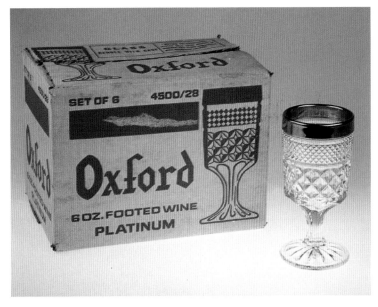

127

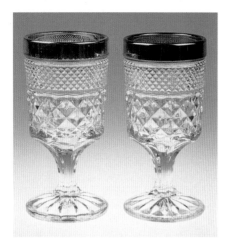

Anchor Hocking applied both platinum and 22 kt. gold to many items in this pattern. Left to right: 6 oz. footed wine/juice with 22 kt. gold rim, 5 1/2", $4-5; 6 oz. footed wine/juice with platinum rim, 5 1/2", $4-5.

Anchor Hocking did experiment with frosting a limited number of Wexford pieces. Unfortunately, the cost of frosting the glass exceeded the wholesale price the company charged, so the process was quickly discontinued. $75-80 for the pitcher, $40-50 for each 16 oz., 6 1/2" iced tea.

Many of the Wexford glasses were packaged in plastic containers, unlike earlier glass patterns. $15-20 for the set of four 9 1/2 oz., 3 3/4" on-the-rocks #4510.

Whirly Twirly™

The 8-Piece Wexford Wine Set #4500/192 consisted of one 32 oz. wine decanter, one decanter stopper, and six 5 1/2 oz. stemmed wine glasses, $30-40 for the complete set, $5-10 for the box only.

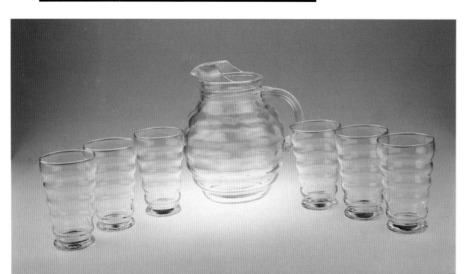

Whirly Twirly pitcher, $35-50, with six 14 oz. tumblers, 5", $10-20 for each glass. I had mentioned in the *Forest Green Glassware* book that company employees said crystal glasses were not made in this pattern, only the Royal Ruby and Forest Green glasses. I was able to find the crystal glasses, but only in a very limited quantity.